W9-BCC-695

Watercolor Lessons
from
Eliot O'Hara

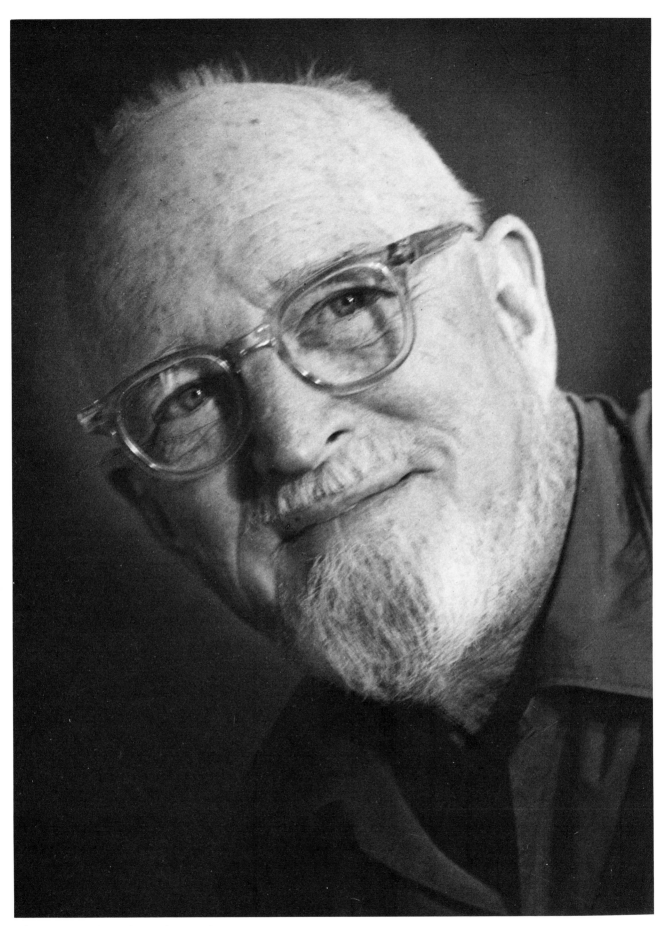

Eliot O'Hara, 1967. Photo Klara Farkas.

Watercolor Lessons from Eliot O'Hara

by Carl Schmalz

Paintings by Eliot O'Hara

Text by Carl Schmalz

All paintings courtesy of the O'Hara Picture Trust, Amherst, Massachusetts
Black and white photographs, except where otherwise noted, by Robert Cornigans
Color photographs by Ronald V. Wiedenhoeft

WATSON-GUPTILL PUBLICATIONS, NEW YORK

PITMAN PUBLISHING, LONDON

To the memory of
Nancy June O'Hara
1927–1951

First published 1974 in the United States and Canada by Watson-Guptill Publications,
a division of Billboard Publications, Inc.,
One Astor Plaza, New York, N.Y. 10036

Published simultaneously in Great Britain by Sir Isaac Pitman & Sons Ltd.,
39 Parker Street, Kingsway, London WC2B 5PB
ISBN 0-273-00806-4

Manufactured in the U.S.A.

Library of Congress Cataloging in Publication Data
O'Hara, Eliot, 1890-1969.
Watercolor lessons from Eliot O'Hara.
Bibliography: p.
1. Water color painting—Technique. I. Schmalz,
Carl. II. Title.
ND2420.032 1974 751.4'22 73-21666
ISBN 0-8230-5666-X

First Printing, 1974

CONTENTS

PREFACE

When the possibility of writing this book first arose I had serious misgivings about undertaking it. One person can never re-create another: even those who know someone most intimately must see him through their own eyes. I decided to proceed because of, first, a lively sense of the value and significance of O'Hara's art and teaching and, second, my recollection of his perennial insistence upon being oneself. O'Hara had a healthy respect for his own uniqueness and urged others to adopt the same attitude toward themselves. Those who knew him will remember his favorite toast: "To our own good qualities, which indeed are not few!" It was O'Hara's example, therefore, which encouraged me to go ahead, accepting the fact that I was bound to present, at best, *my* interpretation of the man and his work. I hope that former students will agree that the task deserved to be done, and excuse any myopia this book may seem to illustrate.

I have tried to follow O'Hara's teachings as closely as possible, in terms of both organization and specific content, injecting myself as little as possible. The style of writing is my own, of course, and I hope it is not too obtrusive. It is inevitable that my ideas, or my twists on O'Hara's ideas, have become intermingled with what I have reported as his. I do not think he would have me apologize for that, but the reader deserves the warning. Though I have been scrupulous within reason, some of what you will read here is me.

The illustrations deserve comment. O'Hara habitually ridiculed—not always unfairly—the self-serving "how to paint" book filled with the author's own work. His own books reproduced examples of varied styles by many artists. In this case, however, a departure from O'Hara's convictions has seemed justified. The heart of his teaching was his daily demonstration. To substitute for that, four illustrations accompany each lesson. As often as possible the pictures chosen are actual demonstrations, frequently unsigned. My object has been to provide apt examples of O'Hara's techniques and solutions for the pictorial problems under consideration. An effort has been made, as well, to suggest his range and versatility, and to include some examples of his very finest work from various years.

A final word: the pigment mixtures included in the section entitled "O'Hara's Solution" of each Lesson were done from the paintings themselves, and are accurate even if the printed color occasionally may not reflect the painted colors with 100% fidelity.

About the Chapter Openings in This Book

The photographs appearing in Chapter openings 1, 2, and 3 are:

Chapter 1. *O'Hara demonstrating for the Corpus Christi Fine Arts Colony, 1954.*

Chapter 2. *O'Hara demonstrating reflections in water at the University of Miami, May 14, 1950. Photo by Fleming.*

Chapter 3. *O'Hara demonstrating reflections in water, c. 1958 (detail). O'Hara is seated on a low folding stool, which gives him complete freedom of arm movement, from shoulder to brush. His paper is clipped to a board and the board lies on a knapsack to raise it up a bit, tilt it toward him, and keep it out of the grass. To his right, the palette box lies open. O'Hara is using a 1" brush with a plastic handle that can also be used for scraping.*

The reproductions appearing in the Lesson openings are O'Hara's solution to the problem covered in that Lesson and are all reproduced in full color in the Color Plates, pages 81–112.

ACKNOWLEDGMENTS

Like every author, I owe a tremendous debt to countless people, most importantly to all of my teachers, colleagues, and students. Specifically, I wish to thank the O'Hara Picture Trust for permitting me to use the paintings reproduced here, and for allowing me to study many others. I thank Desmond and Joan O'Hara for their generosity and support; Donald Holden, Diane Casella Hines, and Margit Malmstrom for their wise and kind editorial help; Ronald V. Wiedenhoeft and Robert Cornigans for their fine photography; Sara Upton for a superbly typed manuscript; and my wife for her unfailing patience and presence.

CHAPTER 1

ELIOT O'HARA ART CLASS
NO VISITORS PLEASE

ELIOT O'HARA: ARTIST AND TEACHER

Eliot O'Hara's first one-man show was held early in 1925. He was thirty-five years old. Since his father's death in 1912 he had been an innovative manufacturer and a successful businessman, responsible for the welfare of his mother and three younger brothers. During this period, however, his creative energy had increasingly overflowed into drawing and painting. By the early 1920s his evenings, weekends, and vacations were consumed by art, and most of his friends were similarly afflicted. He used to joke later that he had begun painting through "consorting with bad companions."

In the spring of 1924 he and his bride, Shirley Putnam O'Hara, spent their honeymoon on an extensive tour of Europe. During this trip O'Hara painted nearly three hundred sketches—more than two a day. That fall five of them, redone and enlarged slightly, were accepted at the Philadelphia Watercolor Club Annual. The next year his second one-man show, at the R.C. Vose Gallery in Boston, sold out. His "meteoric rise to fame," as one critic in 1933 put it, had begun.

O'Hara's accomplishments during the following six or seven years were indeed spectacular. He sold his business, won two Guggenheim Fellowships, and had at least twelve one-man shows—in Boston, New York, Washington, D.C.; London and Sheffield, England; and Tiflis, Russia. In addition, his work was exhibited in major group shows in Paris, Philadelphia, New York, Chicago, Cleveland, and Boston, and a selection of works from his 1929 trip to Russia traveled all over the United States. His watercolors had been purchased by four museums—a good start on the thirty-six public institutions in which his work would be represented by 1969, the year of his death. In 1931 he won the first of his eighteen important prizes, and in 1932, the second. He wrote an article

for the *American Magazine of Art* in 1930, opened his famous school at Goose Rocks Beach, Maine, in 1931, and in 1932 published *Making Watercolor Behave*, the first of his eight books on aspects of watercolor technique, two co-authored with colleagues. Despite the Depression's mounting effects, he continued to sell extremely well, and at excellent prices.

As many reviewers of these early exhibitions remarked, O'Hara from the beginning was attracted by effects of light, shade, and atmosphere. His color was unusually strong for watercolor, and his early mature style was based upon very direct washes and bold brushwork. From the first, his painting displays not only a formidable compositional inventiveness, but also a distinct interest in conventionalization and simplification. All of these qualities persisted, though appearing in variant forms, during the course of his long and active artistic career.

Among the most durable of his characteristics as a painter was his openness and hospitality to new ideas and new media. He taught himself the sgraffito technique of printmaking in the early 1930s and similarly learned etching and aquatint somewhat later. When the first polymer-based paints appeared in the early 1950s, he enthusiastically explored that new aqueous medium. His first love remained transparent watercolor, but he also worked from time to time in gouache and casein.

Through the forties and fifties he continued to paint in a style that is fundamentally a personally modified Impressionism—that is, mainly landscapes in which the chief motivating factor is light and color. These pictures, invariably held together by a lucid and forceful design, became less complex toward the end of the fifties. By the 1960s, and especially during the last four or five years of his life, O'Hara had forged an essentially new watercolor style, albeit one grow-

ing logically out of his perennial concerns. His late watercolors preserve his miraculous technical skill, but eschew many details of illumination and texture. They tend to be mainly simple washes with spare but obvious brushstrokes. In color, too, they are less fulsome, more neutral in tonality, and more restricted in hue. These late compositions stress classic verticals and horizontals. They evoke a calm power and give mute testimony to a new resolution and dignity, rich in nuance, subtlety, and tenderness. A remarkably prolific artist throughout his career, O'Hara maintained in his art a consistently high level of skill and expressiveness. In these little-known late works he achieved a very personal, essential statement that can stand with the finest of American watercolors.

O'Hara's prodigious energies were not confined to his own painting. An ardent and persevering defender of watercolor as a serious artistic medium, he devoted continuous effort to promoting its acceptance on a par with more traditionally respected media. He pursued this end as author, juror, film-maker, and teacher. In 1948 he was among the eight watercolorists to become the first representatives of the medium in the National Academy of Design.

Beyond his own art, however, O'Hara was most renowned as an inspired and enormously influential teacher. For nearly forty years, from 1931 to his death, thousands of people studied watercolor with him, either at Goose Rocks Beach or in one of the many classes sponsored by universities, museums, and art associations across the nation. Additional thousands read his books; others saw the films he began making in 1936. One of the first artists to recognize the potential of film as a powerful teaching instrument, he made more than two dozen movies. Several won prizes and awards, and many of these pioneering films remain models of pedagogical technique in the medium.

O'Hara's outstanding success as a teacher depended upon two basic insights. In the first place, he focused on the physical techniques of painting rather than upon "art." The foreword to his second book, *Making the Brush Behave*, published in 1935, says: "The theory of [this book's] teaching is predicated on the assumption that art itself cannot be taught . . . [but] . . . that a student *can* be taught the technical part of painting, just as a writer can build a vocabulary or a musician learn the fingering of his instrument." In the second place, and perhaps more importantly, O'Hara analyzed and structured his presentation of technique.

An essay by Walter Gropius on the Bauhaus, published in 1923, argued that schooling cannot produce art but that the manual and theoretical knowledge necessary to creativity can be taught. Ideas like these were beginning to appear during the years immediately following World War I, but it is likely, as he said himself, that O'Hara's notions were generated independently out of his experience with manufacturing and his own painting.

When O'Hara first began to exhibit he was a largely self-taught amateur. He had searched out such books

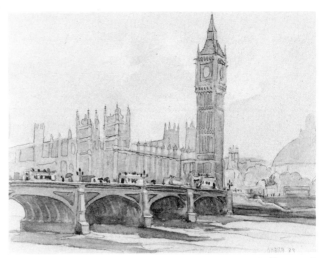

The Houses of Parliament, *1924. 9" x 12", 140 lb. rough paper. O'Hara's earliest style emphasized shape and pattern. In many of these sketches, made on his honeymoon, he outlined shapes with pencil or colored crayon after the washes were dry.*

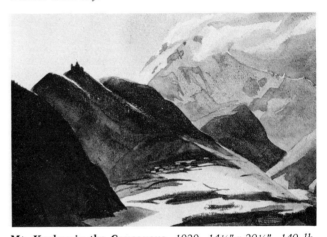

Mt. Kasbec in the Caucausus, *1929. 14½" x 20½", 140 lb. rough paper. During part of his second year as a Guggenheim Fellow, O'Hara painted throughout Soviet Russia. He was the first foreign artist to travel there after the Revolution, and his pictures were widely exhibited both in Europe and in this country. Photo by Woltz.*

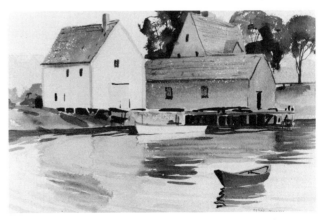

Cape Porpoise, *1931. 12¼" x 17¼", 140 lb. rough paper. This painting is probably a demonstration for O'Hara's first class at the Goose Rocks Beach School. He was still painting reflections in water with hard edges for all the ripples.*

O'Hara at Goose Rocks Beach, Maine, 1947.

He conceived of learning as the gradual acquisition of particular skills, and of mastery of technique as a means to freedom of expression. He divided the complex process of picture-making into easily assimilable bits. Although each segment was independent, each related systematically to previous and to subsequent lessons, so that the units fell into an orderly sequence, forming a tightly integrated whole. In this way the student increased his knowledge as his skills were honed, and at the same time periodically reviewed the techniques and the information that he had already acquired.

Even more significant, perhaps, than the overall organization of his course was the clarity evident in O'Hara's organization of each separate lesson. The morning began with a brief criticism of the previous day's homework. The lesson proper was divided into four parts: a verbal presentation of the day's problem, an on-location demonstration by O'Hara, supervision of student attempts to grapple with the problem, and jury action and criticism.

The presentation usually lasted about thirty minutes and contained as much theoretical information as was needed. It often included a good deal of simple meteorology, oceanography, geology, botany, or physics. The demonstration rarely took more than forty-five minutes, even with copious explanatory comments and full answers to questions. Color mixtures; proportions of water to paint, to brush, and to paper; suggestions as to representation and design — all were carefully dealt with and always linked to the matter at hand.

The students were given an even hour to try their turn at the problem. O'Hara, or an assistant, tried to see each student once or twice during this hour, to give specific help and moral support. O'Hara encouraged his students to express themselves as economically as possible, and quick painting served that end. It had the added advantage of allowing sufficient time for a return to the studio, where jury action and criticism rounded out the day's lesson. This respite allowed all the students to look at their work "whole" after having focused on some narrow aspect of picture-making. It further permitted each student to measure his progress in terms of the others, to see the achievements of the class as a group, and to develop some critical independence.

If O'Hara's analytical and structural approach contributed importantly to his teaching success, so also did the atmosphere of dedication that he generated. Another less obvious factor was his insistence upon the student's developing his own mode of expression. To this end he incorporated into his courses lessons designed to explore alternatives to traditional representation and to encourage attention to matters of composition and content. He invariably stressed the value of variety in one's models, though, equally, the undesirability of copying. One result of O'Hara's persistent emphasis upon the individual personality of the painter was that — as he had predicted as early as 1934 — his best pupils painted in styles different from his and from each other's. That itself is a compelling testament to his effectiveness.

as he could find on painting and become familiar with instruction manuals, particularly of British authors. Primarily to help the would-be draftsman, these books were often of the two-circles-two-triangles-to-make-a-cat variety. O'Hara could not have missed the similarity of this approach to his analyses of the industrial process, which were preparatory to the many inventions that he applied to his own business and that earned him membership in the American Society of Mechanical Engineers. With characteristic imagination, he brought a means devised to teach representational drawing together with his experience as an inventor to create a method of teaching painting technique.

The most obvious connection between O'Hara the manufacturer and O'Hara the teacher lay in his extraordinary ability to perceive clearly and isolate logically the effective segments of a given process.

CHAPTER 2

HOW TO USE
THIS BOOK

The O'Hara method has necessarily been altered in the course of adapting it to book form. Nonetheless, the lessons in the following pages have been selected to give a beginning student of watercolor an introduction to the medium as Eliot O'Hara taught it and to provide the one-time O'Hara student with a useful review.

These lessons, arranged to give you a six-week mini-course, are presented in an ideal sequence, since I have not taken into account the exigencies of weather. There are six five-lesson units, and two final lessons that deal with studio work. The first lesson in each unit is devoted to technique; the second is generally devoted to aspects of value and color; the third to problems of representation; the fourth and fifth to matters of design and expression. As you progress through the book you will find that the lessons advance toward more complex techniques and that the latter ones are dependent upon those which precede them. In a general way, the lessons dealing with design and expression come later in the book, while those dealing with basic techniques and representational devices tend to cluster at the beginning. For this reason you will, as a rule, find it better to take the lessons in the offered sequence rather than to jump around.

Each lesson has four parts: a presentation of the problem on which the lesson focuses; a detailed outline of your procedure; a discussion of O'Hara's solution to the problem; and, finally, a few notes appended to indicate other uses for the devices presented, special situations to watch out for, or alternative possible solutions. The black and white reproduction that begins each lesson is the painting in which O'Hara presents his solution; it is also reproduced in full color in the Color Plates on pages 81–112.

The best way to use this book is to read through each lesson before you tackle it—perhaps even the night before you plan to do it. Also look at the corresponding Color Plate (pages 81–112). This will familiarize you with the problem, the procedure, and O'Hara's solution. Since you will not be able to watch a demonstration, you will find that rather detailed technical information has been included in the sections headed "O'Hara's Solution" and in the captions accompanying the Color Plates. These should give you a pretty clear idea of how he solved the problem. The directions for your own procedure have been made as simple and full as possible. You will enjoy no jury discussion or final criticism, so you may find that treating your finished work to a step-by-step analysis similar to the one given O'Hara's picture will help you identify any mistakes you have made or pinpoint the reasons for disappointing effects. It will also help you remember those things that turned out well so you can use them again for another picture.

Ideally, you will want to budget about two hours for each of these lessons. You will want to be able to do the suggested exercises and you may also want to be able to go outdoors to paint. O'Hara demonstrated outdoors whenever that was feasible—indeed he did most of his finished paintings on the spot, because he felt that his reactions to the total environment, plus the ability to check the appearance of an object or the quality of color and tonal relationships, was of fundamental importance. If you are interested in painting landscapes, as you must be to be reading this, you will do well to learn as soon as possible to adapt yourself to painting outdoors.

PAINTING OUTDOORS
The advantages of outdoor painting are obvious, but there are a number of disadvantages, too, which you must learn to overcome or accept. These include

bright light on the paper, for sometimes it is impossible to find a spot of shade to paint in. Whenever you can, though, do paint from a shaded area. This advice is given for two reasons. One, the glare of sunlight on a white paper before you have begun to paint and during the process of painting can be dangerous to your eyes. It induces something akin to snow blindness, and at the very least adversely affects your ability to judge values both in the subject and on the paper. Two, the heat from the sun causes the washes to dry much more rapidly than is normal, which can lead to technical difficulties. Do not paint while wearing sunglasses: they change your perception of color and value in subject and on paper.

On occasion, wind can be a trial to the *plein-air* painter: blowing up the corners of the paper or wiggling it on the board; flinging dirt, sand, dry grasses, and other debris into the wet washes. Insects are a problem too. Mosquitoes, gnats, black flies, ticks, and other unpleasant creatures can literally bug the watercolorist to death. It is a good idea to carry insect repellent in your painting sack at all times.

Cold is another problem. In northern climates, painting outdoors in the late fall, early spring, or winter can seem impossible. Painting with gloves is difficult, but it can be done. Water that freezes on the surface of the paper can sometimes produce exciting and novel effects, but it is not always a help. It is useful to add a little glycerin to your water to prevent this if you are a really rugged outdoor painter.

When painting outdoors, common courtesy requires that you ask permission—whenever possible—of the owner of the land upon which you wish to sit.

Finally, try to avoid crowds of people. It may be flattering to be so exciting a phenomenon that everyone in town wants to watch you paint. It is also distracting. People get in your line of vision, they kick dirt in your palette, and they annoy you with questions. There is little that can be done about this except to say, frankly and courteously, "I would appreciate it if you did not question me while I am painting. I'll show you the picture and talk about it after I'm finished. Please don't stand in front of me. Stay well back." O'Hara solved one of these problems by flicking his brush in a wide circle beyond his palette, so that if anyone came too close they got paint on their shoes.

There is nothing at all you can do about rain unless you bring the picture inside or find a vantage point under a porch or projecting roof. (See Lessons 23 and 31.)

PAINTING INDOORS

If you are working in winter in a bad climate, or it is otherwise impossible to paint out of doors, you may still find this a useful book but you will be challenged to find appropriate subject matter. In some cases it will be possible for you to utilize earlier paintings or drawings, which you can then redo with reference to the appropriate lesson. For many of the lessons, especially those at the beginning, a simple view out a window will serve. Although O'Hara did not encourage the practice, you may find that you can copy or make variations on some of the compositions illustrated in the Color Plates of this book. It is also feasible to work from color photographs.

A word of warning about this is in order, however. When you are working from either a painting or photograph—or even your own drawing, although that is a special case—you are using an image that has already been reduced to two dimensions through the agency of another artist or a camera. This alters your perception of the scene by denying you your own peculiar sense of its three-dimensional solidity and depth. It is for this reason that teachers as a rule discourage using two-dimensional images as models for paintings—especially for those who are just starting and are therefore without the resources of a "memory bank" of visual effects in nature and paint. Obviously, however, it is better to work at practice painting this way than not to work at all.

If you have to paint indoors and have no studio for the purpose, it will be helpful to spread newspapers or a large piece of builders' plastic on the floor. With some protection for the floor, you will feel freer to wring out your brush and to drip: one of your tangential concerns will be significantly reduced.

PAINTING POSTURE

Your posture for painting must be entirely personal. Our anatomies are at least as distinctive as our psyches! O'Hara preferred, and preached, a posture resembling the kneeling position of Japanese Zen Buddhist artists. This, he felt, gave the painter the greatest freedom of arm and shoulder movement, while keeping the whole body relatively close to the painting surface. In later years he adopted a low stool, which allows virtually the same breadth of gesture but is easier on circulation in the legs.

You can sit on a stool to paint indoors just as you would outdoors. However, some people find it more convenient, when it is possible to do so, to stand to paint. This permits the same wide arm movement that sitting on a stool and painting between your feet allows, and it is less cramping. If you do stand, your paper may be placed on any large table. If there is not a low enough table available to you—usually, for people of average height, a card table works very well—you may want to make a small folding table for yourself, or use an adjustable ironing board. Whatever you use to paint on, try and arrange it in such a way that your paper is illuminated from the left (or from the right, if you are left-handed).

LIGHT FOR PAINTING AT NIGHT

It is not nearly so easy to judge your tonalities at night, but if for some reason you must work after dark, use a daylight fluorescent fixture plus some incandescent lighting. The daylight fluorescents contain more of the short, or cool, wavelengths, and an incandescent bulb, which is largely red and orange light, will help to balance them. A kitchen, from the point of view of lighting and flooring, will often serve very well as a part-time studio.

CHAPTER 3

WATERCOLOR MATERIALS

The watercolorist's basic materials are very simple: paint, brushes, and paper. Besides these essentials, some other necessary equipment is listed on page 15.

PAINTS

Watercolor paints are available in cakes or pans and in collapsible tubes. Since you will be painting on a fairly large scale, you will probably find that colors in tubes will best serve your purpose. Pan colors are hard; water, time, and vigorous brush movement are required to pick up any substantial amount of pigment. Tube colors are packed with gum arabic— the principal binder for watercolor—and sufficient water to permit the moist paint to be squeezed out in any quantity needed. The soft color is easily picked up by the brush, which facilitates mixing and covering large areas. If you have not tried tube colors, you certainly should, though you need not feel bound to use them.

Paints come in different qualities, and most manufacturers produce two. One is frequently designated "Students" grade, and the other is usually called "Artists." If you are confused by terminology, ask your materials dealer to explain the labels. In general, however, you can distinguish grades by the fact that Students colors are normally less expensive and more uniform in price. If in doubt, check comparative prices of a color such as cadmium red light. Artists colors are more expensive, even though the tubes may be smaller, and they also vary in price.

The initial price of coloring agents ranges from quite cheap for earth colors to quite costly for such metal precipitates as the cadmiums. This accounts for the differing prices of the paints. Artists colors are also more concentrated, so that you are purchasing more of the actual coloring agent, or pigment,

in the small tube of Artists color than in the larger Student-grade tube. Students colors are prepared by mixing the pigments with inert substances that extend them. Their coloring power is therefore less, especially in the basically costly colors—the cadmiums and some of the blues, for example. It may be worth your while to buy Artists-grade paints simply because they go farther than Students colors. For your first efforts, however, you may prefer to use the less expensive paints: the Students pigment is as permanent as the Artists grade.

Most manufacturers indicate, either on the tube or on a color chart, the results of the testing of their colors for permanence. This generally involves only light-fastness; it does not include tests for resistance to the chemical reactions that may occur in the polluted air of some urban areas. However, such chemical changes can usually be minimized by covering the painting with glass and by taping the cardboard backing of the picture to the frame to seal out air.

Light-fastness remains the main problem for watercolor; but there are very few colors on the market today that fade easily, and these so-called "fugitive" colors are invariably plainly marked. You may inquire of your manufacturer, or your dealer, when in doubt, but it is easy to test pigments for light-fastness yourself. Paint a patch of the questionable color on a piece of paper, cover half of it, and expose it to strong sunlight for three or four weeks. If the paint is fugitive, the exposed half will be perceptibly paler than the protected section. Remember that pictures seldom suffer such harsh treatment, so a paint that fades only a little is perfectly safe to use.

Watercolor paints differ in their degree of transparency, and it will be helpful for you to learn early on which colors are most transparent and which most

opaque. Make a test by painting a stripe of pure black on a piece of paper. When it is thoroughly dry, paint stripes of each of your paints across it. Some will almost entirely obscure the black—cobalt blue, for example. Others, such as alizarin crimson, will be scarcely visible on the black. Some of the uses of this difference in transparency are discussed in Lesson 29.

Generally speaking, transparent colors are dyes that are made into paint by precipitating them on a finely ground base. Some of these bases are completely transparent, some nearly opaque; in either case, a dye color (also called a "lake") will tend to stain the paper because the fine particles sink down *into* the fibers of the paper. This also happens with finely ground pigments. Such paints are difficult to wash off the paper and so lend themselves to underpainting and related techniques.

Opaque colors may be dyes, but more usually they are coarsely ground pigments. These paints do not penetrate the paper fibers but rather sit on top of its surface. They wash off more easily, and they also tend to form granular-looking washes, especially if two or more are mixed together. In selecting a palette, you may want to choose some transparent and some opaque paints.

Like all artists, O'Hara's palette changed a good deal during his lifetime. Listed below are colors that he used fairly consistently and that provide a suggested basic palette. Do not feel constrained by the colors listed: few aspects of painting are more personal than the choice of favored pigments. A possible arrangement of your palette is discussed in Lesson 3.

Alizarin crimson

Vermilion (or cadmium red light)

Cadmium orange

Cadmium yellow medium

Cadmium yellow pale (or cadmium lemon)

Phthalocyanine green

Phthalocyanine blue

Cobalt blue

Ultramarine blue

Ultramarine violet (or dioxazime purple)

Venetian red (or Indian red, or English red)

Burnt sienna

Raw sienna

Raw umber

Sepia (or burnt umber, or Van Dyke brown)

Ivory black

A well-capped tube of watercolor paint will last several years. If one becomes hard to open, heat the threads of the screw top with a lighted match for a minute: the cap will come free quite easily. When you are not going to be painting for a while, put all your tubes in a jar with a tight-fitting lid.

BRUSHES

Although high quality in your other materials is important to good painting, it is *essential* that your brushes be excellent. These tools become extensions of your hand. They transfer your vision to the paper. If they are in any way inadequate, they will directly impede your thought.

A fine brush is well made. Natural hairs, retaining their original tapering point, are shaped and tied together and then fitted into a metal collar, or ferrule. A setting compound (often rubber) is put in the back of the ferrule, which is then crimped onto a wooden or plastic handle. You cannot tell visually whether a brush has been properly tied and set, but if it has not been, it will drop hairs while you are painting. A ferrule should be of nonrusting metal, seamless, and tightly crimped. A wooden brush handle will resist wear longest if it has a smoothly polished paint or varnish finish of several coats.

The hairs are the most important part of the brush. For watercolor they should be supple and flexible, so that when well wetted they spring back nearly to their original position after they are lifted from the paper. The natural taper of the hair allows a well-made brush to form a sharp point or edge.

The best brushes for watercolor are made from red sable hair, but ox hair—though it varies a great deal—can be almost as good. Red sable brushes are costly in the larger sizes, so you may want to get ox for your bigger brushes. Your dealer can direct you to the manufacturers of good brushes and help you to choose a good-quality brush from their lines. Usually, you can test a brush for spring in water at the shop, and it is a wise idea to do so.

O'Hara used rather few brushes, and you will not need many either. Your basic brush should be a 1″ flat, or stroke. If possible, get one with relatively short hairs—about ⅝″. Those with longer hairs tend to be a little floppy, and they hold more paint and water than you will need. You will find a ½″ flat useful, and you should also have a #10 round. For fine detail, a #6 script, a highliner, or a rigger brush will be helpful.

Optional additional brushes are: a 1¼″ flat for larger areas, a good, big, round brush (ferrule *diameter* not less than ½″), and a 2″ varnish brush. The latter has soft hair, usually "camel," but is excellent for wetting and painting broad sections of the paper.

Take care of your brushes and they will last a long time. Wash them out well when you are through painting, and point them to dry. If you must abandon them for a long period, treat them as you would a fur coat: put them in a tightly closed box with moth crystals. *Never* put a brush away with paint in it or store it in a hot place.

PAPER

The best paper for watercolor is handmade from linen or cotton fibers. It provides an extremely durable support and changes very little over the years. It is available in four basic surfaces: smooth, or hot-pressed; semirough, or cold-pressed; rough; and

extra rough. For most purposes you will find rough paper easiest to handle and the most satisfactory for these lessons.

The characteristics of smooth paper are discussed in Lesson 26. Cold-pressed paper has a slight "tooth," a slightly irregular surface. It will hold a wash fairly well and can be "rough-brushed" quite easily. Rough paper has definite "pimples" and dimples on its surface. Water is retained in the dimples, causing it to dry a little more slowly than cold-pressed paper. Rough-brushing is not at all difficult with this surface. It is the most commonly used paper for watercolor. Extra rough means what it says: the surface is highly irregular. It is agreeable for certain effects, but some people find it a little too coarse (see Figure 21).

These terms for paper surfaces are generally used, but the actual surface of a rough made by one manufacturer will not be exactly the same as one made by another. You may want to shop around to find a paper that pleases you before settling on any one kind.

Watercolor paper comes in various weights: 72 lb., 90 lb., 140 lb., 200 lb., 300 lb., and 400 lb. The weight refers to the number of pounds per ream, or five hundred sheets. Some smooth papers suitable for watercolor are described by their *ply*, a measure of thickness rather than weight. Two-ply paper is a little thinner than 140 lb. paper, for example, and three-ply paper is very nearly the same thickness as 200 lb. paper.

In general, the lighter weights of paper, though less expensive, are more difficult to paint on. If they are clipped to a board, they buckle, or cockle, when wet. To prevent this, you must wet and stretch the paper, attaching it to a board with tape or thumbtacks, and wait for it to dry before working on it. This process tends to smooth the surface somewhat, but mostly it is a tedious and unnecessary process. On the other hand, although paper in the heavier weights is a pleasure to work on, it is very costly. For the beginner, especially, 300 lb., or even 200 lb., paper would be a wasteful purchase. Moreover, with so much invested in the paper, you might easily become too paralyzed to paint! The 140 lb. weight will do very well for these lessons: it is heavy enough to clip to a board without stretching, it buckles very little, and its cost will not inhibit you (much).

Paper for watercolor also varies in size. The most common size is Imperial, or roughly 22″ x 30″. This is what is generally meant by "full sheet"; torn in half, it is a "half sheet," 15″ x 22″. Individual sheets of handmade paper are not constant in size, as you will notice by reading the measurements of the O'Hara paintings reproduced in this book, but they do not vary enough to matter. Less common sizes are Elephant and Double Elephant.

Pads, or blocks of watercolor paper, are favored by some artists. O'Hara did not use them because he disliked their tendency to buckle. This is no reason why you should not try them, though—they are convenient because they require no board, and they come in a wide variety of shapes and sizes.

The O'Hara School at Goose Rocks Beach, Maine, c.1940. This view shows the Watercolor Gallery and attached studio toward the beach at the rear.

Less expensive papers for watercolor are made by machine. Some are not pure rag, and all have a regular texture imprinted or molded onto their surface. Those that are not rag will yellow with age and should not be used for serious work, although they, and other machine-made papers, can serve the beginner well. As soon as you feel able, however, you should acquaint yourself with the properties of fine paper, since this is what you will use as an artist.

Watercolor paper must be kept in a dry place, covered and flat. Do not handle it any more than necessary, for although most handmade rough paper is protected by a layer of glue or starch sizing, it can easily be damaged by abrasion or scratching.

OTHER EQUIPMENT

In addition to paints, brushes, and paper, you will need a few other things, listed below:

One board, about 15½″ x 22½″. Masonite, aluminum, or equivalent.

Four spring clips at least 2″ long, or four spring clothespins.

Water container and large-mouthed jug for painting. Try two ½ gal. plastic milk bottles, one cut down. A GI canteen with cup is also good.

Palette, preferably white. Enameled tray, white plate, or a commercially available palette box.

Boxes for brushes and paint tubes, if there is not space in your palette box.

Stool, low folding camp-type.

Sketchbook, soft pencil, gum eraser, and note-taking material (see Lesson 31).

Sack or knapsack for carrying all gear.

Hat with wide brim.

Insect repellent.

Knife.

Miscellaneous material (see Lesson 16).

LESSON 1

ROUGH PAPER TECHNIQUES

This lesson will acquaint you with some basic ways of using a large brush on rough watercolor paper. (For O'Hara's solution, see Color Plate 1 on page 81.)

PROBLEM

As you begin painting in watercolor, the first thing you must learn is what your materials can do. Fundamentally, you will be working with brushes, water, paint, and paper: these are your variables. Your brush is your most important tool. Its strokes will give you different effects depending upon the way you hold it and the speed with which you draw it across the paper. The proportion of water to paint in the brush, and on the paper, can also be controlled to create distinctive effects.

The exercises in this lesson are designed to help you learn how to manipulate your tools and materials.

PROCEDURE

Clip a half sheet of rough paper to your board. Tilt up the board about three inches by placing something under the side away from you. Squeeze out about a butter-pat of *black* paint on your palette. Wet your 1″ brush well by pushing it down firmly against the bottom of your water container several times. Get out your pencil.

Washes. There are two basic washes: *simple* and *graded.* The first is more or less uniform in tone overall. The second ranges from dark to light (or from one tone to another, as demonstrated in Lesson 6).

To make a simple wash, divide your paper approximately in half with an irregular pencil line, perhaps suggestive of an urban silhouette. Now load your brush with water and wet the area you will paint. Hold the brush vertically; this allows the water to flow most quickly onto the paper. Use strokes that

are firm and even. Tilt the paper so the light reflects on it and check whether you have wet it all over. If there are pools of water, dry your brush slightly by pinching it between your fingers; then it will pick up any excess water (this is the result of capillary action between the dampened hairs of the brush). A few more strokes will even out the layer of water on the paper surface.

Dry your brush slightly, as before. Now pick up some paint and work it well into the brush by dabbing it around on your palette. Paint it on the paper in crisscross strokes, with a vertically held brush. The color will begin to flow outward almost immediately, filling in the spaces between the strokes. If you need more paint, work it into the brush in the same way as before (otherwise you may get dark marks). Using the same even strokes you employed to wet the paper, blend the paint into a smooth, uniform tone.

Be careful not to go back into areas where the paper is beginning to dry. (Keep checking light reflection to determine this.) If you do, you will get messy looking, uneven places in the wash.

While this wash is still wet, clean and dry your brush again. Set it on the wash and observe that it will pick up paint, along with the water. This technique, sometimes called "wiping out," is extremely useful, as you will notice in the discussion of O'Hara's paintings that follow.

Before your wash dries also try dropping clean water into it. The water will spread out, forming "oozles." When properly controlled, they too provide useful effects.

A graded wash varies from a simple wash only in the way in which the paint is applied. After wetting the paper evenly, pinch your brush dry: it should be a little dryer than for a simple wash. Pick up quite a lot of black paint and work it into the brush. Now

16

paint the *top* of your wetted area with broad strokes along the upper margin. As you move the brush in horizontal strokes down the paper, it will begin to run out of paint at the same time that it picks up additional water from the paper surface. This gradual dilution will make the wash progressively lighter. If the change is too abrupt, you can use short, vertical strokes to blend it more, smoothing it with a few final horizontal ones. Again, be careful not to go back into drying areas. But do notice that as long as the paper is wet and the proportion of water in the brush to water on the paper remains about the same, you can modify your wash freely.

One final note: watercolor paintings generally look best when they appear spontaneous. It is better to leave a slight irregularity than to spoil the fresh effect of a directly painted wash.

Rough Brushing. This term refers to the various effects of speckling and broken color obtainable in watercolor. Three factors are most important in producing rough brushing: the angle of the brush, the speed of the brush, and the amount of water in the brush. Rough brushing is most easily accomplished on the new, dry surface of the paper, which still re-

tains its sizing. With practice, however, you will be able to achieve most rough-brushed effects on areas already painted and dried.

Mix up some paint in a fairly wet brush. Holding it upright, draw it across the paper. It will leave a sharp, solid stroke (Figure 1). Now lay the brush flat on the paper and draw it along with the hairs, lifting it as little as possible. This mark will be speckled because the length of the hairs cannot get down into the depressions of the paper as the tips of the hairs do.

With your brush loaded and held upright again, paint a short, solid stroke. Don't change the angle of the brush, but now move it very rapidly across the paper. You will obtain a stroke that appears partly rough brushed and partly a series of very fine parallel lines. The speed of the brush, in this case, does not allow the hair tips to deposit all the paint in the brush.

Again load your brush. Lay it flat on the paper and rotate it gently. You will create roundish areas of rather coarse rough brushing. Then dry the brush a little and lay it flat once more. Rotating it this time, you will find that very little paint is applied to the paper surface. Try again, bearing down hard and moving a little faster. You will discover that you make

1. Brushstrokes, *1937. 22¼" x 15¼", 140 lb. rough paper. This is a class demonstration. Underneath the brushstrokes is a graded wash. All the strokes were made with a 1" flat brush. Note the difference between rough brushing with a wet brush (center) and a dry one (above). The "windows" at left were made by separating the brush with the fingers. O'Hara made an "oozle" by dropping water into the still-wet wash at top center. There are whisking strokes at bottom left.*

2. Harbor in Brittany, *1958 (Above). 15¼" x 21½", 140 lb. rough paper. O'Hara paints the sea with a graded wash. The sky is done by adding new brushloads of pigment to a still-wet area. The brush must be relatively dry for this because there is water already on the paper. The technique is called "wet-in-wet," or "wet blending." It is more fully discussed in Lessons 6 and 21.*

3. Harbor in Brittany, *1958 (detail). Notice the pencil marks, still visible, but unobtrusive and therefore left in place. O'Hara uses rough brushing for the stonework around the little harbor. He scrapes out the boats and masts with a knife while the water is still wet (see Lesson 16). The ripples are made by adding clear water to the damp wash. These "oozles" are similar in effect to "wiping out," which is done by drying the brush between the fingers, then picking up paint from a moist wash.*

18

considerably finer rough brushing with the drier, faster brush.

Special Effects. Your 1″ brush is a versatile tool. If you know how to exploit it fully, you will rarely need other brushes.

Load your brush. Hold it vertically and tip it so that only the corner touches the paper. Now move it so that the corner *trails* the rest of the brush. It will leave a thin, straight line. With a little practice, you can use this stroke to make telephone wires, ropes, twigs, and other fine details.

Set a loaded brush on the paper at an angle of about 30° to the surface. If you move it along in a direction parallel to the tip of the brush, you will produce a mark that is clean and smooth on one side, rough on the other. Try the same stroke at different angles for longer and shorter rough-brushed sections.

With a normally loaded brush, make quick, short strokes by flicking the brush away from you. If you hold the brush vertically and are quick and light enough, you will make "whisking strokes." These are very useful in painting grasses and certain kinds of foliage.

Rinse your brush and dry it slightly. Instead of putting the whole tip into the paint, set only one corner on the palette. Dab the corner around a little, and then make a mark on your paper, holding the brush vertically. You will produce a "double-loaded" stroke (so called because you can as easily make it with a different color in each corner of your brush), which blends from dark to almost white. This is excellent for a shadowed tree trunk.

Ellipses, S's, Squares, and Lozenges. These exercises are like piano scales—they train the hand in dexterity. You will find that they often help in painting a picture as well.

Hold the brush vertically. Now set it on the paper and draw as thin a line as possible. Gradually curve the brush toward you to make its widest mark. Then change direction, keeping the brush in the same position so that it again makes a thin line. Complete the ellipse by moving the brush away from you. Make S's in the same way, except by changing direction in the broad part of the stroke.

Make a series of one-inch squares. Vary them by gradually altering the angle of your brush so that they become lozenges. Draw a number of "gables" of differing spread and fill in their points with lozenge strokes.

O'HARA'S SOLUTION

Land's End (Color Plate 1) shows how a number of the techniques you have been practicing function in an actual watercolor painting.

O'Hara begins the picture by noting with his 4B pencil the location of the horizon, the water's edge, the land mass and buildings at right, and the bit of foreground.

He wets the sky with clear water and evens it out. Then he introduces a little vermilion at the lower-left corner, dragging it across to the right where he adds some ultramarine blue. These tones are quite pale. While the wash is still moist, he puts in some light phthalocyanine blue and alizarin crimson for clouds at upper right and some nearly pure, dark phthalocyanine blue streaks at upper left.

Next he wets the sea area with clean water, evening it out as before. He starts the graded wash with ultramarine blue and a little alizarin, neutralized with some raw umber. As he paints with horizontal strokes down the paper, he increases the amount of color in the brush—but *not* the amount of water—and gradually picks up some orange paint as well. The sea changes from lighter to darker, and from a barely violetish blue to a warm, orange-y violet.

As soon as these washes are dry, O'Hara loads his 1″ brush with ultramarine and alizarin and uses a smooth and rough stroke at right to form the distant treeline. He reserves the buildings. Starting at the left margin, with raw umber, he makes a stroke that stands for shore. He changes this by adding phthalocyanine blue toward the right: this helps the land to seem farther away than the little peninsula at right (Lesson 10). Another rough and smooth stroke, with more raw umber, a little phthalocyanine green, and very little water, makes shrubbery atop the shore at left.

Violet, made from alizarin crimson and ultramarine blue, is set in with the 1″ brush for the buildings. While this tone dries, O'Hara paints vermilion strokes, quite light, on the promontory at right. This will be the color of the rocks. Immediately he adds some yellow-green made from raw umber, phthalocyanine green, and cadmium yellow medium: this will be grass and shrubbery. With burnt umber, alizarin, and ultramarine he paints in the shaded rocks; he places a few dabs of burnt sienna among these strokes before they have dried. Some darker yellow greens are used to model the grass. A light burnt-sienna stroke forms the side of the boathouse, a dab of vermilion, the boat at center.

O'Hara rough brushes in the wind-ruffled water with ultramarine in a 1¼″ brush, speeding up as he moves it from left to right. One lighter stroke goes in just under the promontory. The foreground is set in with orange, yellow, blue, and raw umber. Notice the double-loaded stroke in the extreme lower left. Whisking strokes give a feeling of grass, and some dark sepia dots stand for weeds.

COMMENT

These exercises constitute a drill that you will find very helpful in loosening you up after even a brief lay-off. They limber the painting hand, and at the same time they recall to your mind the technical possibilities at your command. We will be looking at other uses of your materials as we go along. For instance, *Harbor in Brittany* (Figure 2) illustrates rough brushing for the texture of stone in the buildings at right. The detail of this painting (Figure 3) shows knife-strokes and "oozles," both done while the wash was moist. These techniques are specifically discussed in Lesson 16 and are also mentioned in Lessons 6 and 7.

LESSON 2

VALUES

This lesson will help you observe and paint tones that are proportionate to each other in lightness and darkness. (For O'Hara's solution, see Color Plate 2 on page 82.)

PROBLEM

The lightest things in nature are whiter than white paper, and the darkest things are much darker than black paint. This means that you cannot *reproduce* the light and dark relationships you see. To make a believable picture you must instead create lights and darks (values) that relate to each other in approximately the same *proportion* as those visible in nature. To do this, you have to learn not only to distinguish the relative values in your subject, but to translate them into the narrower range of paint.

Most people are able to discriminate among ten values quite easily. If you study your subject, you can number the approximate value of each major area from #1 (lightest) to #10 (darkest) and then paint them, in order, from light to dark. This is a simple method by which you can reduce the complexity of the painting process.

PROCEDURE

Start with a very uncomplicated subject—a pile of boxes, a shed or garage—that includes an area of sunlit white. Draw the subject very broadly with your pencil, merely indicating the shapes of the big areas (you will be able to paint any detail you want with the brush).

Now look at your subject carefully. Pick out the whites and very lightest areas and assign to them the number 1. Next number the very darkest parts with the number 10. The middle values are often the hardest to see. If you have difficulty determining which are lighter and which darker, punch two holes in a card, about two inches apart, and compare the problem areas through it. You can also do this by looking through your loosely held fingers, one hand crossed over the other. Either way, you can isolate the difficult values and compare them with each other and with areas already numbered.

The values nearest white should be numbered 2, 3, 4, those nearest black, 7, 8, 9: the higher the number, the darker the area. Numbers 5 and 6 will be middle values. Since this is an exercise, put the numbers boldly on the paper, as O'Hara does in Figure 4.

Check your painting gear and set out some fresh black paint: you are going to paint this exercise with black only. In watercolor you can cover a light area with a dark one, but not a dark with a light, so you must start painting the lightest values first. Leave value #1 areas as white paper and begin painting with value #2.

This is a good place to take note of a peculiarity of watercolor: *tones dry lighter* than they appear when wet. It may take you some time to get accustomed to this, and to make allowances for it. Right now, just remember that each value will have to go on somewhat darker than you want it to look when it dries.

As each area dries, proceed to the next darkest in value. When you get to the middle values, you may find it helpful to put in a bit of your #10, black. This will give you a guide, showing you how much range you have left. Otherwise you may produce a picture that is generally light and moves abruptly to the darkest darks; or one that is dark overall, with a few very light areas. In either case, you will not have utilized your value range fully.

As you paint you will find uses for some of the brushstrokes you have practiced. Notice that O'Hara employs rough brushing in the trees in Figure 4, the rough and smooth stroke under the boathouse and

lines on its end. He also uses knifestrokes (Lesson 16) for the boathouse supports.

When you have finished this exercise, check your work to see whether the value relationships you have painted correspond to the original numbering. Do not be too discouraged if there are some discrepancies, but take note of what you must work on for another time. If many or most of your values have gone awry, it is a good idea to make one or two value scales like that in Figure 5. Try to make each value differ from the next darker one by about the same degree of contrast.

And *remember:* tones in watercolor dry lighter than they appear when wet.

O'HARA'S SOLUTION

The challenging subject of *Chestnut Vendor* (Color Plate 2) is a view "up sun," or against the light. Value contrasts are extremely strong in this situation. O'Hara brings off the effect by careful control of the distant lights and the deep darks of the foreground.

He begins the picture with a light pencil indication of the arrangement of shapes on the paper. The sky is painted first with clear water, then evened out. Leaving white paper at upper left, for the glare of the haze-shrouded sun, O'Hara sets in orange at value #2, changing it, by adding vermilion, burnt umber, and ultramarine blue, to value #3 at the extreme left and right of the lower sky.

While this wash dries, he rough brushes the foreground sidewalk, using burnt umber and ultramarine. As soon as possible, he returns to the upper section of the picture, drawing in the silhouetted distant buildings with a wash of the same vermilion, burnt umber, and ultramarine that he used in the darker sky. Note that the value is the same, too. This wash is carefully faded out almost to white paper, but it is carried down the picture with a very little cobalt (you can still see it behind the fence). As he works down further, O'Hara adds alizarin, then vermilion, and finally, more burnt umber and ultramarine. He paints a continuously varying wash that grades to about value #6 in the left foreground.

The nearer silhouette of buildings goes in next with alizarin crimson, vermilion, and ultramarine. This also fades off, here into a dry, rough-brushed edge ending just above the fence.

When everything is completely dry, O'Hara mixes raw umber, sepia, and ultramarine blue to obtain a green at about value #9, which he rough brushes in for foliage. A single stroke of the 1¼″ brush suffices for the fence. With a smaller round brush he paints in branches and trunks, fence posts, and details. Vermilion accents suggest reflected light.

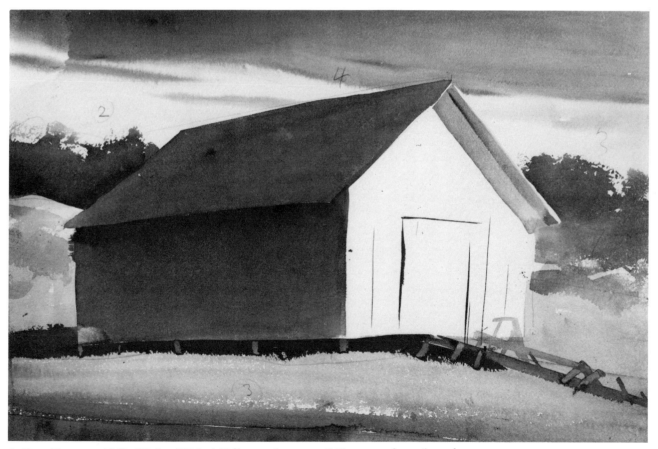

4. Boat House, *c.1942. 15½″ x 22½″, 140 lb. rough paper. O'Hara numbers the values for this demonstration, using heavily penciled figures. Notice that he numbers only the larger areas, allowing himself some leeway in places like the shadow cast on the end of the building. A fairly wet brush is used for the rough brushing of the distant trees. The strokes are rounded to give an impression of silhouetted foliage.*

The cast shadows are painted last. O'Hara puts them in with ultramarine and alizarin crimson, at about values #5–#6. He takes pains to be sure they accurately reveal the position of the sun. Figures are knifed out while the darks are still wet (Lesson 16), and a few touches of cobalt, phthalocyanine green, and vermilion give them color.

COMMENT

Accurate rendering of proportional value relationships is probably the most important single skill you must acquire in order to paint realistic pictures. It will reward you to practice this exercise by doing a simple black and white painting, numbering the values, from time to time. Meanwhile, it is a good plan to number values in *every* picture you do, at least for the present. To remind you to do so in each of these lessons would be tiresome, so remind yourself.

Values also, of course, are essential to good design in painting: learning to control values as you paint will enable you to produce the light and dark pattern you initially envision.

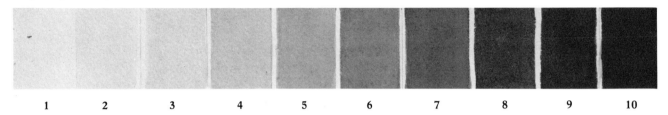

1 2 3 4 5 6 7 8 9 10

5. *Value Scale, by Carl Schmalz. 15" x 2", 140 lb. rough paper. With your pencil draw ten squares of about the same size. Mix the blackest black you can and paint it at one end of the scale as value #10. Then mix a value that contrasts equally with white paper and with the black: this is value #5½. Next, darken this value a little and place it at #6; lighten it a little and paint it in at #5. Then mix a value that contrasts equally with #6 and #10; paint that at #8. Value #7 will contrast equally with #6 and #8. The lighter values may be filled in the same way.*

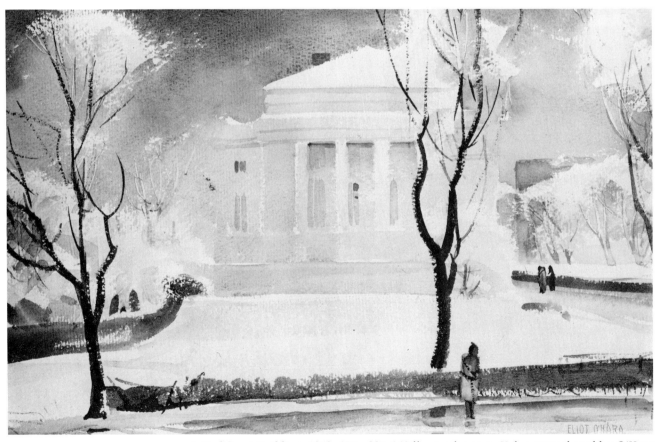

6. Red Cross Building, *1943. 15" x 22", 140 lb. rough paper. Value control enables O'Hara to create this effect of wet snow and overcast. The sky is arbitrarily darkened, to value #7 or #8, while the marble building is allowed to remain at about #4. This provides sufficient contrast with the white paper—the snow and glitter from the wet pavement. Foreground trees at #9 and #10 are dark accents that help to suggest the depth of space behind them. Notice that O'Hara reserves white-paper areas with rough-brushed edges to indicate the twigs, loaded with snow. Photo by Woltz.*

22

LESSON 3

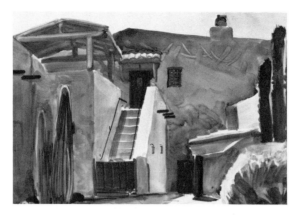

THE SPECTRUM

This lesson outlines the elements of color and color mixing. (For O'Hara's solution, see Color Plate 3 on page 83.)

PROBLEM

Any visible area has what is commonly called a "color." A color (or tone) may be fully described only by looking carefully at three variables: *hue, value,* and *intensity. Value*—the lightness or darkness of a tone—has already been discussed in Lesson 2. *Hue* (sometimes called "chroma") refers to that property of a tone denoted by the word "blue," for example, or "red." Differences in hue result from variations in the length of light waves reflected off surfaces, while value differences result from the *amount* of light reflected off surfaces.

Intensity, which is sometimes called "saturation," refers to the relative brightness or dullness of a tone. For instance, the intensity of an orange marigold is very high. Freshly fallen pine needles, ordinarily called "brown" or "rust," are nearly the same *hue* as the marigold: that is, they are orange. The difference in their appearance is due to their being much less intense (and often somewhat lower in value as well). Low-intensity tones are often said to be "grayed" or neutralized, because the less bright a tone is, the closer it is to those tones with no hue at all—namely, black, white, and the intermediate grays.

All color mixing requires that you pay attention to each of these variables, asking yourself not only, "What is the value?" but also, "Is that red closer to blue or to orange?" and, "Is it relatively bright or dull?"

A long time ago you probably learned the pigment primaries: red, yellow, and blue. When the primaries are mixed they produce secondaries: when you mix red and yellow, the result is orange; yellow and blue, green; blue and red, violet. The primaries and secondaries together make the six basic hues. In addition, most people can easily discern six intermediate hues, sometimes called "tertiaries." These are named on the spectrum chart, Figure 7a. Although there is an infinite number of hues, these twelve are a manageable number and are enough to serve for most of your thinking about color.

The hues near RO (red–orange) are called *warm,* probably because they are associated with fire and other hot things. The hues near BG (blue–green) remind us of cold water and ice and are called *cool.*

Hues opposite each other on a color wheel are called *complementaries* because they tend to neutralize each other when mixed in approximately equal proportions: a blue and orange mixture, for example, produces a gray (neutral) tone.

To alter only the hue of a particular tone, you must mix it with an intense hue that is near it in the spectrum. If you want a red that is slightly more orange than what you have on your palette, add to it the reddest orange you have. If you (quite logically) decide to add yellow, you will obtain a mixture considerably lower in intensity than either of the pigments you started with.

This happens because any change you make in a given hue, except by the addition of an equally intense hue very near it in the spectrum, will lower the intensity of that hue. This can be seen in Figure 7a, where any mixture across the area of the circle will yield a relative neutral, and the closer the mixed hues are to complementaries the more neutral will be the result. In addition, a little thought will make it evident that any *other* change in a hue at its highest intensity will *lower* that hue's intensity. For you can alter the hue

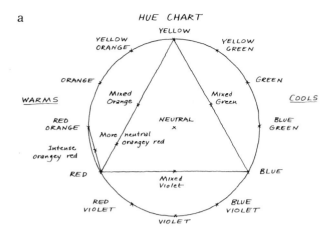

a

HUE CHART

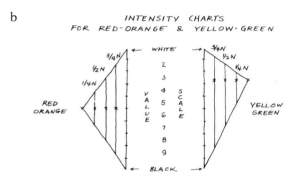

b

INTENSITY CHARTS
FOR RED-ORANGE & YELLOW-GREEN

7. *Hue and Intensity Charts, by Carl Schmalz. (a) Yellow, and the hues adjacent to it, are much higher in value at their most intense than are violets, blues, and reds. This is one reason why cool colors seem stronger than warm ones. In general, hues produced by mixing (secondary hues) are lower in intensity than pure hues (primary hues). (b) The triangle diagrams show, schematically, the range of variations in the hues red-orange and yellow-green. Altering any hue at its highest intensity necessarily reduces its intensity.*

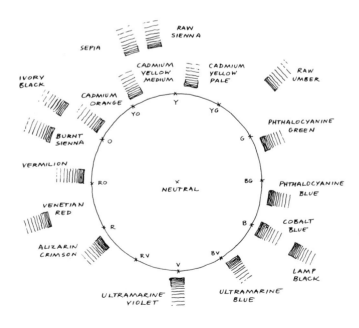

8. *Pigment Chart, by Carl Schmalz.*

further only by a greater admixture of white (the white of the paper, by thinning the pigment with water), or by adding black: both white and black are, of course, neutrals.

PROCEDURE

Though you are accustomed to think of colors by their hue names and to gauge specific tones by their distance from "pure" red or blue, you know—or will discover—that the colored pigments with which you paint correspond to such "pure" hues in only a few instances. As an initial exercise, therefore, draw a circle about 8″ in diameter on a fresh sheet of paper. Divide the circle with light lines into twelve equal sections and label as in Figure 7a.

Squeeze out on your palette a little of each tube color you have. You may find it a good idea to split the intense colors at the reds, placing your warmest red at the left end of the palette, running through the oranges, yellows, greens, blues, and violets to a cool red like alizarin crimson. In the lower tray, if you have one, place the neutral colors. This arrangement has the advantage of allowing you to mix in the tray, if it is slightly tilted, so that the mess runs down into the pigments that are already less intense, rather than spoiling your bright colors. (See Figure 9.)

Paint some of each color on a spot outside the circle at about the place indicated in Figure 8. By adding water, lighten it to form a little graded wash dwindling to white paper. This will show you how your pigment tones vary from "pure" hues.

Next, using your brightest pigments, nearest to pure hues, mix tones that are as close as possible to the pure hues you have named on your circle. Paint them in to correspond to Figure 8.

Now draw lines across your circle from red to yellow, from yellow to blue, and from blue to red. Mix the pigment colors closest to pure primaries (they will probably be alizarin golden, cadmium yellow medium, and cobalt blue) to form secondaries. In each case paint a patch on the appropriate line. You will observe that these mixed secondaries are much less intense than the pigment secondaries just outside your circle, in accordance with the phenomenon mentioned earlier.

You may want to mix red, yellow, and blue together to see what kind of neutrals you can produce. It is also a good idea to try some neutral mixes by combining complementaries, those colors that are opposite each other on your circle.

This is a good time for a reminder: clean your brush thoroughly every time you start a new color mixture; a fresh brush is absolutely essential to color control in painting. Change your water, too, whenever it begins to get distinctly muddy.

Finally, paint a graded wash for each of your neutral tube colors, as you did with the bright colors. Each will have a definite hue—except black, of course (unless you have both lamp black and ivory black, in which case you will see that the former is relatively bluish and the latter relatively orangish). When the neutrals are placed as shown in Figure 9, they are

24

then more or less below the hues to which they most closely correspond. This facilitates mixing of neutrals and intense hues.

There is one more exploratory exercise that you will find useful. Mix each of your neutral pigments with some of the bright ones above it. In every case, except with black, you will obtain about what you expected —a less intense tone of the same hue as the bright pigment you started with. Black, however, is somewhat different. When you mix it with the warms—especially yellow and orange, and red, but to a lesser degree —it tends to turn those hues cool. This results in distinctly greenish tones in a mixture with yellow or orange, and a slightly violet or purplish tone in mixtures with red. These maverick hues can be easily corrected by the addition of the warm neutrals—raw sienna, burnt sienna, Venetian red, and so forth. But do not overlook these mixtures when they can serve you. Orange and black, for instance, make an excellent tone for winter evergreens in sunlight.

O'HARA'S SOLUTION

In *Patio, Tucson* (Color Plate 3) O'Hara boldly uses nearly every hue in the spectrum, at very high intensities, to create an effect of the strong winter sunlight of an Arizona noontime. He puts in the sky first, using phthalocyanine blue and grading it from light at left to darker at right. This helps to locate the sun, for the sky is lighter in value near the sun. The patio flagstones in sunlight are painted next, with a yellow only barely neutralized with raw sienna. Notice how O'Hara leaves white edges between the strokes to help the viewer recognize the flags. The next lightest areas, adobe in sunlight, are put in at about the same value (#2) with orange. On the stair in the center, a blue and orange reflected light are painted at about value #3. Darker areas of orange, and mixtures of orange neutralized with blue, occur at left and lower right.

Then O'Hara paints values #3 and #4 of green, blue-green, and yellow-green, which stand for cacti and shrubbery in sunlight. These are extremely intense hues mixed from phthalocyanine green and cobalt blue for the cacti, phthalocyanine green and cadmium yellow medium for the bush at lower right.

He mixes alizarin crimson and ultramarine blue for the violet color of the background enclosing wall. This is modified by the addition of orange, mixed on the paper (notice a few unmixed blobs of orange still visible), toward the left of the area. The value here ranges from #7 to #6. He now puts in the dark greens: at left the value is about #7; the mixture is phthalocyanine green with raw umber, as is the bush in shade at right. He paints the tall cacti above it with phthalocyanine blue to which he adds a touch of orange for reflected lights. These darks are about #9.

Many of the other darks are added with body color, or pigment as it comes out of the tube. This is true of the gate and especially the cobalt-blue gateposts, the window, and the pane of glass in the door. O'Hara paints in the doors with burnt umber and a little black to obtain the necessary #10 values in these spots. The strokes of alizarin crimson and vermilion, which stand for shaded roof tiles and the chimney pot, are strong accents. He completes the picture with a few linear details like the stair rails.

COMMENT

Color and color mixing are central to good painting. Later on in this book there are several lessons that develop these topics further. In the meantime, it is wise to remember that you need *not* use every color in the rainbow to make a "colorful" and convincing painting. Concentrate for now on learning the color-mixing possibilities of your pigments. Make a special effort, too, to recall how you produced tones that you find especially useful or attractive.

ALIZARIN CRIMSON		VERMILION		CADMIUM ORANGE		CADMIUM YELLOW MEDIUM		CADMIUM YELLOW PALE		PHTHALO-CYANINE GREEN		PHTHALO-CYANINE BLUE		COBALT BLUE		ULTRA-MARINE BLUE		ULTRA-MARINE VIOLET
VENETIAN RED				BURNT SIENNA		RAW SIENNA		SEPIA		RAW UMBER				IVORY BLACK				

9. *Palette Arrangement, by Carl Schmalz. This is the way O'Hara arranged his palette during most of his life. The intense colors are placed across the top of the palette so that, if it is tilted a little, mixtures run down into the neutral paints in the lower tier. This prevents the bright colors from becoming quite as dirty as they might otherwise.*

LESSON 4

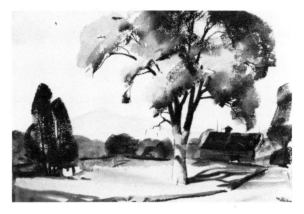

TREES IN BLACK AND WHITE

This lesson examines the structure of trees and reviews rough brushing as applied to foliage. (For O'Hara's solution, see Color Plate 4 on page 84.)

PROBLEM

Trees and foliage are ubiquitous features of landscape, and they come in an enormous variety of shapes and colors. This lesson considers shape only, leaving color for Lesson 7.

Figure 10 illustrates two essential aspects of the structure of trees. First, trees can be handily conceived of as water-supply systems. The hidden roots, fanning out like the branches, collect water from the ground. The trunk is the main line, conducting water through the branches to the leaves, blossoms, and fruit. This means that the trunk, or main conduit, will have a diameter about equal to the sum of the diameters of the branches, and that no branch will be as thick as the trunk. Therefore, *never* draw a tree like that in Figure 10b.

Second, every species of tree has a particular branch structure. You will be repaid by careful observation of the patterns of branches. For example, elm trees branch in a characteristic V or Y fashion. Oak and apple branches, on the other hand, tend to have an erratic-looking sickle shape. Willows frequently display a U where branches join their trunks, while pine branches leave the trunk nearly at right angles, and the lower, more heavily needle-laden ones often bend down from their weight. The Japanese refer to this as the "duck-leg" shape. Maples tend to branch in a Y fashion, but their branches often curve upward. Plants from more tropical areas, such as the coconut palm, frequently have a simple silhouette—one trunk carrying water to a crown where fronds sprout out close to each other. You need not memorize characteristic silhouettes and branch articulations if you form

the habit of looking at trees analytically with these points in mind.

If you are doing a portrait of a tree, you will want to emphasize its special deviations from the norm for that species, and you will therefore observe its peculiarities with care. Similarly, there may be times when the subject of your picture will be the particular deformations worked upon a tree by exposure to hostile conditions. Here again, you will want to focus on the shape of the unique tree, rather than on its generally shared structural pattern.

Although they will not always be of primary concern, the varying textures and foliage patterns of trees should also be studied. Trees with small leaves, like birches, locusts, and mimosas, may best be suggested by using fine rough brushing. Oaks, maples, and plane trees, which have quite large leaves, can be differentiated from others by using broad, coarse rough brushing. The whisking stroke is useful for suggesting needles on pines and similar evergreens.

PROCEDURE

Your subject for this lesson should include a variety of trees. You are not going to paint every plant known to botanists, but you *do* want to be able to contrast structure, silhouette, and foliage. An established cemetery is often a good spot, as is a public park, a college campus, or other mature landscaped area. Failing these, a roadside will be fine.

Your intention is not to make a painting, so do not worry about composition this time. Draw your trees in general outline, making them big enough to fill the sheet. Do not draw them in detail, but indicate clearly the directions and structural patterns of trunks and branches and suggest the overall shape and location of the larger masses of foliage.

Number very carefully the values you see. (Remem-

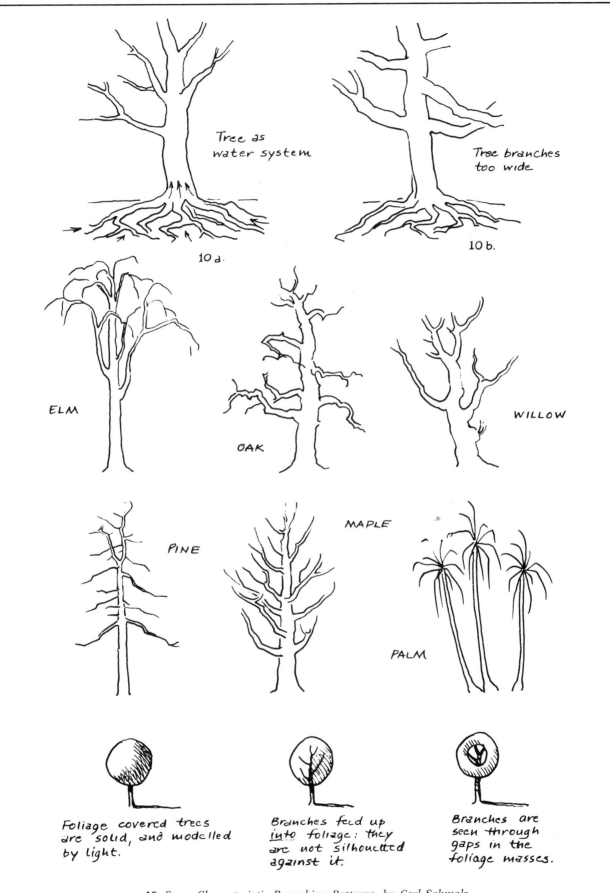

Tree as water system

Tree branches too wide

10 a.

10 b.

ELM

OAK

WILLOW

PINE

MAPLE

PALM

Foliage covered trees are solid, and modelled by light.

Branches feed up into foliage: they are not silhouetted against it.

Branches are seen through gaps in the foliage masses.

10. *Some Characteristic Branching Patterns, by Carl Schmalz.*

ber that for a black and white exercise, it may be possible to leave the sky as white paper.) With your 1″ brush, using only black, begin to paint the lightest values. These will ordinarily be the foreground grass or gravel. Leave any very light areas of foliage for the moment. Foreground detail may be adequately suggested by rough brushing, as in Figure 11. If there are any tree trunks in sunlight, put them in by rough brushing if the bark is coarsely textured and by simple washes otherwise. You may want to try a double-loaded stroke on the trunks to show the shadow side.

The lightest parts of foliage in sunlight are usually values of about #3, #4, or #5, depending on the kind of tree. Pick one of your trees and mix a "puddle" of paint of the right value. Lay the fully loaded brush on the paper and gently rotate it. Keep in mind that you will want to add some darker paint before the rough brushing you are now applying is dry (do not panic, but proceed with deliberate speed!). Follow the general outlines of your drawing without trying to be too exact. You are now *drawing* the tree's massed foliage with the brush. Leave some gaps in the foliage, if possible: most trees have a few holes.

Before the rough-brushed area is dry, mix some darker paint—about value #7 or #8. Do not put too much water in, and dry your brush slightly before applying it to the paper. Because the foliage area is still wet, you will lose your value contrast if you add much more water. Lay in the darker tone on the *undersides* of the foliage clumps. Be sure to put a dab or two just above the holes as well. This dark tone will partially blend with the sunlight value already on the paper, as in the tree at left in Figure 11. The effect is to model the foliage in sunlight.

Again, quickly—if possible before the darker paint has dried—get some very dark paint in your brush (once more the brush must be fairly dry) and put in a few twigs and small branches, allowing their ends to blend into the dark undersides of the foliage clumps.

From here on it is not difficult to finish the tree. You must hook up the twigs to branches and then the branches to the trunk. If shadows are falling across the trunk, put them in by rough brushing; be sure to curve them up and around the nearest part of the trunk (note the right tree in Figure 11). The upper trunk will, for the most part, be in shadow, however. To see why this happens, hold your left hand up with the fingers making a basket vertically; put your right hand across it, like a mass of foliage. You will notice that the "foliage" casts a shadow on all but the lowest reaches of the "branches" and "trunk."

11. Trees in Black and White, *1937. 15¼″ x 22½″, 140 lb. rough paper. This is a class demonstration in which the sky is white paper. Rough brushing is extensively employed for the grass and texture of the tree trunks, as well as for the foliage. Note the shading on the undersides of the foliage masses, and the feeding of branches up into their undersides. The upper parts of trunks and branches are shaded. Branches are not seen against the lighted parts of the foliage. Photo by Gerhardt.*

Paint in the rest of the trees in your picture, varying value and rough brushing as necessary. You may find it helpful to "label" your foliage with a few small dabs standing for leaves, as O'Hara does in Figure 11. Resist firmly any temptation to put in very many, or your trees may seem surrounded by polka dots.

As you finish up, bear in mind that a tree is a three-dimensional object. Individual masses and the tree as a whole will be modeled by the light (see Lesson 5). Branches feed up *into* the foliage. Do not paint them as if they were separate structures in front of the leaves. A solid object also casts a shadow. Notice the direction of the shadows, and root your trees to the ground by painting each one's shadow.

One more thing: you may have chosen a subject that includes a light tree against a darker background. Although this presents a special problem, it is not a difficult one to solve. The procedure in watercolor is to paint light things first, so begin by painting the foliage in with appropriate values. When it is *dry*, rough brush the edges of the dark background where it adjoins the lighter tree (note Figure 6).

O'HARA'S SOLUTION

In *Roadside Elm* (Color Plate 4), O'Hara treats a rather commonplace subject with simplicity and delicacy. The tree itself is the center of interest, but it has additional importance as a symbol of vitality and endurance, as its branches overarch the barn and the little family cemetery at left.

O'Hara begins by drawing the tree shape rather carefully, indicating other shapes in summary fashion. He checks the values, then paints a pale wash of yellow on the sky, adding a touch of ultramarine blue at the upper left corner. While that wash is drying, he puts in the road with long, rough-brushed strokes of vermilion and a little ultramarine at about value #2. With almost the same tone, the light trunk goes in. Notice that he now adds some ultramarine shading that blends into the lighter rough brushing of the trunk. A mixture of ultramarine and a touch of alizarin crimson, at value #3, is used for the distant mountain. Somewhat darker, but still near #3, the sunlit grass goes on next. This is done mainly with cadmium yellow medium and phthalocyanine green, but modified by touches of orange, and raw umber. O'Hara varies the tone in order to show undulations in the surface of the ground. He leaves the tombstones white. He puts in the dark shadows of the trees, while this grass wash is still wet, so that the strokes blend softly with the sunny grass, expressing its texture. These shadows are a combination of phthalocyanine green and raw umber, the closer ones at left being warmer than the more distant ones (see Lesson 10).

The main foliage shapes go in next, at about value #4. He mixes the color mainly from phthalocyanine green and raw umber, and applies it quickly. Adding more green, sepia, and a bit of phthalocyanine blue, he goes back lightly into the still-wet foliage, carefully modeling the masses below and on the right sides. Where the first wash has dried, he rough brushes the darker tone to add to the impression of leafiness.

Twigs and small branches are drawn in with sepia and black at value #10. O'Hara employs his rigger brush for these important details. Notice that the branches show only against the sky, and that some foliage, therefore, seems to jut forward from the central trunk. The dark, heavier branches with their characteristic Y pattern are reinforced with alizarin crimson, to account for reflected light (Lesson 5).

The distant trees are added quickly with a vermilion, yellow, and cobalt mixture, and a little green is spilled down over the farther edge of the field to obscure two tombstones that seemed distracting. O'Hara sets in the barn with alizarin, vermilion, and sepia, and he adds the dark cedars at left as a foil. A few shadows and details in the foreground complete the picture.

COMMENT

Observe how abstractly O'Hara handles foliage. He does not draw the exact shape of each mass, but concentrates instead on the general effect of color, modeling, and silhouette. In a number of places, the shape of the 1″ brush is visible. Brushstrokes such as these, if not too obvious or too frequent, are not distracting. You may prefer, however, to use a large round brush for foliage in order to avoid the "square" look that is sometimes left by the 1″ stroke.

12. Trees in Black and White, *1937. 22¼″ x 15½″, 140 lb. rough paper. This demonstration shows clearly how O'Hara varied the value of branches to help distinguish those coming toward the foreground from those going away from it.*

LESSON 5

SHADOWS ON WHITE

This lesson outlines the five elements of lighting with particular reference to light reflected into the shadowed surfaces of white objects. (For O'Hara's solution, see Color Plate 5 on page 85.)

PROBLEM

Since you see everything by means of light, it is important to learn something about how sources of illumination affect the appearance of things. It is a good idea to begin by looking at white objects, for light on colored objects is more complicated (see Lesson 12).

Get a rectangular white box and place it on a piece of manila paper or corrugated board. Put the setup in full sun, preferably outdoors, but with a strong, direct light source if indoors. Make some notes with a pencil and pad as you observe the following aspects of lighting.

First, you will see that the top and one or two sides of the box are brightly lit: nothing is interfering with light coming from the source to these surfaces. Such illumination is called *direct light* and should be noted as "A." Notice that large parts of the cardboard surface are also illuminated by A lighting.

Second, consider the fact that you would see nothing else unless some sort of light were illuminating the other surfaces. Since you *can* see them, you will want to figure out the sources of this secondary illumination, or *reflected light*.

Look at the side of the box in shadow that is nearest to the light source. If necessary, examine it through a hole formed by your hands. You will be able to see that the area varies in value, and if you are outdoors you will notice that the hue varies as well. The upper, darker part of the area will have a distinctly gray or bluish tone compared to the lower portion, which will be lighter and yellowish or orangish. The reason for

this variation will be obvious after a moment's thought. The entire side of the box must be receiving light reflected generally from the sky (or the surrounding objects in the room): but the lower part of the area is visible by light reflected from the relatively close surface of the cardboard, which is brightly lit by the sun or lamp. Hence the lower portion of the side is almost certainly receiving *more* light, making it lighter. Also, the light it is receiving is of a definite yellow-orange tone. This effect will be even more pronounced if your box has a lid on it. The edge of the lid facing down will be comparatively lighter and more yellow than the lower section of the side.

Note that general reflected light is often bluish. Let's call it "B" lighting. Light reflected into a shaded area from illuminated nearby surfaces may be greater in amount, and it will contain something of the local color of that surface. Call this "C" lighting. Test the color of C lighting by placing sheets of colored paper —green, red, or blue—on the cardboard near the shadowed side of the box; notice how each color is reflected into the lower part of the area.

You will find it helpful to remember two other things about reflected lights. First, the power of reflected light is very much less than that of direct light. Consequently, only *brightly lit* surfaces that are fairly *close* to a shaded area will affect it. And second, no reflected light is strong enough to tint a surface that is directly illuminated by the sun.

Now look at your setup again, checking for any spots where little or no light seems to be visible. This will occur primarily under the box, where a narrow crack of dark brown or black may be seen. If the box is torn at the corners or has any small holes in it, these areas will be extremely dark. Such places may be designated "D" lighting.

Finally, the box, like any solid object that stands

between a light source and another surface, will cast a shadow on a part of the surface or surfaces near it. Call *cast shadows* "E" lighting, and note that when the surface on which a cast shadow falls faces upward, it will receive general reflected light (B lighting). This is why such areas are often tinged with blue. If, however, a cast shadow falls over a barrel, for example, the shaded surface that faces downward toward the earth will often receive some warmer C lighting. If you have a can or stone, place it partly in the cast shadow and note the fact that cast shadows follow the contours of the surface on which they fall. You can frequently utilize this effect to augment modeling.

PROCEDURE

This lesson is again mainly an exercise, so, in the absence of a handy subject, you may simply paint the setup you have made. Otherwise, look for a white object—a shed or house, boxes or barrels, or something similar. Try to pick a subject that is fairly simple as to shadows; if there are complications, caused for instance by the shadows of trees falling on the building, omit them at this point. (We will consider briefly below a means of treating them.)

Sketch the main shapes of your picture, especially indicating the location and shapes of the shadow areas. It is advisable to do this because, of course, the positions of the shadows will change as time passes during your painting. Number the values. White paint in sunlight will be value #1, and you will leave it unpainted paper. Determining the next lightest areas may be more difficult, but look at patches of bare ground or roadway in the foreground, at illuminated grass and foliage, and at low sky. You may see the high sky as about value #3, and you have to make an important decision here. If you paint the value relationship between high sky and shadows on the building as you see them, the shadows will be about value #4 or #5—that is, darker than the sky. This relationship will enhance the effect of modeling and hence increase the illusion of solidity in your building. On the other hand, if you decide arbitrarily to darken the value of the sky, making it, say, about value #5, allowing the shadows to remain at #4, you will sacrifice some solidity but achieve a far more intense effect of illumination. For this lesson, try following the latter course: number the shadows #4 and the high sky value #5, omitting #3, if necessary, or using it for low sky. The darker values will be noted in surround-

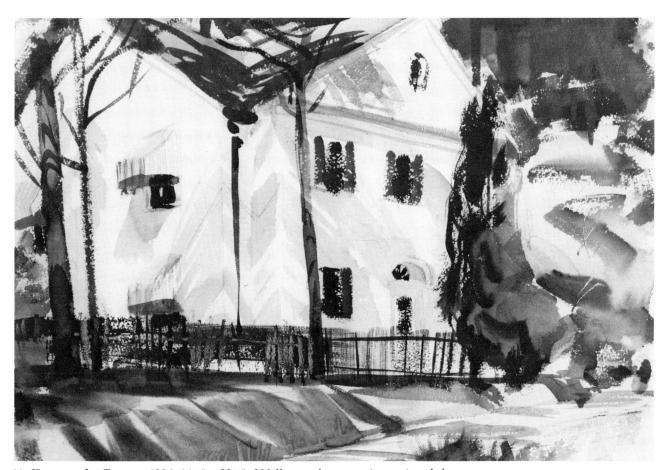

13. House under Trees, *c.1954. 16½" x 22¼", 300 lb. rough paper. An unsigned demonstration, this painting illustrates how O'Hara handled tree and foliage shadows on a white building. The streaks of shadow fall along parallel axes on each plane of the house, and their angles are the same on planes parallel to each other. Value and color mixtures are similar to those used in Lesson 5. Note O'Hara's effective use of rough brushing to minimize detail in the windows and door. Whisked strokes appear in the awnings and fence.*

ing trees, trunks, and particularly among the cast shadows. Look for the deepest darks in holes and cracks. Number these bits of D lighting #10.

Paint in your #2 and #3 areas first, using your 1″ brush. Now examine carefully the areas of shadow, noting the parts that are mainly B lighting and are therefore bluish. These will generally be somewhat darker than the areas receiving C lighting, and they will face outward. Areas illuminated by C lighting will tend to be those facing downward, or those nearest the ground where it is in direct sunlight. These C areas will also tend to be somewhat lighter and warmer than the B sections.

You will have three problems to contend with as you paint the reflected light in these shadow areas. First, the values: beware of timidity—put on enough paint so that the B areas will *dry* to value #4. Second, edges: begin painting each area in the *center* of the section, gradually pulling the paint out to the edge as you get it to the value and color you want. Third, color: since you will be working with blue and orange or yellow-orange, your pigment mixture is going to keep moving toward green, a most unlikely and unattractive shade in this instance. To avoid this problem you will have to neutralize the green by adding small amounts of red to the mixture. Alizarin crimson or cadmium red deep will do the job. You will

probably find it helpful to try out this mixture on a separate piece of paper before beginning to paint.

To keep the color as fresh as possible, mix *on the* paper. First put on a bit of blue. You will find that cobalt, the purest of your blues, will work best. Add some orange at the edge of this, and a little cadmium yellow medium. Where the two colors join, blend in a touch of alizarin to overcome the greenish tone. Practice the same experiment with ultramarine blue, which is sometimes useful for its slightly warmer (purpler) tone.

Now paint in your shadows, doing an area at a time so that you do not have too much to manage all at once. Wet any large section before you apply the paint, and put your first touches in the center of the area. Extend the wash to the edge only when the color is right. Try not to overlap the edges of other areas as you paint. If you make a mess, ignore it and go on to a new section.

If there are other areas of value #4, put them in next. Then proceed to the sky, remembering to vary its value from darker away from the sun to a little lighter near the sun. The darkest part will be value #5 —or even a bit darker than that. You may want to use phthalocyanine blue for the sky: its greenish hue will tend to emphasize the warmer tones in the shadows on the building.

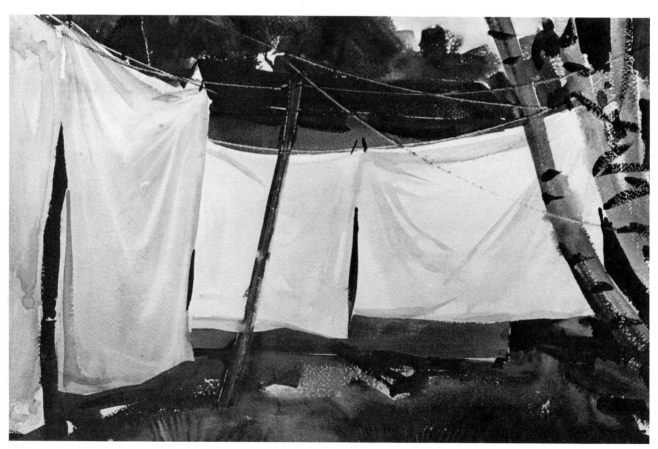

14. Sheets on the Line, *c.1940. 15¼″ x 22½″, 140 lb. rough paper. O'Hara paints shadows on white in hazy sunlight in this demonstration. The values of the shadow tones are lighter than they would be in stronger sun. A very dark background, deliberately generalized to focus the viewer's eye on the laundry, relieves the sheets. In the foreground, "oozles" are used to suggest grass.*

It is a good plan to put in at least some of the D lighting next. Windows, doors, holes, cracks, and other deep darks will give you a measure of your value range and suggest how much leeway remains for values #6, #7, #8, and #9. Cast shadows, your E lighting, will tend to be about value #7 or #8. Remember, cast shadows that face upward will receive some reflected light from the sky (B lighting) and hence will be bluish variants of the hues on which they fall.

Finish up by adding any further dark accents you may require.

O'HARA'S SOLUTION

Morning Sun (Color Plate 5) is an excellent example of the way in which dramatic lighting can transform a rather ordinary subject into an arresting and cheerful image. The main subject, quite simply, is the play of light and shade—particularly the reflected lights— over the varied planes of the house.

O'Hara begins this picture with the shadow on the central section of the house. He lays on a wash of cobalt blue directly in the middle of the area, without wetting the paper first. Then, making sure that the brush remains at about the same degree of wetness, he goes back into the wash with orange, adding a little alizarin crimson to neutralize the incipient green. This lighter tone blends evenly into the blue, especially up near the eaves. Drying his brush a little, he picks up some paint on the chimney, leaving it lighter and warmer than the body of the wall. The two awnings at the right are left white, but he picks out the one to the left of the chimney with a wrung-out brush. Working fairly rapidly, the artist then moves to the shadow on the garage (note the touch of alizarin crimson at the edge of the shadow at the extreme left).

While these washes are still damp, O'Hara cleans and wrings out his brush and dips it in a little more orange. The brush then picks up blue as it lays down orange, for the reflected lights on the window frames.

The same procedures are used for the front of the house, but only after the column is painted. The artist does this with one quick stroke of cobalt blue, rough brushed at the right edge to suggest the column's roundness. At the left edge and under the capital, O'Hara takes out blue and adds yellow with a dry brush, as he did for the window frames.

While the shadow areas are drying, O'Hara paints a vermilion tone at about value #2 on the asphalt driveway. The green grass, about #4, is mixed of phthalocyanine green and orange. Before it dries he adds cast shadows with phthalocyanine green and raw umber. The heavily textured roof of the garage ell goes on with rough brushing. O'Hara puts the sky in next, using straight phthalocyanine blue and starting at the extreme left where it is darkest. Gradually adding a very little water, he pulls the wash across the top of the picture, carefully reserving the shape of the house as he goes.

The building is now ready for some dark accents of D lighting, so O'Hara sets in the door and windows at values #8 to #10. The latter is chiefly sepia. The cast shadows, or E lighting, go in quite late because it is better to paint the objects that cast the shadows, and the objects on which they are cast, before doing the shadows themselves. An exception to this general rule is the grass: since the shadows are blended to indicate texture, they must go in while the sunlit grass is still wet. Ultramarine and alizarin crimson are used for the shadows cast on the driveway and the roof.

Phthalocyanine green and burnt sienna (left), and the same green with raw sienna and raw umber (right) are used for the flanking foliage; sepia makes the tree trunks. Ultramarine and cobalt blue serve as B lighting on the upward-facing awnings in shadow.

Finally, once all the value and tonal relations are on the paper, the artist considers such modifications as may make the illusion more convincing. He touches up the eaves at right with a stroke of alizarin crimson, almost straight out of the tube, and some vermilion for the illuminated bit. The chimney is sharpened with neutral orange along its right edge, but with pure cobalt where the wider section faces the sky. A couple of strokes of darker orange mark the top of the chimney, and a stroke of yellow orange accents the underside of the eave to its left.

COMMENT

While *Morning Sun* illustrates the most basic form of shadows on white, there are a number of common variations of this phenomenon. For example, Figure 13 shows a way of treating foliage shadows falling on a white house. The color here is the same, but the shadows slant along the walls at angles dependent upon the relation of the wall planes to the sun. The shadows themselves are permeated by circular holes, which form elongated ellipses as they stretch along the wall planes.

Figure 14 presents shadows in less intense sunlight. Here it is chiefly the shadow *values* that are different. They are considerably lighter than would be the case in bright light. Note especially how skillfully O'Hara models the sheet at left by wiping out the folds from the damp wash.

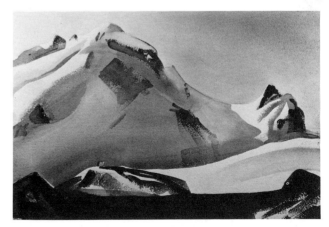

15. Breithorn from Schwartzee, *1968. 14½" x 22", 300 lb. rough paper. The principles discussed in Lesson 5 apply to snow on a bright day. Normally there will be more blue-sky reflection, however, and the reflected light from the ground will be lighter and less warm than in summer, because it is coming from the white surface of the snow.*

LESSON 6

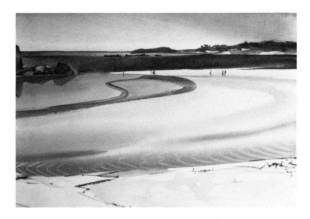

BEACH

This lesson reviews brush drill and washes, but focuses particularly on transitions, or gradations of color. (For O'Hara's solution, see Color Plate 6 on page 86.)

PROBLEM

A good watercolor painting of a beach often has an enviably effortless look. In *Autumn Tide, Maine*, for instance, broad, sweeping washes seem to stretch out into the distance, their changing colors modeling the sand and defining the beach's form.

Every beach has its own characteristic color and shape, but generally sand can be rendered with variations of a play between warm and cool colors. In the case of very white sand, the colors will be close to those in any shadow-on-white subject. At low tide, expanses of wet sand may be revealed. These areas sometimes pick up a little sky color and are often more blue or lavender, as well as darker, than the dry sand high up on the beach.

Beaches are easily ill-drawn. It is important to recall that perspective on those extended curves squashes them down, creating long parabolic lines. Usually the turn of a beach is quite a sharp elliptical shape, almost pointed in the far distance.

Expanses of sand, like cloudless skies, do not maintain a flat, even tone all over. To control these desirable alterations of value and color, you must attain a nice sense of the degree of wetness and dryness of both your paper and your brush. When new color is added to a wash already on the paper, the brush must be loaded with pigment and water to almost exactly the same wetness as the wash: otherwise you will either pick up paint (too dry a brush) or create unwanted "oozles" (too wet a brush). Adding color to a wet area is referred to as wet blending, or painting wet-in-wet; it is an essential skill for the watercolor-

ist, and one which can be acquired only with conscientious practice.

PROCEDURE

Your subject for this lesson should include an expanse of flat sand. If you cannot handily get to a beach, you may find an analogous situation at a river mouth, a desert, or a more homely place like a gravel pit. You can also adapt the focal concern of the project to lawns, fields, or a view of prairie. A lake or large body of water will normally involve transitions of tone, too.

Having found an appropriate subject, proceed with your sketch. Keep the picture very simple. Remember that you do not want to introduce much detail in the drawing because you will be selecting and drawing detail with your brush as you paint. Number the values, and make a special effort to observe gradations of color and value in the large areas of your planned picture. Check these changes with your value card or by looking through your crossed fingers (the methods of determining value distinctions described in Lesson 2).

It might be a good idea to review washes (Lesson 1), before starting with the sky. Assuming that there are no clouds, the sky farthest from the sun will be darker by one or more value levels than the sky nearest the sun. Toward the horizon, it will be lighter and very likely a different color as well.

If the sky area is fairly large, wet the paper first. Work some blue paint well into your 1" brush, keeping the brush only moderately wet. You don't want it to be sopping because there is water already on the paper. Put a dab on the dark side of the sky. Is there enough color to dry to the value you are aiming for? If not, pick up some more. Now start spreading the color across the top of the sky, letting it lighten a bit

as it naturally will. So far, you are doing a simple graded wash.

Working as efficiently as you can, rinse your brush and dry it between your fingers. Pick up a little orange or vermilion, say, and add it into your wash at the horizon. Hold the brush upright and, using long strokes, smooth the color and blend it with the blue above. It will help to extend the wash down the paper a little lower than you had marked the horizon, in order to avoid a dark drying edge there.

You are ready to do the sand area, unless it touches the still-wet sky. If that is the case, wait. Wet the sand section (except, of course, for any parts that you want to retain as white) and even out the clear wash. With a dryish brush, start putting in the warmer tones. You may run them over those sections that will be cool, since normally the cools are darker than the warms. Rinse your brush and dry it well (remember that your paper is drying). Work some blue into your brush, perhaps mixing with it a little alizarin crimson and some raw umber or sepia to neutralize it a trifle. Add this to the sand area, where required. There may be a tendency for the whole beach to darken away from the sun, as the sky does. If that seems to be the case, emphasize the cool tone at that side of the painting. *Do not try to work in the wash after the gloss disappears from the surface.* You will cause irremediable, uneven marks if you do.

You will probably find that you can effectively use a little rough brushing for distant elements in your picture. The sand area may require the addition of a few details—bushes, grass, and miscellaneous detritus. For grasses, the whisking stroke will be useful.

The water, normally darker than the sand, should be painted next. Since the color of the water depends on its reflection of sky color, you will want to pay particular attention to the transitions visible there. There will be a dark to light gradation in the sea corresponding to the one in the sky above, and there may also be a darker blue at the horizon, as well as bands of varied blues and greens nearer the shore.

O'HARA'S SOLUTION

Autumn Tide, Maine (Color Plate 6) shows how transitions of color and value can be used not only to suggest the appearance of sand, but its pattern and form as well.

O'Hara lays out his composition broadly, barely

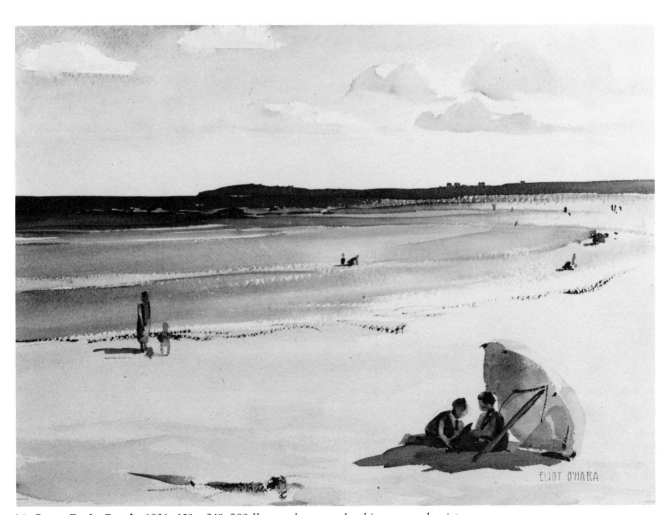

16. Goose Rocks Beach, *1931. 15" x 21", 200 lb. rough paper. In this very early picture, O'Hara depends heavily upon transitions of hue and value. He uses rough brushing much more generously than in* Autumn Tide, Maine *(Color Plate 6). Notice that it appears in the clouds and the umbrella as well as in the water, sand, and seaweed.*

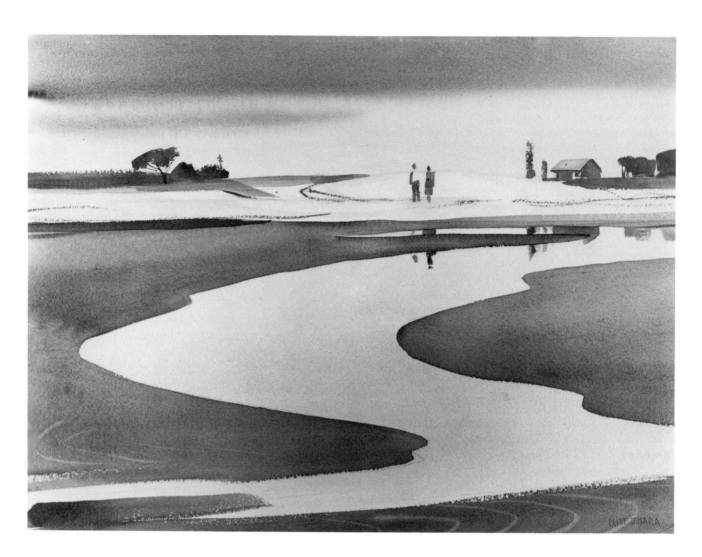

17. The Beach Pool, *1968 (Above). 22" x 30¼", 300 lb. rough paper. Striking transitions animate the water and wet sand in the foreground. Both areas are treated as smooth graded washes. Only the "oozles" at the lower margin interrupt the smooth flow of color. The background is likewise kept very simple, with bare indications of trees and the house.*

18. The Beach Pool, *1968 (detail). In this detail you can see how very spare the setting for this painting is. Judgment is required for such simplicity. Each figure is made with four or five brush strokes, and the tree near the house with one. For the seaweed a very dry brush barely touches the top of the rough paper. O'Hara makes each stroke do a job. The effect is one of great economy.*

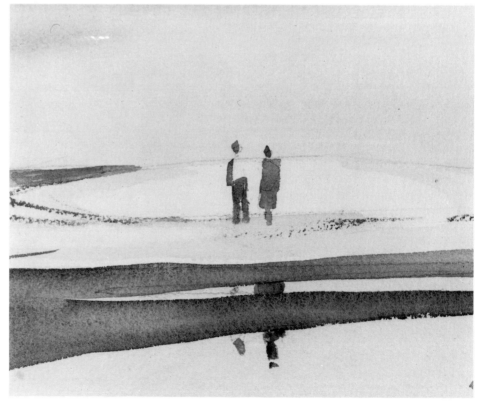

indicating the edges of the main shapes with pencil. Because he wants it to be dry when the background detail is painted, the sky goes on first. He wets the paper and then starts from the right, painting on the blue. This is quite dark, nearly value #4: it is ultramarine, neutralized with a little sepia. He pulls it to the left with long diagonal strokes (you can see the remains of some, where they did not fully blend). The color gradually weakens, creating a lighter area at left. The tone is modified slightly at left, too, by the addition of a bit more sepia. At the horizon, a touch of alizarin crimson, added to the sepia, creates a purplish look of dense atmosphere.

Moving now to the largest area of sand, O'Hara quickly lays on a wash of warm, orange-y neutral. He covers the entire section, using this tone to wet the paper. With a brush of about the same wetness and a little more pigment, he puts in the darker oranges at the upper edge of the sand at left and the sweeping curve at right. Again loading his brush, this time with violet, he adds the two dark strokes at right. He is working generally down the paper, you will notice. The lower, nearer portion of the wash stays wet longer than the higher part because gravity pulls the water down the tilted paper.

O'Hara works into the lower left area next, adding pale violet and vermilion. The nearest sand, adjacent to the dry white beach in the immediate foreground, goes in with a mixture of violet, sepia, and vermilion. The artist varies it from relatively violet at left to relatively vermilion at the right. While this tone (about value #3) is still moist, O'Hara goes back into it with his rigger brush charged lightly with clean water. The oozles thus created convey a nice hint of ripples left in the damp sand by the retreating tide (compare with Figure 3). The total effect is of a low channel in the foreground modeling up to a higher, gently rounded mound of sand that gradually tapers off toward the distant figures.

While the beach is drying, O'Hara puts in the light of the distant rocks with the same neutral orange used for the beach. The blue and yellow tone in the immediate foreground goes in next (note how generalized these shadows are—merely brushmarks to indicate footprints and other depressions in the sugary dry sand). He paints the sea next, using ultramarine blue at the horizon and to the left. This color is gradually modified by the addition of black as the wash is drawn forward and to the right. At the extreme point of the projecting sand spit the artist changes the

water's hue. He rinses the brush and reloads it with a mildly neutralized phthalocyanine blue, which he changes to phthalocyanine green and lightens as it comes forward. The rocks at left and the small area of damp sand in the center of the picture are carefully left white.

With almost pure ultramarine, the artist indicates the distant point of land. He changes the tone with small admixtures of orange and green to represent the nearer peninsula, which is foliage-covered, and uses rough brushing for texture against the sky. The shadows on the rocks are set in with violet.

The spit of wet sand at the center is painted with much the same orange and violet mixture as the rest of the sand, but a darker, bluer stroke defines the edge of the dry sand and continues along the shore to the left. Sepia at about value #3 is used for the lighter part of the rocks at left. The artist gets out his rigger brush again for the very dark brown strokes that signify dried seaweed in the foreground. The same brush is used for the distant figures. They are heightened with a little vermilion. A few dark umber and vermilion strokes on the left rocks and in the distance finish the painting.

COMMENT

In cases where the sand is darker than the water, as can happen on an overcast day, the water may be painted in first as a graded wash over the entire area. Figure 17 shows an example. Here O'Hara paints the wet sand over the water after it is dry, using ultramarine, sepia, and, toward the foreground, alizarin crimson golden at about value #5. In the detail illustrated by Figure 18, observe how sketchy are the figures in this picture. All background detail, in fact, is kept as simple and as spare as possible. This helps to focus the viewer's attention on the large pattern and the colors in the composition.

There will be times when a large wash is interrupted by a lighter object. This makes the painting of the wash much more difficult, and it may be wise to avoid the situation until you are confident of your ability to handle washes. If the area is quite small, you may be able to mask it (see Lesson 16); otherwise, paint around it. It is a good idea to paint any modeling or detail on the light object before applying the wash. We all tend to respect what we have already painted and will probably take more care to avoid messing it up or covering parts of it than if we are avoiding only a bit of white paper.

LESSON 7

TREES IN COLOR

The focus of this lesson is color mixing for the myriad greens found in vegetation. (For O'Hara's solution, see Color Plate 7 on page 87.)

PROBLEM

Many of the hue names in ordinary usage are simply convenient tags that we employ to call to mind the general family of color that the name covers. This is especially true of green. Grass is "green" and foliage is "green" only in the grossest sense. Leaves come in hues ranging from red through the oranges and yellows to green verging on blue; some plants have leaves that can truly be called purple. In addition, the values and intensities of the local color of foliage run a wide gamut. Indeed, there are many more colors in leaves than one can hope to paint. The point, of course, is that when you have a tree to paint, you cannot reach automatically for your green pigment and expect to create anything like an impression of nature's appearance. It is necessary to explore the "green" mixtures possible with your pigments, to recall them, and to apply them to appropriate situations in pictures.

PROCEDURE

This lesson involves two exercises. The first is simple paint-mixing. The second is applying what you have discovered to a picture.

For the first part, take a half sheet of paper, preferably the back of a discarded picture, and clip it to your board. Squeeze out some fresh paint, if necessary. You will need every color you have.

In the center of the top of your paper, make a square of your tube green about 2″ on a side. Next, mixing approximately half and half, make a series of squares to the left using each of your warm colors and green. Do the same with each of your cool colors, to the right. Below this line of mixtures, make squares using the yellow nearest your green mixed with each of your blues and violets. Below this, use the next yellow. Do this for each of your warm colors. This will give you a sample of all the green and greenish mixtures you can get with your bright colors. Of course, if you want to be complete, you will want to mix these greens in different pigment proportions and in different values.

If you didn't need a new sheet of paper for the last row or two of greens, get one out now for the next series. These will be mixtures of your warm neutrals with each of your bright cools. Finally, do a sequence with black and the bright warms. Though you have not really exhausted the green possibilities of your palette, this exercise will serve to familiarize you with the major kinds of simple, or double, mixtures available to you.

As you discovered in mixing shadow tones in Lesson 5, there are many occasions when triple mixtures, or even mixtures using four or five pigments, are necessary. As an experiment, try the following triple mixtures for greens:

Ultramarine, cadmium yellow medium, and black

Ultramarine, cadmium orange, and raw umber

Cobalt, cadmium orange, and raw sienna

Phthalocyanine green, raw sienna, and alizarin crimson

You will notice that each of these triple mixtures presents another whole range of possibilities. Other triple mixtures will occur spontaneously.

For the second part of the lesson, go back to your subject for Lesson 4 or find a new location with a variety of trees. Make a simple drawing, taking particular note of the varying silhouettes and branch

38

patterns of the trees. Check those with fine foliage against those with larger leaves and consider carefully the varied tones of green represented. (Incidentally, in temperate climates the variety of greens is much greater in the spring and early summer; by August many deciduous trees have become close to each other in tonality).

Paint a simple picture, referring, if need be, to your experimental chart of greens for appropriate mixtures. Remember that you can make these greens lighter or darker as required, and pay special attention to the shadow tones. Where foliage-laden branches extend out over the ground, the shadows on their undersides will reflect warm light from the grass or earth below. Use your dark, warm mixtures for these areas. In general, it is a good idea to make the shadow tones for a given foliage color from a mixture using some of the same colors as were used in the lights.

O'HARA'S SOLUTION

In *High School Yard* (Color Plate 7), O'Hara asserts the effectiveness of varied greens. Again, he takes a mundane subject and imbues it with mood and in-

terest. On a mildly overcast day, as in the painting, hues show up in greater variety than they do when, literally overshadowed, the sunlight contrasts of value make them less noticeable.

O'Hara begins by making the usual rough drawing and by numbering the values. The very pale sky wash is applied with alizarin crimson at the top, gradually changing to a neutral bluish tone below. The foreground grass, value #2, goes on next, with a little burnt sienna added at right while the wash is still wet. Using the same orange and neutralized green as in the grass, the artist lays in the light portion of the foliage on the center tree. Rather than going back immediately into this area to apply the shadow tone, he lets the wash dry. He waits because he wants to silhouette the lighter foliage against the darks of the pine tree behind, and he will need dry paper to rough brush the edges of its masses.

The distant foliage, which is in values #3 and #4, is made from cobalt blue, raw sienna, and alizarin crimson at right; toward the left the alizarin is reduced, then eliminated entirely. The resultant bluer tone suggests increasing distance (see Lesson 10). O'Hara rough brushes these distant trees on the

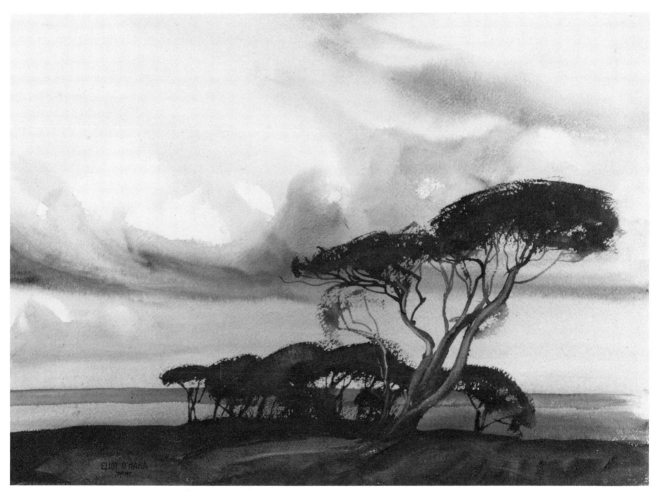

19. Young Monkey Pod Trees, Oahu, *1939. 15½" x 22", 140 lb. rough paper. O'Hara uses a rigger brush for the detailing of fine branches in the larger trees. The branches of the small ones are done with the 1" brush. A knifestroke draws the light branches against darker foliage. The feeling of struggling oceanside trees is enhanced by windswept clouds. Observe that shapes in the sky mirror the foliage clumps.*

39

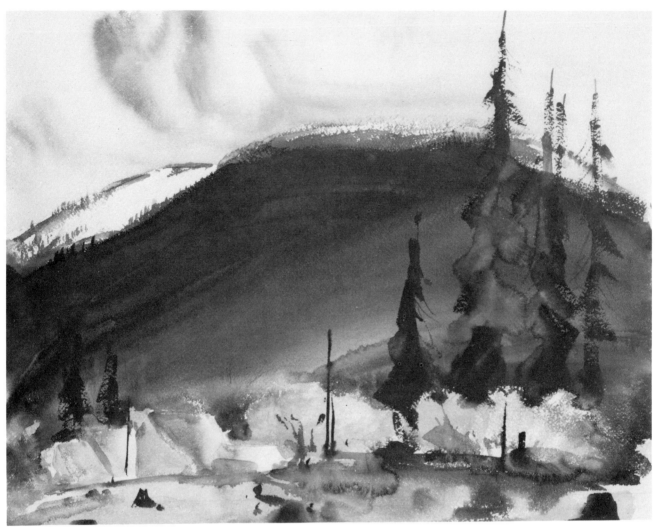

20. Near Seattle, *1940. 18" x 22¼", 140 lb. rough paper. Spruce and fir trees may be painted with downward-swinging strokes of the 1" brush, held with the end close to the paper, as O'Hara has done here. Two of the trees at right have "oozled" yellow added to help model them. The rigger brush describes the leaders at the trees' tops and indicates bare branches. Distant firs against the snow and sky are depicted with the corner of the 1" brush. The sky in this picture is made with varied values of pure black paint.*

21. Old Eucalyptus, *1957 (Right). 16½" x 22½", 200 lb. extra-rough paper. Wet blending (Lesson 21) and coarse rough brushing are used for this scene near Mendocino, California. Vigorous life is suggested by the repeated curves of the branches and the firmly modeled bulk of the trunk. Detailed leaves and split-hair strokes enrich the more purely watercolor textures. Photo by Woltz.*

thoroughly dry sky. The branches go in while the tree tone remains wet: they are painted by touching the end hairs of the 1″ brush to the surface. White paper is reserved for the circular bench.

The light sections of both trees at the margins of the picture are about value #5. Their color is different, however. O'Hara uses a mixture of orange, green, and raw umber at left, with orange dominant. A darker value of nearly the same mixture serves as shadow tone. At right, yellow, green, and sepia, with green dominant, provides a cooler color. Here again a darker variant of the same tone makes the shadow. In both these trees, the initial wash was partly damp when the shadow was applied, causing softly wet-blended edges in parts of the foliage. While the darker tones remain moist, O'Hara draws in the trunks and branches. He uses a rigger for the finest branches, and a medium-sized round brush for the trunks.

The center of interest in this painting is the large, dark pine tree. Using phthalocyanine green and raw umber, the artist blocks in the characteristically flat-tish planes of compact needles. He works rapidly and "labels" the masses with short whisking strokes. Before this color has dried, he moves back into it with a relatively dry brush, fully loaded with a phthalocyanine green and sepia mixture. He carefully rough brushes the *bottoms* of the foliage areas, letting the

resulting speckle stand for fine twigs. The silhouette of the lighter tree in front is also rough brushed around its edges. A few strokes of warm color, particularly alizarin crimson and raw umber, are added in the darks; the same colors are drawn in as branches, and the trunk receives a good deal of alizarin.

While the trunk and branches are still damp, O'Hara wipes out a couple of lighter areas to hint at modeling and with a knife scrapes some lights into the branches.

The basic tone of the bench is a neutral violet to which strokes of sepia and vermilion are later added. A few quickly drawn strokes of orange and green, and of burnt sienna, articulate the foreground and hint at a shaded area under the pine. Whisking strokes at left provide some foreground textural interest.

COMMENT

Always remember that you must paint in light foliage before rough brushing a darker background around it.

Often an interestingly formed tree will suggest itself as the subject for a painting, as in Figure 21, where the gnarled trunk of the old eucalyptus is O'Hara's basic motif. Such subjects can be enhanced by attention to the modeling of the branches and by textural detail like that O'Hara uses, dragging a brush with splayed hairs along the branches.

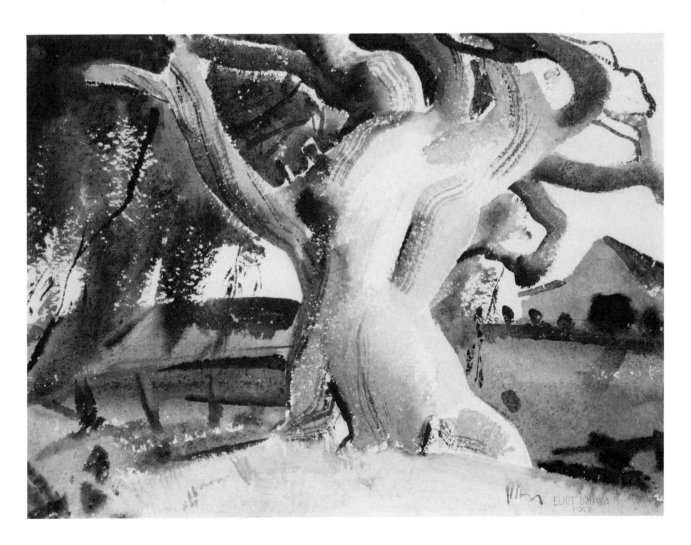

41

LESSON 8

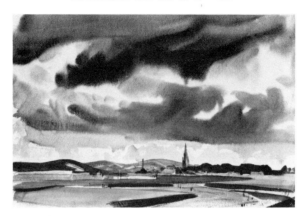

CLOUDS AND SKIES

This lesson describes some frequently encountered kinds of clouds and suggests techniques for painting them. (For O'Hara's solution, see Color Plate 8 on page 88.)

PROBLEM

Skies can be among the most dramatic visual events in nature. Their color and cloud formations are often a major element in landscape compositions. Although it is possible to be fairly arbitrary in your handling of some sorts of clouds, it is essential to know a few principles of cloud formation in order to design them so that they will conform to nature as well as fit into your picture.

The simplest sky is a moderate overcast, with a layer of clouds covering all the visible sky. This can sometimes be represented by leaving the paper white, especially if you are painting a scene in which relatively little sky appears. Otherwise, a simple graded wash will do the trick, although you will often find that some transition or gradation of color will be useful (see Color Plate 7). This treatment is best for a clear blue sky as well. Occasionally you will see streaks of darker color—bluish or violet—in an overcast sky. This occurs where the clouds are a little thicker. You may easily add these to your basic wash with a dryish brush and the appropriate color mixture (see Color Plate 15).

There are three main "families" of clouds: nimbus, cirrus, and cumulus. Each can appear in straightforward fashion, but more usually cirrus and cumulus clouds are broken up (hence *fracto*-cumulus) either because they are in process of forming or because of strong wind action.

Nimbus clouds are harbingers of rain. They are generally rather low, heavy-looking, and dark. You see mainly the bottoms of these clouds, especially when they cover the sky, and their color will normally reflect some warm, brownish tones from the earth below. A sky filled with nimbus clouds looks a bit like a ceiling from which hang heavy, gauzy swags.

The reason for the apparent ceiling is important. It occurs because clouds do not form at arbitrary distances from the earth's surface. They form at what is called the "dew point," a level in the atmosphere on a given day where the temperature permits water vapor to condense. On any particular day the dew point is at a consistent height, visible as a plane at the base of the clouds. You will notice that perspective makes more distant cloud-bottoms seem to be mere lines in the low sky.

The dew-point formation level, and consequently the perspective effect, applies to *all* clouds (exceptions are haze rising from warm spots, such as river valleys and fog, which occurs when the dew point is at ground level).

Cirrus clouds are very high and are made of ice or broken snow crystals. At their altitude, they are usually blown by strong, cold winds, and their shapes are like long drifts in the sky. They behave like blown sand or snow, sometimes puffing at the ends (mare's-tails) or forming ripple patterns (mackerel skies).

In their purest form, cumulus clouds are thunderstorm clouds. They boil on great updrafts, forming tall piles of domes in the sky. But notice that their bottoms are flat! Like any dense object, cumulus clouds are subject to the rules of lighting, and modeling their shapes convincingly is a challenge to the painter. Cumulus clouds are frequently seen in their broken form, as in the near sky in *Tralee, County Kerry* (Color Plate 8). When one looks directly up at their flattish bottoms, cumulus clouds have some of the appearance of nimbus clouds, and they similarly reflect the color of the earth beneath them.

PROCEDURE

Because they are in some ways the easiest, we will do nimbus clouds for the first exercise. On a half sheet of paper draw a low horizon, wetting the sky area thoroughly and evening out the wash as usual. With a moderately dry brush, pick up a little ultramarine and sepia (other mixtures will do as well, since what you are looking for is a lively neutral with warm overtones) and place it near the top of your paper in bold strokes. Some of your strokes may have a slightly hammock-y shape. The sky is receding as you move down the paper, so make your cloud strokes somewhat bluer and more horizontal as you go. Do not fill in the entire sky area with strokes: as the pigment flows out into the wet paper it will tend to obscure the lights, and you want to save some of them to represent thinner places in the cloud cover. Be sure that you have enough paint in your brush. It is easy to make a wet-blended sky too light to be very interesting. Color Plate 26 may give you a suggestion as to the look of this kind of sky.

One secret of a nimbus sky is to paint it fast so that a few runny areas will help to suggest the raininess of the clouds. Remember that you can exaggerate the warmth of the undersides of the clouds for variation, design, or other purposes. A double-loaded brush may be effective for this. In some circumstances you may find it easier to work from background to foreground; that is, *up* the sky from the flatter clouds at the rear to the bigger, darker forms above your head. In this case, tip your paper slightly away from you to help keep the upper part wet.

Take a second sheet of paper for your cirrus clouds and divide it in half vertically, for there are two ways of making these high clouds. Decide which way you want their streaks, or drifts, to go. Try to keep their angle from the horizontal rather small, because unless they are nearly overhead the effect of perspective tends to flatten them. Take some blue paint (these clouds almost invariably appear against a clear sky) and paint it directly on the dry paper section at the left of your sheet. Try to dry brush the edges of the strokes. Make them long, following the direction of your clouds. You are, of course, painting the sky *between* the clouds: they will be the shapes of white paper that you *leave*. As you approach the horizon, remember to lighten the blue, altering its color toward green or lavender if you wish.

Now wet the right half of your paper. When the gloss is nearly off it, go back in with a dryish brush loaded with quite a lot of blue paint. Again, paint the sky *around* the clouds, letting the edges of your blue

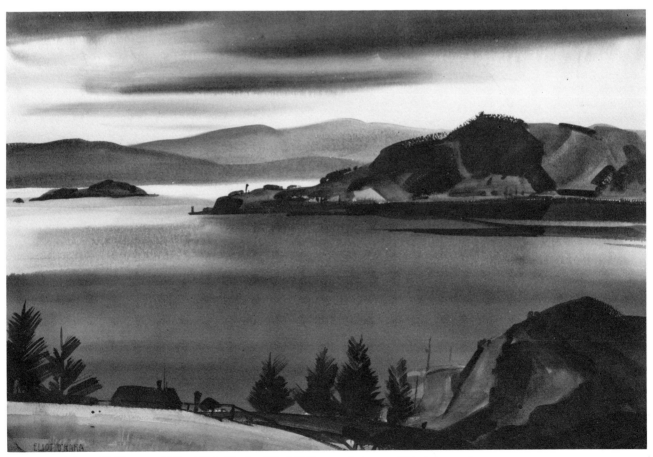

22. Oriental Bay, Wellington, N.Z., *1953. 15¼" x 22", 140 lb. rough paper. This is a good example of the wet-blended technique for nimbus clouds. O'Hara put the paint onto a very wet area, using a very dry brush. You can see the rainlike streaks that result when the paper is tilted. Reflections from the dark clouds make the nearer water dark. Where low sky reflects, to the left and farther away, the water is much lighter (see Lesson 18).*

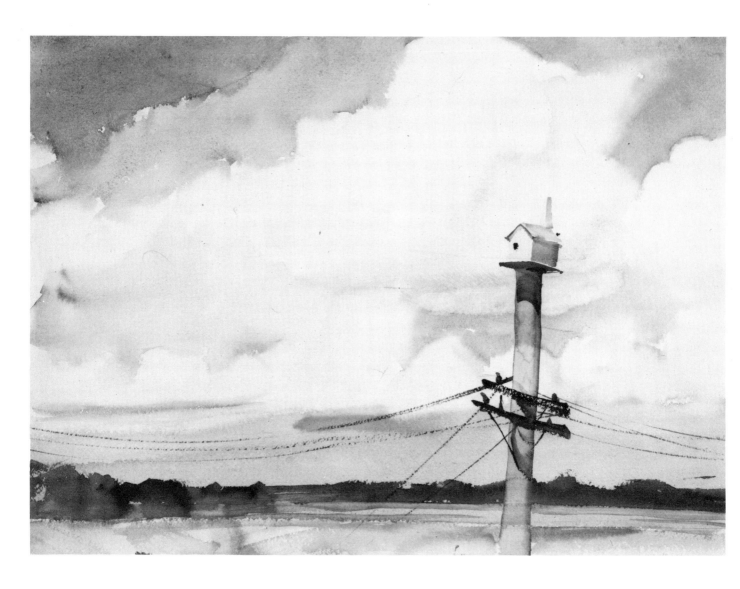

23. Bird House, Goose Rocks Beach, *1938 (Above). 15¼" x 22", 140 lb. rough paper. In this class demonstration for cumulus clouds, O'Hara shows his technique for painting these difficult phenomena. At the upper right he outlines the cloud tops with blue and then softens their edges by drawing around the contours with a clean, damp brush.*

24. Sky from Northern Oahu, *1953. 15" x 22", 140 lb. rough paper. In this alternative method for doing cumulus clouds, the sky is almost entirely wet blended. The cloud tops were outlined with blue first. This was blended out, and the modeling, flat bottoms, and other sky tones were added before the area was dry. Photo by Woltz.*

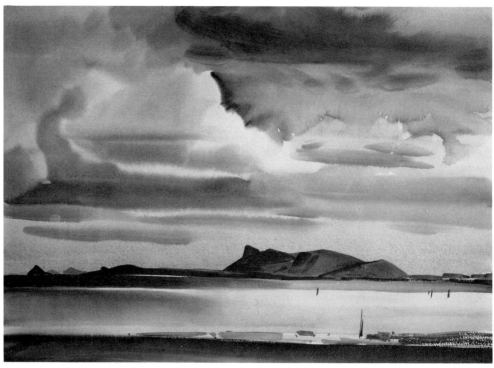

strokes blend softly with the damp white of the paper. As you proceed down the sky your brush will run out of paint, gradually lightening the value of the low sky. You will find an example of this sort of treatment in Figure 32. As with the nimbus sky technique, this is a wet-in-wet, or wet-blended, process.

Pure cumulus clouds are technically the most difficult for the watercolorist. Take a good look at Figure 23 before sketching some clouds on your third sheet of paper. Consider the fact that they will be a good deal smaller toward the horizon, and remember that above your head you may see mainly their bottoms. It is a good idea to have some clouds go off the paper, creating two or more areas of blue.

Do not try to follow your sketch exactly. Concentrate on the technical process. With the paper dry, put in a patch of blue, outlining with your brush the tops of any *illuminated* clouds. Wash your brush clean, dry it slightly, and, with one edge just touching the still-wet blue, moisten the cloud tops so that a little blue runs in unevenly, softening the hard line you drew a moment ago. If any *shadowed* cloud sections touch the blue area you have just painted, mix a warm violet and try to get it on so that it, too, can form a wet-blended edge with the blue. Blend it out into its cloud form, if need be, by rough brushing or by adding clean water to the edge where the light and shadow meet. Keep in mind that you are actually drawing and modeling your clouds with paint, so try to avoid sharp angles and arbitrary shapes.

Now proceed in the same way with any remaining areas of blue in your sky. As you work down the sheet, you will want to lighten or change the color of the blue. Near the horizon, flat strokes of warm violet may be used to suggest the bottoms of clouds in perspective.

As you improve with this technique you will be better able to differentiate between the B and C lighting on the cloud masses themselves. Figure 24 may also provide some suggestions for handling these complex cloud formations. One tip: always take care not to model cumulus clouds like rocks or dinner rolls. They do, of course, receive light, but they are airy masses, not solid ones, and it is best to work rapidly within them, with plenty of wet-blended and rough-brushed edges.

Among the most common and most varied skies is one that is filled with fracto-cumulus clouds. Close at hand, these frequently have something of the appearance of nimbus clouds. One way of handling them is discussed below.

O'HARA'S SOLUTION

Tralee, County Kerry (Color Plate 8) is a superb example of the way a brilliantly painted sky can form the subject of a watercolor. Here the clouds contribute a sense of the moist atmosphere of the Emerald Isle as well. The picture was done very quickly, taking no more than thirty to forty minutes.

After indicating in summary fashion the directions of landscape elements, O'Hara puts in the shadow tones of the distant cumulus clouds, using a neutralized ultramarine blue. These are outlined with phthalocyanine green, for low-sky tone.

While the green is still wet, O'Hara dampens the upper part of the paper, leaving a "dam" of dry paper between this new wet area and the green. A few dabs of phthalocyanine blue go in. Then, using black and sepia and black and ultramarine blue, the artist lays in the dark undersides of the clouds overhead. Because the paper is wet, he uses little water in the brush. Being careful to leave white areas for the illuminated parts of the clouds, he then adds more ultramarine blue to his brush and paints the bottoms of clouds in the middle distance. He takes pains to make the shapes both cloudlike and intrinsically interesting. The lower edge of this blue tone is then joined to the still-damp green. The addition of a little black and alizarin crimson helps to turn the far edge of the cloud mass under. And that's the sky: the whole process has taken no more than five or six minutes.

Ultramarine blue and alizarin crimson are rough brushed in for the wet mudflats; cobalt and ultramarine form the distant hills. Some quick, narrow strokes of neutral orange, green, and blue serve for the buildings, and the focal steeple also goes in at this point. Orange, green, and raw umber in varying proportions are set in for the meadows. Some darker ultramarine blue suggests cloud shadows cast on the hills. (*Watch* for E lighting, cloud shadows, when you are doing this sort of subject!) The distant row of trees is orange, phthalocyanine green, ultramarine blue, and a little sepia or burnt umber. O'Hara is careful in painting the trees to go around his buildings, and he leaves a few white glints for sparkle. Some final details and darks—a few more buildings, some cobalt blue trees, the chimney, windows, and the stakes and dark banks in the foreground—further describe the landscape.

COMMENT

Once you get the hang of it, you will find that wet-blended skies are really rather simple to control. For that reason, they can easily become a habit. In many cases it is a good idea to use some rough-brushed edges in your skies. This will help you to avoid a sameness in your paintings and also prevent mushiness in your handling of skies.

Try always to design your skies. But remember that you must keep the painted "events" consistent with what is possible, if you seek a representational result. Look back at *Tralee, County Kerry* and observe how O'Hara has placed the church steeple right under a dark drip in the nearest cloud. These two fingerlike shapes pointing at each other create a tension between up and down and near and far that helps immensely to unite the disparate parts of the painting. Notice, also, that the artist is careful to keep nearer clouds in front of more distant ones by overlapping them slightly: in the upper left the black overlaps the blue; below right, the blue overlaps the crests of the cumulus clouds on the horizon.

LESSON 9

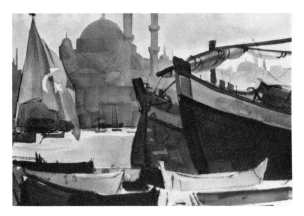

SPOTTING

This lesson is an exercise in design. You will explore the placement of light and dark shapes in a picture. (For O'Hara's solution, see Color Plate 9 on page 89.)

PROBLEM

Any painting, even a predominantly representational one, must first arrest attention and then sustain it, if it is to work well. Subject matter, handling, color—all have a great deal to do with the success of a picture—but a satisfying design is fundamental to any painting of quality and lasting pleasure.

At the root of good design is fitting placement of light and dark elements. Things in a picture—not just the represented objects, but the areas of paint on the surface of the paper as well—are seen by the viewer largely because of value differentiation. They may also differ in color, shape, and size, of course, but value is the means by which the human eye makes primary distinctions.

Figure 25 exemplifies a fine solution to one of the most common design problems: what do you do with a group of similar darks against a light background? Here the palm tops are very nearly the same in color, shape, and size. It is their arrangement on the paper—their spotting—that provides variety and interest. Notice, though, that the angles of the trunks enhance our feeling of the wind; that the horizontals of sea, distance, and low clouds stabilize the design; and that the large central cloud sweeps up to the right, its direction countering that of the wind-blown trees. The result is an arrangement in dynamic equilibrium.

PROCEDURE

Tear a discarded picture in half so that you have a sheet of white paper about 11″ x 15″. Paint the other half of the paper solid black, and after it dries tear or cut it into pieces of about the same size: approximately four square inches is good. Make all the pieces somewhat different in shape.

Now play with your spots, making written or mental notes as you go along. The paragraphs that follow suggest some things you might try and some effects you might look for.

Put one spot in the center of your paper. This arrangement is simple and direct: it says, "Look at me!" Unless the object(s) depicted, the color, and the painting itself are very interesting, however, a single central focus seldom generates long-lasting engagement. Even if you add other, overlapped spots, making the central area larger and less regular in outline, the arrangement remains basically undynamic.

Now take two spots and see if you can dispose them in a way that attracts you and satisfies your eye. Again, you may discover that regular placement—one beside the other or one above the other—is fairly dull. In fact, it is quite difficult to make an interesting arrangement from two spots of about the same size, a point to keep in mind. Add another spot, overlapping one already on your paper, so that you have a larger and a smaller area. This will make a pleasing arrangement easier. Notice that a spot right on the edge of the paper is hard to deal with. You may find yourself playing with arrangements in which the larger spot is more or less centered in one quarter of the field and is pleasingly balanced by the smaller one in the diagonally opposite quarter. Remember this. If you continue to have difficulty in making an arrangement that you like, cover the smaller spot with another in such a way as to produce a less regular (more interesting) contour.

Arrangements of an odd number of spots are usually more satisfying than those with an even number of spots. Start with three spots of the same size.

Notice how many kinds of placement seem interesting. Watch out for making the *intervals* between the spots too much the same. Change the size and shape of one or more spots by adding pieces from your stock, and observe the necessity for shifting their relationships on the two-dimensional space of your paper.

This game of moving spots around on a field is a very useful kind of visual calisthenics. Note that what you learn about dark spots applies equally to light ones on a dark ground. Try four and five spots; and return to this game once in a while to explore new possibilities and to keep your eye in trim.

It should be obvious that making rules for spotting is a trap for the unwary. Every picture creates its own requirements. An eye trained to subtlety of judgment is the best guarantee of interestingly arranged paintings.

O'HARA'S SOLUTION

Mosque on the Bosphorus (Color Plate 9), together with Figure 26 and Figure 27, offers a rare opportunity to examine an artist's eye and mind at work on a spotting problem. *Mosque* is O'Hara's first version of the scene. It is a fairly straightforward atmospheric rendering of boats tied up in the foreground against the domes and minarets of Istanbul across the Bosphorus. The design is worked out mainly in terms of hue and value contrasts. The color, shape, and modeling of the flag at left are counterbalanced in three ways. First, O'Hara echoes the vermilion in the small boat at lower right and in the superstructure above it. Second, he makes the blue of the larger vessel at right very intense. Third, he includes the rather complex furled sail, an inherently attractive shape against the pale background.

The blue of the boat is not isolated: it appears in various permutations in the lower-left boat, in the water, and in the sky, as well as in the ship in the center of the painting. All of these elements serve to enframe the mosque in the background, itself an attractive shape and a significant descriptive detail that locates the scene.

Why change this picture? Very likely, O'Hara thought he might be able to make his statement more economically. Look at the primary changes in Figure 26, the second version. The color scheme has changed somewhat, the blue becoming a blue-green. Apart from this, there are four major differences to observe. The large boats are greatly simplified and the sail is omitted, the artist relying on a strong value contrast to create interest at the right. The central bow is made

25. Southern Sunset, *1942. 14¾" x 22½", 140 lb. rough paper. O'Hara spots similar darks, clustering three together at the left against two at right. The imbalance works because the implied wind from the right forces the viewer's eye into the picture from that side. Palm trunks at left help to keep the viewer's attention within the picture. O'Hara employs the whisking stroke for the palm fronds.*

26. Mosque on the Bosphorus II, *1952. 15" x 22¼", 140 lb. rough paper. In O'Hara's second try at a scene he liked, the vermilion flag plays against the vermilions of the center bow and the boat in the middle foreground. The dark boats marching up to the left help to organize the space of the picture. Additional minarets at right provide verticals to echo the flagpole. Note that O'Hara drew in the furled sail but chose not to use it.*

27. Cargo Boats, Istanbul, *1952 (Right). 15" x 22¼", 140 lb. rough paper. In the third version of this subject, also painted on location, O'Hara dramatically centers the ship bows and moves the flag to the right. There it is a light balanced by the pale green shape of the water at left. The background is less modeled, but more linear detail animates it.*

red orange to obtain a powerful hue contrast as well. Second, the small boats are conspicuously rearranged. No longer simply a group of stabilizing horizontals, they carry the eye into the picture to the left. Third, to stop that movement before it gets to the margin, O'Hara reverses the flag and puts the city behind it in shadow to provide more value contrast. Now the vertical flagstaff echoes the upright lines of the minarets, linking the foreground and the background as well as the left and right sides of the composition. The increased modeling on the mosque calls more attention to it. Finally, the odd shape of the bow on the central boat is eliminated, leaving the arc-shaped bow as a dominant theme in the picture.

For the third version, Figure 27, O'Hara alters the blue of the first to a definite phthalocyanine green; the neutrals are warmer and yellower, too. In this painting the theme developed in Figure 26 is given powerful emphasis, the bows of the vessels becoming large, central forms. The flag, with its stabilizing vertical staff, is moved to the right where it is silhouetted against the dark of the ship's side. A new boat appears at left, where it functions effectively to channel the eye back toward the dome of the mosque. This boat is red, and it balances the red of the flag. The dome itself assumes new importance as the center bow, exaggeratedly arrow-shaped, points directly to it. Because the flag now blows into

the picture, pulling the eye with it, some small figures are introduced below the mosque: their presence tends to stop the viewer's eye, permitting it to look up to the mosque through the channel created by the red ship prows.

In each of these variations on a theme, O'Hara makes skillful use of spotting. The designs are all interesting and satisfying. Beyond that, however, you can see how he eliminates superfluous elements to focus on shapes essential to his pictorial idea, changing the spotting to accommodate each new plan.

COMMENT

The foregoing discussion makes it clear that effective design is more than merely arranging shapes on the picture's surface. Some other aspects of the problem are explored in Lessons 13, 19, 27, and 30. It is well to begin thinking seriously about the arrangement of surface areas early in your study of painting, however, as developing a sense of spotting is essential to all good design.

Remember that you are dealing not only with dark areas against light grounds but with light ones against dark as well. The flag in Figure 27 is a case in point. Note also how O'Hara firms up the shape of the light water in the course of the three versions of the Bosphorus subject.

49

LESSON 10

RECESSION INTO SPACE

This lesson examines the use of atmospheric haze as a means of manipulating the illusion of distance. (For O'Hara's solution, see Color Plate 10 on page 90.)

PROBLEM

The air close to the surface of the earth contains floating particles of dust and water vapor. The amount of this haze and smog varies from day to day, but some is present even in the clearest weather. As a result, we see things as though we are looking through veils that increase in density the farther they are from us.

For centuries, painters have utilized this phenomenon to control and augment effects of distance in their pictures. The rule is simple: distant things appear bluer, paler, and less detailed in direct proportion to their remoteness from the observer. The opposite is equally true: nearer things tend to seem warmer, darker, and more detailed. The one significant exception to this rule occurs when you look directly at a low sun through haze; then the distance will be relatively *warm*, though still paler and less detailed.

An artist can exaggerate or minimize the illusion of spatial depth in his painting by conscious application of these rules.

PROCEDURE

Select a subject that requires an effect of considerable distance. It should be a relatively simple subject because you are going to paint it twice. Obviously, there must be some *things* out there to be affected by atmospheric haze, so a view of empty ocean, for example, will not do. Something like O'Hara's *Rhine at Braübach*—a receding sequence of hills or mountains—is ideal.

With a line, divide the paper in half along its short axis. Make two identical drawings, indicating with pencil the main shapes in your intended picture on

each half of the paper. In one, number the values in the usual way and paint it straightforwardly. Then, using the first picture as a reference, paint the scene again. This time, however, make the distant things bluer if necessary, much paler, and less detailed. They will look still farther away if you also paint some of the nearest things warmer, darker, and with greater detail, greater texture, and greater value contrast than you did in your original picture.

A comparison of the two finished studies will illustrate how judicious use of these rules will give you great power to control effects of distance.

O'HARA'S SOLUTION

For this tranquil evocation of one of Europe's great rivers, titled *Rhine at Braübach* (Color Plate 10), O'Hara uses broad washes accented by a little rough brushing. This technical simplicity may be deceptive, however. Modulation of such large areas of wash is necessary to provide the interest of variety, and such modulation requires considerable skill.

To begin, O'Hara wets the sky, one of the lightest areas in the picture. Then, mixing on the paper, he adds ultramarine and orange to produce a soft, warmish gray, swinging the brush in an arc with a big "hammock" movement to give an effect of the sun behind heavy overcast. While the sky dries, he puts in the next lightest area, the near water. For this he uses an orange similar to that seen in the sky (since water reflects sky color), touching it with a little phthalocyanine green at the upper margin.

When the sky wash is dry, O'Hara adds the pale, distant mountain, using a pure cobalt blue. In a picture as simple as this, the edges of shapes must be especially expressive, so the artist is careful to draw the silhouette of the farthest mountain with attention to its inherent interest. As the wash moves down,

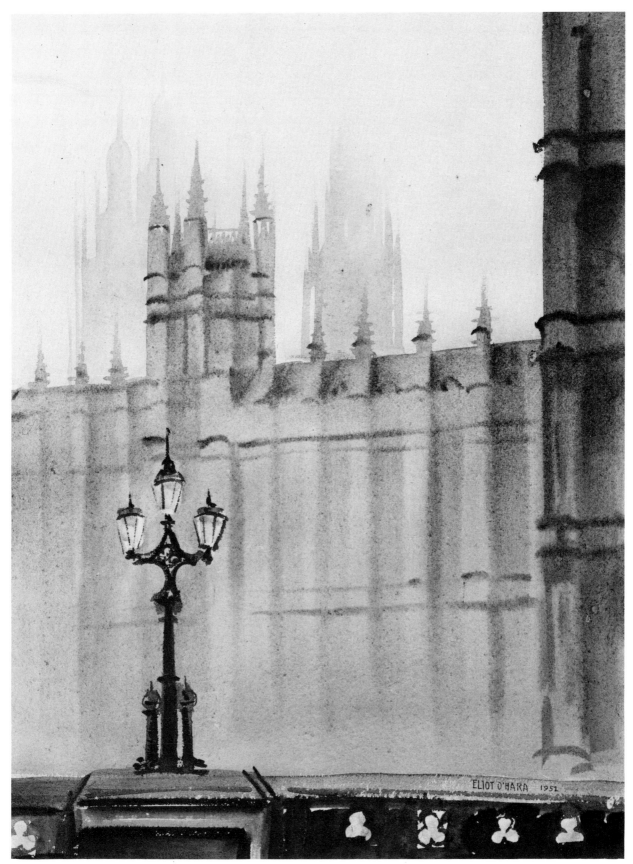

28. Parliament in the Rain, *1951. 21¼" x 16¾", 90 lb. cold-pressed paper. The effects of recession are exaggerated in rain or fog (see Lesson 28). Here, for the distant towers, O'Hara lays in a light wash and then picks up parts of it to suggest sheets of falling rain. Detail in the middle-ground building is completely suppressed at the base, where it goes behind the near parapet. Photo by Woltz.*

observe how he softly interrupts it with lighter areas where extra water has been carefully added, to form an illusion of mist hanging over the distant reaches of the river.

Again waiting for the wash to dry, the artist puts in the steep outcropping at left. Because this area is considerably closer than the center mountain, he uses a warmer blue here—ultramarine—and once more lightens the wash toward its bottom. To make a convincing picture from this rather bland start, O'Hara needs a center of attention and a foil with darker, warmer details. (Cover the little peninsula with your hand to see what the painting looked like before the town was painted.) Using a mixture of ultramarine and orange, with some sepia added, he draws a wash across the paper, quickly rough brushing in a few trees. The buildings are done in the same drying time. An especially effective transition from light to dark enhances both the appearance of space within the town toward the right and the suggestion of mist. Ultramarine and orange appear again at the right in a wash that models, not individual roofs and towers, but the town as a whole.

To pin down and dramatize the nearer ground, O'Hara draws three single brushstrokes from right to left, which stand for wind ripples on the river surface and which simultaneously suggest the ripples themselves by their rough-brushed ends at the left.

The nearest of these patches is a grayed blue analogous to the tone of the peninsula, thus alluding to a possible reflection. To the left, the rippled water is greener, joining it to the more distant phthalocyanine tone in the water. Just to the left of the center of the painting, at the right end of the greener patch of ripples, O'Hara deftly places a stroke for a river barge. Warmer and darker than the town behind, it includes a little detail—the aft cabin—and neatly accents the foreground to background relationships. As a whole, the picture is a masterfully understated rendering that calls to mind the river landscapes of the great Oriental painters.

COMMENT

Remember that the rules discussed in this lesson apply to more than just the depiction of great spaces. You will find them equally helpful in separating apples, vases, and walls in a still life, for example. At any point where a nearer and a farther shape adjoin, you can clarify their spatial positions by reducing the intensity and detail of the farther area while raising its value.

Two additional observations will be useful: the hazier the day, the *less* intense will distant objects become; and *contrasts* of value tend to be greater in the foreground.

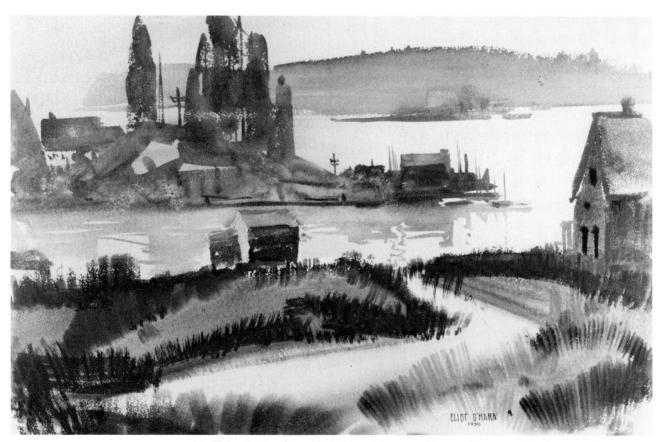

29. Maine in October, *1950. 14" x 22¼", 140 lb. rough paper. The distant island is pale and undetailed. Wet-blended edges soften the contours of the house and trees on the islet just in front of it. Values are darker and contrasts greater in the foreground. O'Hara uses rich, warm siennas and Venetian red in the washes and whisking strokes of the grass, as well as in the details of the house at right.*

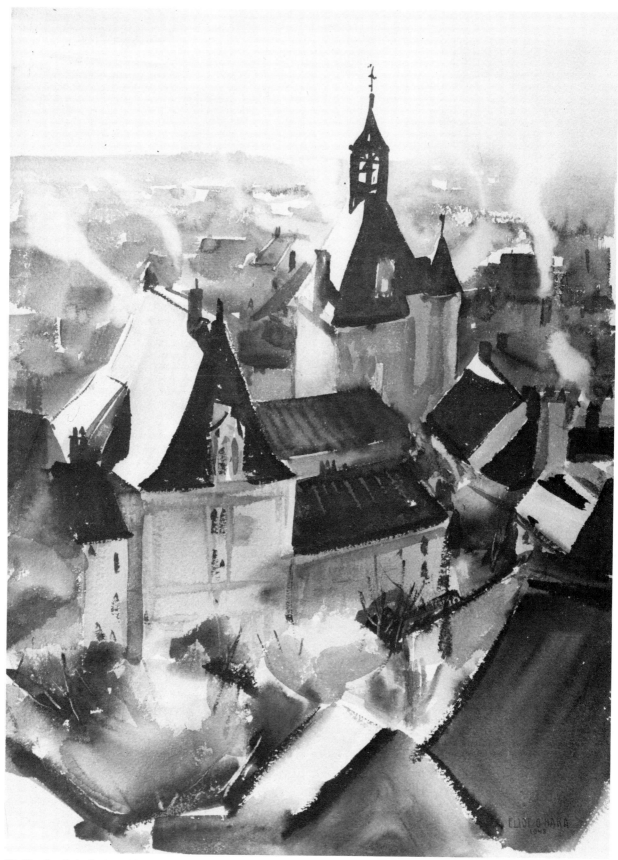

30. Roofs of Amboise, *1948. 22¼" x 16", 140 lb. rough paper. This painting illustrates knowing use of painterly textures to subordinate a detailed distance (see Lesson 24). The section above the roofs, painted in one drying time, was rough brushed with cobalt and touches of raw sienna. The wisps of smoke were removed from the damp area with a clean, dry brush.*

LESSON 11

QUICKIES

This lesson will help you to gain experience in making decisions and painting rapidly. (For O'Hara's solution, see Color Plate 91.)

PROBLEM

As with any good painting, a watercolor requires deliberate thought and planning. Unlike other media, however, the actual application of paint in watercolor must be rapid, so that very often you are faced with the necessity of immediate judgments, of deciding upon steps that must be taken before an area you have just painted dries.

Additionally, many people prize a fresh, directly painted paper. One of the temptations of the beginning watercolorist, and one that is most difficult to overcome, is that of niggling and diddling. This results in paintings that are incongruously detailed, laden with "dead" color areas, and generally labored looking.

Finally, acquiring the skill of making quick color notations will of course be beneficial to a painter.

For these reasons, it is desirable to learn how to paint fast, even though you may not always need to do so.

PROCEDURE

For these exercises you are going to need a series of subjects—they need not be of earthshaking inherent interest—that you can paint from the same or nearly the same spot. Your front porch or backyard will do very nicely; so will your kitchen, especially if you can look out of it. Other possible places include parks, dumps, or industrial sites. One of the first paintings O'Hara sold was of a dump outside his factory!

Get an alarm clock or some other timepiece. Take two discarded half sheets of paper, each with one clean side. Tear or cut one into quarters, so that you

have four small pieces of paper about 7½″ x 11″. Tear the other in half to make two pieces about 11″ x 15″. Prepare your palette, squeezing out fresh paint if necessary: you will need to be able to get hold of it in a hurry! Put your watch or clock where you can see it easily. Wet your 1″ brush and get ready.

You are going to paint one of the smaller sheets in five minutes. Do not attempt to make a picture that is too complicated. You are after the major patterns of value and tone. It is unnecessarily time-consuming to make a drawing, so check your time and start right in painting. Go from light to dark, as far as possible, but do not hesitate to enter a darker tone that is *not* adjacent to a wet area while you wait for lights to dry. Be careful to rinse your brush carefully (but quickly) between colors. Otherwise, in your haste you may produce muddy, unvaried tones. When the five minutes are up—*stop*. Do not cheat (". . . one more stroke won't make any difference. . ."—it will!).

Now take stock. Look at your work and ask yourself why you were unable to finish covering the paper, if that is the case. Did you use too much water and have trouble with slow drying (and perhaps values that are undifferentiated as well)? What about the quality of your shapes—do they tell the viewer what they are? In short, were you attending to the *drawing with the brush* that is so important in watercolor? Did you economize where you could have—that is, did you let simple strokes of color *stand for* distant objects or areas of less than central importance? Did you try to use a telling detail here or there to identify things?

With a fresh piece of your smaller paper, try another five-minute quickie of the same or a very similar subject. See whether you can correct any problems you may have had with the first—but concentrate on covering the paper. When the five minutes are up, again check your results.

It may be helpful at this point to take another look at Figures 31 and 32. Notice that O'Hara does not hesitate to leave thin lines of white paper, which act as "dams" between two adjacent areas that would otherwise run together. On the shadow side of the center building in Figure 32, he allows the detail of the door and porch support to blend in a little because sharp edges there are not absolutely necessary. Remember also that relatively dry paint will not run or blend as much as wetter paint. For darks especially, therefore, use as little water as possible in your brush. This is O'Hara's device for the shadow under the foreground bench in Figure 31.

Change your point of view a little now and do two more five-minute quickies focusing on (1) covering the paper, (2) obtaining accurate value differentiation and clean color, and (3) producing a recognizable facsimile of the subject.

Ten-minute quickies are a little easier, largely because of the increased drying time. Paint one, of a new composition, on your larger paper and then check it over as before. Do a second, making a determined effort to get a good little "painting."

Stand up your six papers, either on the spot or at home, and consider critically where you have succeeded and which aspects of rapid painting you need to work on further. Notice especially where you may have created an unusual or unexpected effect through simplification, unusual color juxtaposition, or brushwork, and file such effects in your mind for future reference. If you think you might profit from doing this exercise again, resolve to do it at some definite interval. If you have done really badly, redo Lesson 1, trying to speed up and master your brush. Then do quickies again.

O'HARA'S SOLUTION

Although *Castle Gregory* (Color Plate 11) is not, strictly speaking, a quickie, it is a rapidly painted picture that illustrates supremely well how quickie techniques may be utilized within a more formal context. The picture's luminous serenity owes much to O'Hara's deft use of fresh color and speedily executed rough brushing.

The artist begins, as usual, with the sky. (It is not always the lightest area in the picture, but often the painting goes more logically and smoothly if the sky is done first. Some light foreground patches can go

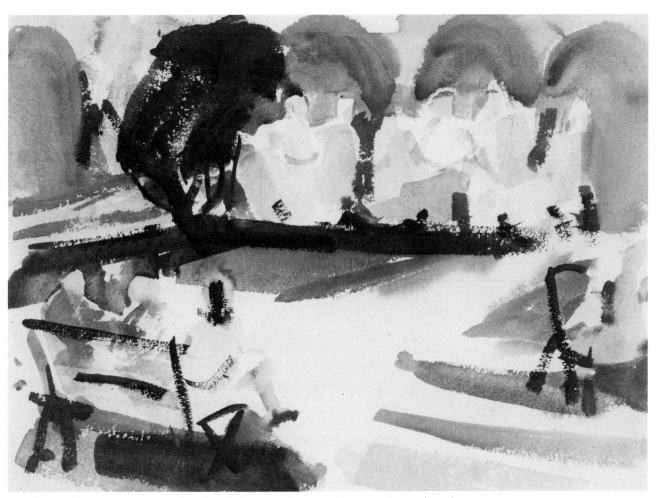

31. Florida Quickie, *early 1950s. 11" x 15", 140 lb. rough paper. In a ten-minute class demonstration, O'Hara worked mainly from light to dark, painting the figures first. He used as dry a brush as possible so that he could paint around them soon. The arches of the background outline the rear figures. Dark green shadows on the grass clarify the people on the bench. Deep darks, put in last, go on with a very dry brush.*

in while the sky dries, and then background objects are readily painted against it.) He wets the area quickly and dabs in strokes of phthalocyanine blue, starting at the left and allowing the color to lighten toward the right. At the extreme left, he adds a touch of cobalt blue. A shadow tone for the clouds is mixed from black with a little sepia and alizarin crimson. He puts this in while the blue is still wet. Some streaks of clear water at the upper right margin oozle out to suggest cirrus clouds above and behind the nearer fracto-cumulus ones.

While the sky dries, O'Hara sets down the roadway. He uses rough-brushed vermilion at about value #2. The sunlit grass and weeds are made from cadmium yellow medium, orange, and a little phthalo-cyanine green. The wall at right, of slightly neu-tralized yellow and orange, goes in next, and a mix-ture of orange, cobalt blue, and alizarin crimson makes a color for the thatched roofs. The artist paints these with a rather dry brush so that the strokes re-main to indicate the direction of the thatch; they gradually become rough brushing, which stands for the straw texture. Working very rapidly now, O'Hara

paints the house at right and the distant buildings, using various proportions of orange, alizarin crimson, and ultramarine blue. Notice that he leaves a dam of white paper between the violet gable and the still wet orange thatch.

He paints the shadow tone of the low building at left with a cobalt blue, alizarin crimson, and yellow mixture. A variant of that is also used for the wall at extreme left. He is very careful to reserve white paper for the heads of the two figures. The house at left, close to #5 in value, is indicated with alizarin crimson, ultramarine blue, and sepia. While this is drying, he puts in the first tone of the figures.

O'Hara is now ready to paint the mountain. He models it partly with color and partly with value. The basic wash is made from alizarin crimson, ultra-marine blue, and yellow. Streaks of a yellower mix-ture, added with a relatively dry brush while the wash remains wet, show sunlight glancing over the heather-covered slopes. Additional ultramarine blue, with a little alizarin crimson, make cloud shadows (remember that a cloudy sky must cast shadows on the land below it).

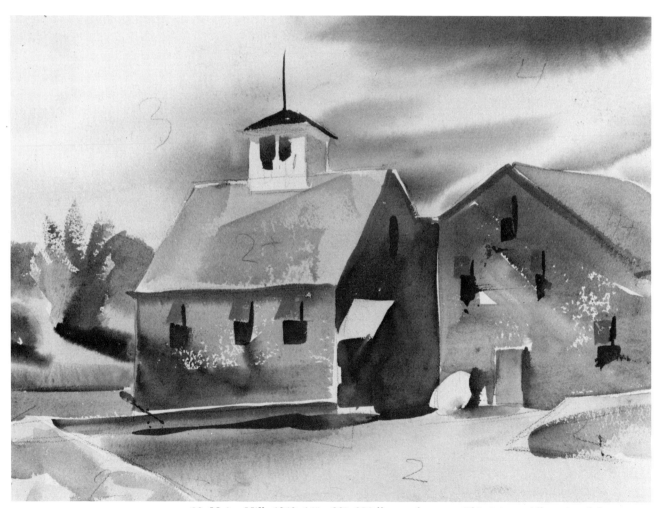

32. Maine Mill, *1968. 16" x 22", 300 lb. rough paper. This is a rapidly painted demonstra-tion. The light tones on the foreground and buildings went in first, followed by the sky. O'Hara left "dams" of white paper between wet areas: to the left of the cupola he knifed a dam to prevent the blue from spreading into the roof. At the left corner of the mill a tone was painted over a dam to reduce its attraction. Brushes were 1¼" and 2" flats.*

Sepia and a little ultramarine blue for doors and windows go in next, and then some foreground shadows. O'Hara uses phthalocyanine green, orange, and yellow—somewhat neutralized—for the rough-brushed weeds behind the wall at right. He mixes ultramarine blue and alizarin crimson for the shadow cast by the walls and the house at left, as well as for those cast by the figures. The dark trees above the figures are made of yellow, phthalocyanine green, and burnt umber. Some strokes of ultramarine blue, raw umber, cadmium red deep, and alizarin crimson articulate the foreground.

Surveying the picture, O'Hara decides to add some details and sharpen up the value distinctions. He lays a violet tone over the yellow of the foreground wall at right. Vermilion, blue, and sepia make a pale, warm gray that gives further direction and texture to the road. Almost pure ultramarine blue is used to accentuate the cast shadows at left and in the background. Lighter, more neutral ultramarine blue is rough brushed on the receding section of the wall at right. Observe how the split hairs of the dry brush model the rounded top of the wall. Washes of yellow and

blue give the figures greater crispness, and interest is added by the dark gate at left.

As a whole, the harmonious adjustment of tone and value, the firm, direct painting, and the bold composition create an atmosphere of sunny tranquility. By offhandedly including the dog, basking in the sun's warmth, O'Hara conveys a sense of peaceful gossip; and the equally casual placement of the young lady between the older woman and the baby carriage evokes for the viewer a feeling of the continuity of generations and the slower pace of village life.

COMMENT

Do not underestimate the value of quickies because they may be difficult to do or because they do not always produce "paintings." Although they are fun to do with a friend or in a group, they are particularly useful for the solitary watercolorist or for one who is an "only child" in a group of oil painters and pastelists. Under such circumstances, we almost all have a tendency to spend too much time drawing and tinkering and diddling with a picture. Like brush drill, quickies are wonderful "loosener-uppers"!

33. Wet Day, Bergen, *1967. 22" x 15½", 140 lb. rough paper. Here O'Hara used quickie techniques to help overcome drying problems in very humid weather. "Dams" separate many of the washes. Rough brushing and whisking strokes, which tend to diffuse much less than do solid washes, appear in the buildings and road. Color almost as it comes from the tube, or body color, also diffuses less; it is used for details.*

LESSON 12

SHADOWS AND LOCAL COLORS

This lesson examines the theory and practice of painting shadows on objects with distincitve local colors. (For O'Hara's Solution, see Color Plate 12 on page 92.)

PROBLEM

The five elements of lighting discussed in Lesson 5 apply equally, of course, to light effects on objects that have a strong local color of their own. Two particular situations, however, may present complications. These are: (1) objects that have a very *dark* local color, and (2) objects that have a very *intense* local color. The two problems combine, for example, in a dark but bright blue boat or a dark red barn, but for simplicity's sake we will discuss them separately.

A little thought will suggest that it may be impossible to obtain in paint a wide enough value range to render the A lighting on a dark object at its *actual* value, and the B or C lighting at *its* actual value, while retaining a proportionate differentiation between those values. Generally speaking, in these situations you must paint the A surfaces lighter than they appear in order to achieve a proper value interval between them and the darker B or C illumination.

To solve the second problem you may find it useful to acquire an elementary grasp of the differences between light mixing and pigment mixing.

Suppose you are painting a yellow house in sunlight. The values pose no difficulty, nor does the A lighting. The B lighting, however, reflected from the sky, is bluish. You add blue to your yellow and—presto! green shadows. But the shadows are *not* green: they have an orange-y, or even lavender-y tone.

This problem can arise because you paint in terms of pigment mixtures, whereas some of the colors you see result from interactions of pigments and colored light. Pigments and light mix differently.

As you know, white light, a neutral, contains all the visible wavelengths. When a surface illuminated by white light looks blue to us, it is because the pigment on the surface *absorbs* from the white nearly all the long wavelengths and reflects only the short, or blue, ones. That is, the light that reaches our eyes from that surface is blue, with a scattering of green and violet wavelengths, those close to blue in length.

When yellow paint is mixed with blue paint, the particles of pigment intermingle. The yellow particles reflect yellow, but also a little orange and green, while the blue ones reflect blue plus a little violet and green. The yellow pieces mixed with the blue *absorb* the violet wavelengths and most of the blue wavelengths reflected by the blue bits, letting through only a little green; and the blue pieces *absorb* the orange and most of the yellow wavelengths reflected by the yellow bits, again allowing only greenish wavelengths to reflect. The resultant light reaching our eyes is a green that is darker and less intense than either the original yellow or blue (Figure 34b).

Pigment mixtures like this are called *subtractive mixtures* because the more pigments you mix together, the more light is absorbed—or subtracted—from the illuminating white light. The green mixture appears darker because *less* light is actually reflecting from it than reflects from yellow or blue alone (or *unmixed* green).

Like the pigment primaries, the three light primaries are so-called because mixtures of two pure hues will yield additional hues, and mixing all three together will give neutral white light. The light primaries are a yellowish orange called amber, a bluish green called cyan, and a reddish purple called ma-

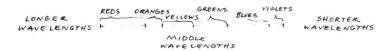

LONGER WAVELENGTHS ← | REDS | ORANGES | YELLOWS | GREENS | BLUES | VIOLETS | → SHORTER WAVELENGTHS

MIDDLE WAVELENGTHS

THE VISIBLE
SPECTRUM

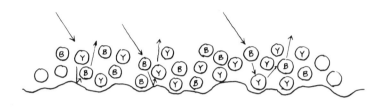

34. *Subtractive Color Mixing, by Carl Schmalz. When a ray of white light strikes a green mixed from blue and yellow pigments, it may hit a fragment of yellow paint (left). This will absorb most of the spectrum red, blue, and violet from the white, reflecting only middle wavelengths (yellow, and a little orange and green). When this light, now mainly yellow, strikes a blue fragment in the mixture, it absorbs the orange and most of the yellow, reflecting only the remaining green wavelengths. The same thing happens in reverse order if the white ray strikes a blue particle first (center); that is, the blue absorbs red, orange, and yellow wavelengths, reflecting only green, blue, and a little violet. When this reduced light encounters a yellow particle, all but a little green is absorbed. Hence the mixture reflects green wavelengths, and many fewer than composed the original white light. For this reason the mixed green appears darker and less intense than would either pure blue, pure yellow, or a green pigment.*

RED, ORANGE, YELLOW, GREEN, BLUE AND VIOLET STRIPES AT
#2 VALUE, IN FULL SUN.

STRIPES IN ACTUAL SHADOW (AT TOP): RED AND ORANGE
STRIPES PAINTED TO MATCH SHADOW TONE.

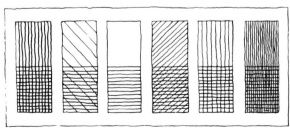

LOWER HALF OF ALL STRIPES PAINTED TO MATCH
SHADOW TONES, AND REMOVED FROM SUNLIGHT.

35. *First Exercise, Shadows on Local Colors, by Carl Schmalz.*

genta. If a beam of amber is directed onto a white surface and a beam of cyan is overlapped on the same spot, the spot will appear yellow, and lighter. Similarly, cyan and magenta make blue, and magenta and amber make red. Light mixing of this sort is called *additive* mixing because when you focus two beams on a given surface, more light is actually falling there than when there was one beam.

Effects that are purely the result of additive mixing almost never occur in nature: they are features of the theater and the laboratory. Some special situations may arise, however, at sunset, for example, when the light is colored yellow, orange, or red. Similarly, as was discussed in Lesson 5, light reflected into a shadow is usually colored bluish from the sky or yellow-orange from the earth. In these cases, the critical thing to understand is that because colored light does not contain all the wavelengths of white light, it *cannot* disclose certain hues. (Remember the black lipstick in pre-panchromatic black and white photography?) The resultant effects are a variant of subtractive mixing.

Let's reconsider the shadow on your yellow house. The paint on the house is composed of fragments of a material that absorbs the short, and the very long, wavelengths. It reflects only the middle wavelengths, those denoted by the word "yellow." It also reflects a little of the somewhat longer and shorter wavelengths adjacent to it on the spectrum—orange and green. The B lighting from the sky contains chiefly short wavelengths, blue and violet. Now the yellow pigment will absorb most of these, allowing only that small fraction of middle wavelengths which the surface is receiving from other sources to reflect back to your eye. Blue light simply cannot illuminate a yellow surface. Hence, the yellow house in B lighting will appear quite *dark,* and of a very low intensity. From scattered warmer sources it will appear yellowish—in short, brown.

The C lighting will be different. In this case, the reflected light from sunlit grass, for instance, will contain a high proportion of medium wavelengths, with a few longer orange and shorter green ones. The yellow pigment on the house will absorb most of the green, but will reflect all of the yellow so that the C lighting will tend to be a light, intense yellow.

For another example, take the case of the dark, bright blue boat. In order to obtain an appropriate value distinction between the illuminated and the shadowed surfaces, you will paint the A lighting lighter (consequently somewhat more neutral) than you see it. The B lighting will be a darker, very intense blue because the pigment absorbs any stray long wavelengths and reflects all of the blue and nearly all of the violet ones in the light from the sky. The C lighting, on the other hand, will be darker and rather greener than might be expected. The reflected light—again let's say from sunlit grass—contains a high proportion of middle wavelengths—yellow, with some orange and green. The blue paint will reflect only the few shorter, greener wavelengths. So the C lighting will look to be a relatively low-value greenish tone.

A little knowledge of the way light and pigments interact in nature will help you to understand the complex causes of what you see and prepare you to expect the unexpected. Hopefully, it will also encourage you to look carefully at the tones you see in shadows, for finally, of course, you must depend upon your own eyes to determine the appropriate mixtures of pigment to suggest the relations that nature presents.

PROCEDURE

These exercises must be done on a sunny day, preferably outdoors, although you can work inside at a window, if necessary.

Take a used half sheet of paper. On the clean side, make three sets of color patches, each patch about an inch wide and four inches long. At left put patches of each of the six basic hues, using the pigments on your palette that are nearest to those hues. Make this first set all the same value, about #2. In the center make six more patches, with the same pigments but this time at value #5. At the right make the same hues, all at about value #7, using your dark neutrals where necessary to achieve this value. (See Figure 35.)

Now place your paper in such a way that a shadow covers the top half of each set of patches. You can arrange this by using a bench, fence, or your portfolio or painting sack to shade your paper. Your task is to match the colors of the patches in shadow by painting, on the nearer half of each patch, pigments mixed to appear the same as the shadow tone.

You will discover that it is fairly easy to match the lighter tones, and not too difficult to match the #5 patches. The darker patches are almost impossible to match. You do not have paint that equals the lowest values produced by natural light. This is why it is necessary to make the A lighting on dark objects a little lighter than you see it.

You will also notice that the shadow tones you have made on the lighter stripes are more affected by reflected light from the sky than are the shadows on the middle-value stripes. They may be a bit bluer or grayer than you expected.

Another discard sheet will do for your second exercise. Using Figure 36 as a model, draw eight cubes in perspective, as O'Hara does. Your problem is to paint believable tones to represent A, B, and C lighting on white, black, and the six basic hues. Let the rhomboid at the left of each "lollypop" be A lighting, the one at right, B lighting, and the one below, C lighting. Paint an orange stripe under each series of lollypops, and a bit of blue to the upper right to remind you of the sources of reflected light.

The white lollypop should be simple. Observe O'Hara's notations under each figure. The first letter stands for the color of the paint on the object (the local color of the object). The next letter stands for the color of the light reflected into the shadow surface. Hence, white paint with blue light reflected onto it produces a blue effect. Yellow paint in shadow, with blue light reflected onto it, creates an effect of neutral. Consider what each color might look like in shadow with blue and orange reflected lights, and

paint your lollypops accordingly. If you have any difficulty in figuring out what the colors will probably be, experiment in sunshine with some construction paper, arranging a cylinder of one color on a ground of orange, then blue, so that the ground reflects into the shadow on the cylinder.

When you finish the six basic hues, try black. You will find that you must cheat by lightening the A side, as O'Hara does, and as you have already done for your red, blue, and violet.

O'HARA'S SOLUTION

O'Hara starts *Connecticut Barn* (Color Plate 12) by indicating the main shapes with a brush, outlining them in pale pink. He paints the silo roofs first, and then the lights on the silos in pure vermilion and water. Before the color dries, he applies a mixture of ultramarine blue and alizarin crimson with a drier brush. This tone blends with the vermilion to make a soft edge to the B lighting. Working rapidly, he rinses and dries his brush, picks up more vermilion, and sets in the strongest C reflected light. Toward the top of the silo, the vermilion is modified with cadmium red deep. The shadow of the eave curves down with alizarin and ultramarine again, and a quick rough-brushed stroke augments the cylindrical modeling on each building. Knifestrokes from right to left pick out a light from the shadow tone and deposit the paint in the A illumination, marking the reinforcing bands on the silos.

The barn roof at left goes in next, with orange, ultramarine blue, and alizarin crimson. An orange patch at right indicates a bit of sunlit field. With vermilion again, he indicates the illuminated section of the barn itself. The lighter green of the little shed and the rough-brushed neutral orange of the haypile

in the foreground are quickly painted. Some light violet and orange tones indicate the distance.

O'Hara paints the shaded side of the barn with vermilion, alizarin crimson, and burnt sienna, making it considerably darker in value at the top. The cast shadow on the passageway to the silo has more blue in it, since it picks up more sky reflection.

The foreground greens are painted next. O'Hara uses orange and phthalocyanine green, with various admixtures of yellow, raw umber, and burnt sienna to modify it. While it is wet he knifes out some lumber at left. Shadows on the green shack and haypile are made with blue and orange, applied separately so that they do not blend too much. Knifestrokes indicate highlights and prevent the colors from running together.

Now the sky goes in, with phthalocyanine blue. Tree trunks and darks in the distance at right are quickly painted, and the knife picks out light branches. O'Hara puts in the leafless twigs with warm burnt sienna and a bit of vermilion. Dark accents of ultramarine blue and burnt umber in varying proportions function as shadows in the foreground, windows, and final indications of the edges of the roofs. Although the artist chose not to sign it, the painting is a strongly evocative picture of clear April light in New England.

COMMENT

You will require this technical information on color theory less and less as you become more experienced in looking and painting. It will provide a sound foundation, however, upon which you can build your experience. If you wish to learn more about the behavior of light and paint, several books are suggested in the Bibliography on page 173.

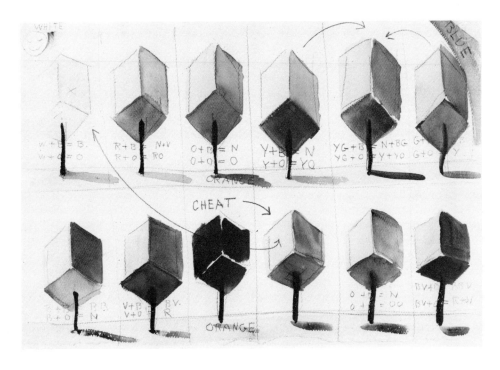

36. "Lollypops" in Color, *undated. 15" x 22¼", 140 lb. rough paper. O'Hara's demonstration for your second exercise in this lesson includes yellow green (second from right, top row). Arrows indicate that a tone between the B lighting on yellow and that on green will be appropriate. Include YG in your exercise, for it relates to trees. In the bottom row, A lighting on black must be shown paler than it appears, as indicated in the experiment third from left. The "lollypop" next to it is gray for A lighting. Disregard the long arrow and the two final "lollypops."*

LESSON 13

PAINTING ROCKS

In this lesson you will investigate some methods of representing rocks in nature. (For O'Hara's solution, see Color Plate 13 on page 93.)

PROBLEM

Rocks come in a wide variety of sizes, shapes, and colors. They may appear as cliffs or ledges, tumbled together as at the sea's edge, erratically scattered, or built into walls. In whatever configuration, they are a frequent source of agony to the watercolorist partly because the very wetness and softness of the medium seems antipathetic to the hard solidity of stone.

Like most things in nature, rocks betray their structure and their history to the acute eye. It is this visibly manifest structure that you must strive to suggest in your picture. As an example, look at O'Hara's *White Cliffs of Dover*, Figure 37. The shape of the major promontories tells us about the blocky stratification of these sedimentary limestones, and the angle of some of the shadows suggests the way in which they have weathered. Long, slightly oblique whisked strokes at left reinforce our sense of the layered structure of this particular formation. By contrast, *Goat Island* (above, and Color Plate 13) shows granite shore rocks rounded by glaciation and worn by the sea.

The most important thing to remember in painting rocks is the necessity of identifying a structural pattern or theme in the formation you are representing, and of simplifying and stressing that pattern.

PROCEDURE

Find a subject. Suitable locations will include any natural outcrops in your neighborhood, or quarries, highway cuttings, building sites, or the shores of lakes, rivers, or ocean; if your area is singularly unrocky, try to gather some stones and make a little arrangement of them to practice on.

Before you start a drawing, study your subject. Look for dominant shapes and repeated angles in rock faces or cracks. See whether there are any characteristic angles or dimensions in the layering of the rocks if they are sedimentary in origin. Are there slopes of fallen gravel and sand? Check the "angle of repose" of these. Do the sizes of the component elements seem similar or very different? Can you find any pattern there? Examine the color of the stone, too. It may vary quite a lot or be nearly uniform. Are the rocks dark or light? Generally warm or cool? What is the prevailing color? What are the variants?

Be sure that you do not undertake too complicated a subject. If you are looking at a great cliff, do only a small section of it.

Make your drawing, indicating the general shapes and the major directional lines that you will use thematically in your painting. Let the rocks be the largest element in the picture. Number the values, remembering that if the local color of the stone is dark, you may want to make its A lighting lighter than you see it.

Generally speaking, it is wise to treat rocks as a "confused subject," that is, a subject in which you aim for an overall impression rather than a collection of little portraits. Since the rocks are your center of attention, start by painting their A lighting, even though there may be some lighter sections in the picture. Use a wet brush with a pigment mixture approximating the dominant color of the stone. Mix the paint on the paper, as far as possible, leaving some original pigments visible. This is important, because you want ultimately to create some variety of tonality in the rock. If there are substantially different colors in the rocks, modify the paint mix-

tures accordingly. Cover the entire rock area, going right over those portions that will be in shadow. Use firm strokes and try to apply them in the *pattern* of the penciled directions. (But resist any temptation to draw individual rocks.) If the rocks are very light or very coarse-textured, leave some rough-brushed strokes.

Before the tone for the A lighting has entirely dried, add some darker colors in those sections where you plan shadows. Some of these can be bluish to suggest B lighting, some warmish to suggest C lighting. Your strokes should now seriously accent those characteristic shapes you earlier indicated with pencil.

While this wash dries, paint in any other light sections you may have included, such as sky, foreground gravel, grass, and so forth.

You are now ready to put the shadow tones on the rocks. At this point, you must develop that structural pattern toward which you have been working, so consider for a moment whether you have created in your first washes any good "rocks" that may be worth identifying further. Work as much from the pattern already on the paper as from your subject or your drawing. As you paint, be sure that your values are

both dark enough and varied enough. Set in some definite warms and cools, rough brushing the edges of the areas where the rocks turn into shadow. Make these edges bluish, reserving the warms for places where C lighting might logically be expected. As these strokes begin to dry, put in some darker blue cast shadows, and with a very dry brush and sepia, or burnt umber and black, draw a few cracks (D lighting). Allow the cast shadows to follow the shapes of the rocks you are creating, and let the cracks (not too many) reinforce the structural angles you have planned. You may find it helpful to look at Figures 38 and 39 for examples of handling this stage of the picture.

Some further darks in peripheral sections of the painting should finish it.

O'HARA'S SOLUTION

Goat Island (Color Plate 13) is a simple, dramatic rendering of light on seaside rocks. Its skillful variation of hue and perfection of value relationships give it unusual authority. The rocks—and rocks are among the most difficult subjects to paint convincingly—are absolutely persuasive, largely because of the bold

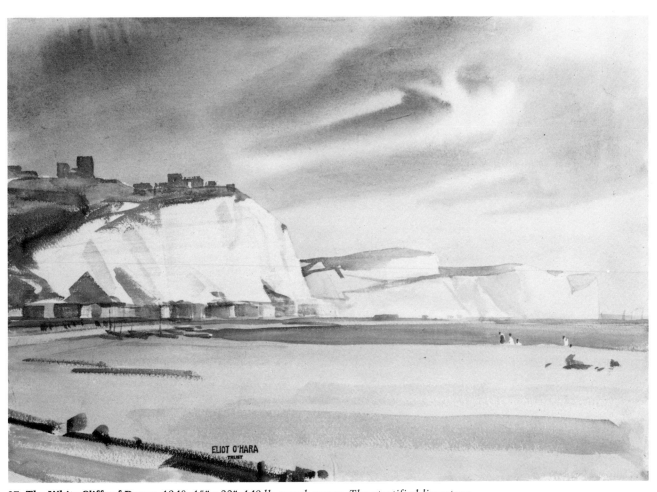

37. The White Cliffs of Dover, *1948. 15" x 22", 140 lb. rough paper. The stratified limestone is indicated by whisking strokes that go the length of each headland. The shapes of shadows show how rain has eroded the relatively soft rock. The painting beautifully exemplifies the principles of recession, as well as the use of scale to suggest the huge cliffs (see Lesson 25).*

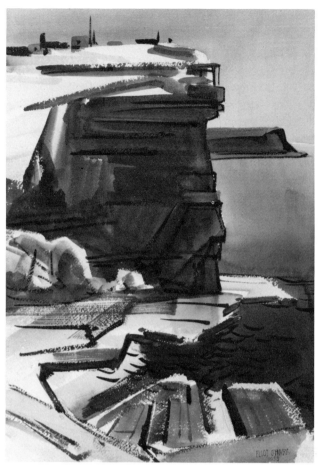

38. South Head, Sydney, *1953. 21¾" x 15½", 140 lb. rough paper. Here O'Hara uses the structural pattern of the rocks as a basis for semiabstract, semicalligraphic treatment. The horizontality of the deposits is emphasized in the central cliff. In the foreground, cracks along a cleavage plane form parallel lines in perspective.*

conception of their light and dark areas.

O'Hara begins this picture by wetting the sky area thoroughly; only the lighthouse remains dry. He paints on phthalocyanine blue, working it in smoothly and introducing a little yellow toward the horizon. He keeps the value at about #2–#3 so that the shadowed rocks and lighthouse can be more emphatically silhouetted against it. While this wash is drying he uses brisk strokes of cadmium yellow medium and vermilion to stand for rocks in sunlight. These are also very light in value.

When the sky is dry, he wets the right portion of the lighthouse tower, so that he will have time enough to model the B and C lighting. Starting at the upper left, with ultramarine blue to which a very little alizarin crimson is added, he paints the curved shadow cast by the walkway. The same color comes down the cylinder. Before the left edge can dry, O'Hara rinses and dries his brush and then with clear water

makes a stroke to the left of the blue, just overlapping it. The blue blends into this wetted band, forming a soft edge that models the rounded shape of the tower. (This is the same technique as for doing the tops of cumulus clouds.) He returns now to the right side of the tower, adding cadmium yellow medium and alizarin crimson. Some of this tone goes in at the top, under the walkway. At the extreme right side of the tower the reflected light becomes bluer and darker again because the rocks below, which are in the cast shadow of the lighthouse, reflect very little warmth.

Next he paints the B and C lighting in the rocks. Because it is a little lighter, the C illumination goes in first. O'Hara uses vermilion, yellows, and ultramarine and alizarin crimson all at about value #5 for the varied and quite intense tones. In places he rough brushes edges adjoining the A lighting; in others he softens the shadow with water. At all times, however, he maintains a bold angularity of stroke to prevent the rocks from becoming mere "dumplings."

While portions of the C lighting remain wet, O'Hara moves back into those washes—using quite a dry brush—with ultramarine, alizarin and a little burnt umber. These colors form the accenting darks, both B lighting and D lighting. At left a wide crevice in the formation is marked out with vermilion body color over burnt umber. The oozles forming at right are allowed to remain, since they function effectively in the context.

The black painted walkway and railing are first indicated at left with vermilion standing for black paint in sunlight. While this dries the housing for the lamp and reflector are put in, with heavy orange and pure ultramarine. Blue reflected light at right is added to the walkway rim, the railing is drawn in, and a few knifestrokes indicate the glint of sun on the uprights. The supports for the walkway are also entered with short knifestrokes.

Below, O'Hara washes out a bit of paint at the lower margin so that he can more effectively model a typical rock shape with cast shadow. Ultramarine and alizarin crimson shadows are set in at center and right; a bit of very dark burnt umber at the base of the lighthouse contrasts with it, accentuating the effect of whiteness. Two or three strokes of cobalt blue suggest the shadow cast on the foreground rock. No further detail is added to the picture.

COMMENT

One of the greatest problems in painting rocks is caused by your having missed the structural pattern at the beginning. When this happens you are tempted to draw individual bits of what you see—usually to the detriment of the total effect. O'Hara frequently warned his students: "It's the last stroke that spoils the picture!" This is especially true of confused subjects such as rocks. Practice stopping just as you are about to "finish" the picture. Step back and see whether it may not better be left as it is.

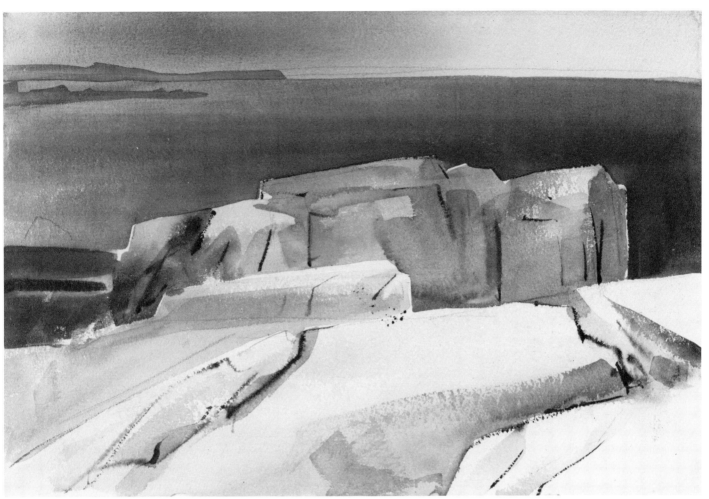

39. Maine Shore, *1968. 14½″ x 22″, 300 lb. rough paper. This simple interpretation of sea-side rocks was done mostly with a 1¼″ brush. Rough brushing suggests the rocks' texture, contrasting it with the smooth sea and sky. As in Color Plate 13, wet-blended edges are used in some of the shadow areas. The cracks were painted with a rigger brush.*

LESSON 14

RHYTHM

In this lesson, you will explore some pictorial possibilities of rhythmic repetition. (For O'Hara's solution, see Color Plate 14 on page 94.)

PROBLEM

The necessary unity of a painting may be achieved in diverse ways. Usually you will employ more than one device to ensure the harmonious fitting together of your picture: rhythm will probably be one of these techniques, and so you will want to become familiar with it.

Visual rhythms, like auditory ones, involve the repetition of distinctive elements. Audible emphasis, or beat, forms the rhythmic basis of musical composition, but in painting repeated lines, shapes, or intervals—and, less often, colors—are the usual elements by which pictorial rhythms are created. And while in traditional Western music rhythm generally provides a constant basic structure for composition, in painting the term usually refers to variations on one or more formal themes. In this respect, pictorial rhythms share the character of melodic variations in music and alliteration in writing.

As in music also, visual rhythm may be quite complex. The simple rhythm of a march, for example, fosters a very different response from that engendered by the varied simultaneous rhythms of African tribal music or the syncopations of jazz derived from it. Although there are expressive and compositional uses for every sort of rhythm in painting, as a rule some complexity will offer greater interest to the viewer and greater flexibility of expression to the artist.

As a painter, you are working with spatial elements rather than temporal ones. Nonetheless, both the painting of the picture and the appreciation of it by an observer take place in time. Your aim, then, is to employ rhythmic elements that will jog the observer's

memory as his eye wanders over the painted surface, and at the same time let differences in the form he recognizes stimulate his recollection of the infinite diversity of visual experience.

If you look over some of your paintings, you will find that you have already created rhythms of various kinds. This is because the human mind and hand, and the natural function of the brush and of your other materials, tend to produce shapes, lines, colors, and spaces that are similar. The object of this exercise is to alert you to the usefulness of rhythm when it is *consciously* harnessed for expressive and compositional purposes.

PROCEDURE

Select a subject. This may be a good time to consider reworking an old paper, but you can equally profitably start from scratch on location. Whichever method you use, you will find it better to choose a subject that avoids overwhelming natural rhythms, because such subjects tend to obscure the purpose of the lesson. Trees and still-life compositions will often lend themselves willingly to rhythmic treatment.

The representational painter has both a problem and an opportunity that the musician does not because he may select a rhythmic motif to directly enhance his subject, rather than inventing one only out of the abstract possibilities of his medium and tradition. Your first move, therefore, is to examine the subject for rhythmic possibilities which you can use to underscore the appearance or feeling you would like to emphasize. Since this is purely exploratory, start with a sketch pad or the back of an old painting and with a pencil draw characteristic identifying lines or shapes that seem potentially useful. It may be helpful to recall your examination of trees and rocks for repeated structural elements. In the present case, however,

try to find shapes that not only reveal the basic qualities of the subject matter but that may also be repeated, with some variation, in subordinate sections of the picture. Sometimes a particular branch pattern will attract your eye, or the special shape of a hill or roof line can be adapted and repeated in other areas of your picture.

Once you have isolated a motif, examine ways in which it can be modified and applied to other parts of the picture. Remember that the sky and foreground may offer opportunities for effective restatement of your theme. You will probably find that there are a number of possible submotifs as well. If you like, adopt one of these, but do not allow it to acquire such prominence that it distracts from your dominant theme. Look, for example, at O'Hara's *Milkweed*, Figure 40. He uses the long, accelerating curve of the central stem as a dominant motif, repeating it with numerous variations in the background strokes and the other stem. He uses the individual seeds themselves as a submotif, arranging their little V-like accents along a line from lower left to upper center that echoes the dominant theme.

Although our first thought may be that a rhythmic motif involves some sort of lyrical curve, there are many other sorts of shapes that lend themselves to rhythmic treatment. Figure 41, O'Hara's *Home Port*, is an excellent example of a composition built of rectangular rhythms that—with the accompanying vertical and horizontal linear accents—emphasize the quietude and inactivity of a fishing boat at "home."

When you have selected your rhythmic theme and considered its possible variations, make a sketch indicating the general shape and placement of areas in your picture. Number your values, as usual; but before you begin to paint, mark with a darker line the location and shape of the elements that will constitute your rhythmic pattern. This will help you to remember your emphasis during the heat of painting and will also provide you with an opportunity to check the arrangement of the rhythmic elements. Try to vary the size of the elements and their distance apart. Regularity is often merely dull.

O'HARA'S SOLUTION

O'Hara begins *Korolevu Sands* (Color Plate 14) with a drawing that carefully locates the rhythmic shapes of the foreground areas and delineates the related shapes of the more distant mountains. Without wetting the paper, he paints in the light sky, applying phthalocyanine blue first and modifying it with some warm gray mixed by adding burnt umber and alizarin crimson to the blue. This color, applied with a drier brush, is also used to indicate the clouds lower on the horizon.

For the sand, which is the next lightest area in the picture, ranging in value from #2 to #3, O'Hara again paints directly onto the dry paper. He relies on speed to eliminate any danger of too-rapid drying. (Incidentally, this is a good example of the advantage gained by adopting the position for painting recommended

by O'Hara: With your arm completely free and a 1" brush in your hand, you will be able to cover these large areas fairly easily in the required time.) The sand color is orange reduced in intensity with a little burnt sienna. As he moves down the paper, closer to the foreground, O'Hara increases the intensity of the orange, adding to it—right on the paper—an ultramarine blue with which a bit of alizarin has been mixed. These colors blend together in the damp wash and model the smooth forms of the sand.

While the sand dries, O'Hara goes back to the upper part of the paper, setting in the mountains with ultramarine blue and alizarin crimson, slightly neutralized with the orange on the palette. These are quite dark—about value #5. White paper strips are left for lights on the palm trunks. Before all of the violet has dried, O'Hara lays in some yellowish green at about value #4 at the base of the hills. This will stand for distant foliage.

Returning to the sand area, the artist quickly paints the phthalocyanine green wedge of water. With a brush dry enough so that he can split its hairs, O'Hara then picks up some blue and some red paint to make the double-loaded strokes that define darker sand at

40. Milkweed, *1962. 21¾" x 14½", 3-ply smooth paper. O'Hara reinforces the rhythms of the plant with sweeping brushstrokes in the background. Highlights on the stems and leaves, as well as the puffy seeds themselves, are picked out from the background wash with a dry brush. The floating seeds are arranged in a curvilinear sequence that echoes the background strokes.*

41. Home Port, *c.1950. 15" x 22", 140 lb. rough paper. This is a highly rhythmic picture, based on rectangular repetition. Particularly instructive is the way O'Hara varies shapes, sizes, and intervals between the pictorial elements. The repetition of rectangles does not become mechanical or boring.*

42. Arc of Dolphins, *1957 (Right). 16½" x 22½", 140 lb. rough paper. O'Hara was fascinated by the grace of these animals and painted many variations on this theme. The challenge was to retain and augment the rhythm of their movement within the rigid confines of the paper. Here, he selects characteristic positions and echoes these shapes and directions in the wet-blended weeds and sea grass of the background. Photo by Woltz.*

the high-water mark along the beach at right.

With the mountains dry, he can attend to the palms and other foliage. The color in the palm fronds is cadmium yellow medium, cadmium red deep, orange, and raw umber, each mixed in varying proportions with phthalocyanine green. The paint is applied with a fairly dry brush, to achieve a bit of rough brushing, and the strokes are firm. Some are a little curved, picking up the main rhythmic theme and at the same time suggesting a brisk breeze from the sea. Cadmium red deep is used for some of the palm trunks. Notice that O'Hara does not hesitate to paint the fronds with the 1″ brush held end on.

He paints the remainder of the distant foliage with a ¾″ brushstroke, which is again dry enough to create some rough brushing. He uses some dabs of yellow, but at the left the foliage color is mixed from phthalocyanine blue and burnt umber. Toward the center and right the same blue is mixed with orange. A few darker strokes, about value #9, are put in with sepia to indicate the deeply shaded holes under the foliage.

O'Hara waits until the trees are painted before putting in the foreground lagoon at left. This enables him to place reflections from the trees accurately. The area is painted with a quick wash of cobalt blue, and while it is still wet vertical strokes of neutral orange

are added to form soft-edged reflections. The same color, drawn along the bases of the sand spits, stands for their reflections in the smooth water.

At lower right, some dark foliage shadows are painted with ultramarine blue and alizarin crimson. On the nearer hump of sand this violety blue is modified with orange; a few whisked edges provide interest while suggesting the fringes of the palm leaves that cast the shadows. To finish the painting O'Hara adds blue shadows cast on the farther beach by the foliage, and sepia touches—fallen branches along the more distant beach and bits of debris in the foreground.

COMMENT

Although the paintings illustrated in this lesson are all of a basically representational nature, it should be clear that the use of rhythm need not be limited to the compositional and expressive role it can play in such pictures. Rhythm, or repetition of a theme with variations, is also one of the most important devices available to the artist who wishes to work more abstractly. Remember that rhythmic forms are created not just by edges; the brush itself, in the painting of an area, can also echo a rhythmic motive, as in Figure 40, *Milkweed,* or in the sky, water, and grass of Figure 43.

ELIOT O'HARA

LESSON 15

RESTRAINT

In this lesson you will address the problem of reducing detail for technical manageability and expressive effectiveness. (For O'Hara's solution, see Color Plate 15 on page 95.)

PROBLEM

With a very few exceptions, the things you encounter in the visible world are composed of multitudinous details of line, shape, and ornamentation, as well as color, texture, and light effect. These details constitute the minutiae of appearance. You will seldom want to reproduce all of them. For one thing, you risk patronizing or boring your observer by telling him a great deal that he already knows. For another, excessive detail can easily become mere aimless repetition—what O'Hara called "gossiping in paint." A picture overloaded with detail frequently lacks focus, clarity, and punch.

The quality of restraint in a painting, as in any sort of performance, suggests skillful control and reserves of strength. Even in those styles that appear almost microscopically detailed, the best artists select very carefully the kind of detail they include, whether it be the special texture of grasses or the precise effect of illumination. It is important to cultivate an ability to limit detail to that which enhances your purpose so that your picture will say what you want it to say.

PROCEDURE

Although this project is designed as an exercise to point up the virtue of restraint, there is no reason why it cannot yield a good picture as well. Find a subject that is both interesting to you and inherently more complicated than you normally undertake: a view of a city, the activity of a downtown street, a circus or fairground, a large bouquet of flowers, or a Victorian house, for example.

Before you begin to draw, stop and ask yourself what it is about the subject that appeals to you. Is it a certain pattern of light and dark, an odd juxtaposition of color, or perhaps the very bustle of the subject? Once you have identified your interest, consider how you can emphasize it by omitting elements that do not contribute to it. This may mean, to start, that you will wish to limit the actual scope of the scene. Suppose you are intrigued by an industrial site, and you decide that the scaffolds and railings against the steam are mainly what attracts you. In that case, you can omit the boxcars or trucks, the warehouses, the dark smoke, and so forth.

As you draw, keep in mind the desirability of indicating any structural patterns you may discern, as you did with trees and rocks. Consider also the possibilities of using recurrent rhythmic effects as a means of emphasizing your central expressive aim. Keep constantly in mind your intention to eliminate anything that is not essential to your purpose. Do you need light effect or will a silhouette do? How important is texture to your aim? Can you suggest the effect of many automobiles with only a few? Pare down everything you can. You may be surprised at how little of what you actually see is necessary for a good picture.

O'HARA'S SOLUTION

O'Hara, like so many painters, toward the end of his life increasingly found the means to create works of surpassing simplicity. His ideal was always a lucid, elegant picture, but it was only in the 1960s that he consistently produced such spare and tranquil papers as *Shore Home* (Color Plate 15). Every inessential quality in the scene is omitted. The luminous washes are accented by a few telling shapes, and the whole subject is reduced to the clear language of brushwork.

O'Hara starts this painting by locating with pencil

the main lines and shapes that will form his composition. The house is diagonally opposed to the area of dark sand at lower right, offsetting the slight oblique of the beach waterline.

The two primary washes go in first. The sky is painted with a large brush (1¼″ flat) fully loaded with water and a small amount of ultramarine blue and black. Toward the horizon O'Hara increases the amount of paint in the brush and makes the wash bluer at left, warmer—because sepia is added to the mixture—at right. He obtains a sense of low-hanging fog, the lighter sky at upper right indicating the sun above the mist. The sky wash is carried down behind the house, but only to the top of what will be the grass area.

The large wash for the foreground water is also painted directly onto dry paper. Again using a large brush, O'Hara puts on a rather light mixture of raw umber, blue, and a touch of phthalocyanine green. He carries this about halfway down the area and then reloads his brush with ultramarine and burnt umber, making a warmer, slightly violet tone. Toward the immediate foreground, the blue is increased. This entire wash is painted with a moderately wet brush, so that the blending of tones is soft and even.

A mixture of ultramarine blue, burnt umber, and a bit of alizarin crimson are painted onto the now dry sky to form the basic tone for the house. While this is drying, O'Hara puts in the strip of sand with a very light gray made from blue and orange, neutralized with a little of the paint left on the palette from the previous mixtures. The strokes he employs for the beach are firm and rapid, leaving rough-brushed edges that are characteristic of watercolor on rough paper and suggestive of grassy texture where they adjoin the green.

The slightly neutralized phthalocyanine green of the roof goes on next. The grass is painted with raw umber and phthalocyanine green. A touch of orange and sepia at left makes the tone warmer and darker. O'Hara puts the stroke on and then picks up some of the color at the right to increase the interest and variety of the transition. With ultramarine and sepia, he puts in the barest indications of architectural detail on the house—the eaves, a porch overhang, and a couple of windows. The chimney is painted with the same color.

With orange, raw umber, and green, O'Hara lightly brushes in the little scrub tree to the right of the house. He uses the tip of the 1″ brush to make its branches. The same brush serves to indicate the poles to right and left. With all of the elements to be reflected now on the paper, he sets in the reflections in the glassy surface of the tide pool. Notice that

43. Shore Home, *1968 (trial). 14″ x 22″, 140 lb. rough paper. O'Hara chose not to sign this earlier try at* Shore Home. *Comparing it with Color Plate 15, you can see that in the final painting he eliminated the distant trees, the complexity of the tidal pool, and the soft reflections, as being inessential to his concern. The colors remain very similar.*

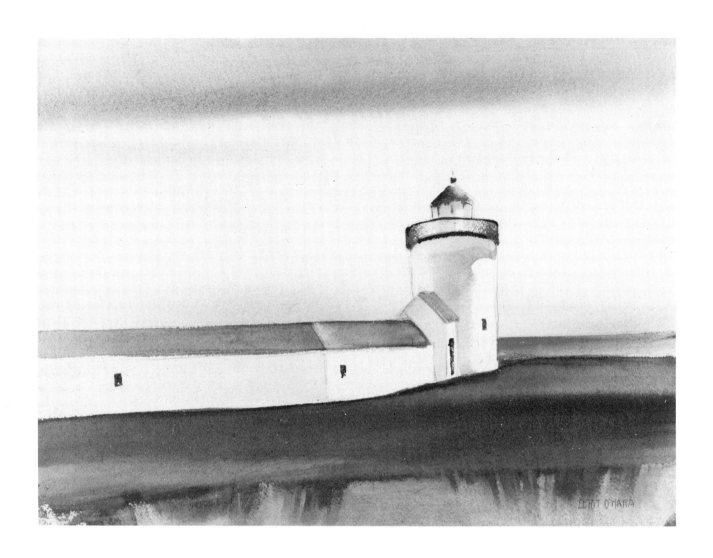

44. Sketch for Lighthouse, Cape Porpoise, *1968. 15¾" x 22", 300 lb. rough paper. Compare this on-the-spot sketch with the larger, studio version shown in Figure 45. The sketch is extremely simple, the generous washes accented by single rough-brushed strokes as in the lighthouse tower and railing. The roof of the ell is modeled by picking up a little paint from the wet wash. Whisking strokes indicate foreground grass.*

45. Lighthouse, Cape Porpoise, *1968 (Right). 1¼" x 29¼", 300 lb. rough paper. Here, O'Hara alters the design to emphasize serenity. The baseline of the buildings becomes horizontal, and the horizon line itself is correspondingly lowered. The effect is to render the tower more monumental, a feeling enhanced by the darker lamp housing and rail. The simple design complements the simple technique. Color Plate 13, a painting done thirty-one years earlier, shows this same subject from a different angle; the contrast in interpretation is instructive.*

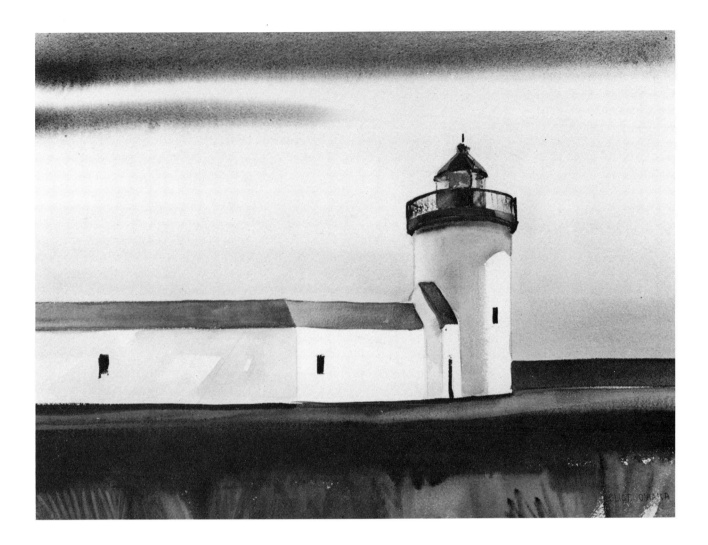

with the single exception of the tree, O'Hara eschews all naturalistic texture, relying instead on the textural qualities of paint and paper for interest. By breaking the lower parts of the reflections he suggests ripples, but the actual surface of the water is unmarked, its wetness simply stated by the blended colors of the wash.

The reflections, just a trifle lighter than the dark house, are brushed in boldly with ultramarine, raw umber, and a bit of phthalocyanine green. They become greener toward the observer.

Once the major darks are in place, O'Hara pins down the foreground with the rippled wet sand at lower right. This is made with a mixture of cobalt blue and sepia, a series of double-loaded strokes indicating the junction between the water and the sand. While this wash is still wet, he adds clear water with a rigger brush to form oozles that stand for more ripples.

Finally, surveying the picture, O'Hara decides to accent the beach by adding the dark stroke at the water's edge. To increase interest in the house he sets in the vermilion stroke that illuminates the chimney and lays a light vermilion wash over part of the lower section of the building. Some deftly placed dark lines of seaweed are enough to indicate the high-water

mark. And that's the picture, a statement of absolute candor in which all elements are transformed into terms of watercolor and through which an inescapably precise mood is evoked.

COMMENT

It is safe to say that restraint is always a virtue in painting, though obviously you must adapt it to your personal interests and way of working. Above all, however, avoid an overzealous pursuit of it. It is, after all, possible to be so restrained as to be silent, to say nothing. A barren painting, like a barren home, is as uninteresting as one that overwhelms with antimacassars and souvenirs. To put it another way, in your search for simplicity, beware of simplemindedness.

The notion of restraint, of course, is closely related to that maxim of O'Hara mentioned in Lesson 13: "It's the last stroke that spoils the picture." He sometimes referred to this as "the hammer" because, he said, every painter should try to hit himself over the head with a hammer before he put in those last, well-meant touches. Stand up and look impartially at what you've done *before* you think you've finished. And remember: if you don't know *why* you're doing something—don't!

LESSON 16

TEXTURES

In this lesson you will experiment with a variety of textural effects obtainable in watercolor. (For O'Hara's solution, see Color Plate 16 on page 96.)

PROBLEM

There are two primary types of textural effects in painting: those that imitate the appearance of a real texture and those that add interest to a picture by exploiting the possibilities of the materials themselves. Obviously, these general categories sometimes overlap, but it is helpful to make the distinction when you are thinking about *why* you are considering using a special texture or *what* texture might be employed to achieve a desired aim.

There are numerous circumstances under which imitative textures may emphasize your expressive intent. Because of the limitations of paint, it is often desirable to distinguish two areas that must be painted the same or nearly the same color. For example, rough-brushed bushes can be differentiated from grass of the same tone by whisking the grass. Old wood can be given a grained look by using the split-hair stroke. The pitted, rusted surface of ancient machinery may be evoked by rough brushing or the addition of salt or sand to the wash.

It is sometimes important to be able to enrich the entire surface of a picture, quite independently of imitative or represented textures. In this case, you are creating a visual field in which painterly "events," rather than purely pictorial ones, entice and engage the viewer.

The purpose of the following exercises is to familiarize you with a number of ways by which you can manipulate textures in watercolor.

PROCEDURE

For this lesson you will need several half sheets of rough paper and a sheet of smooth paper as well.

Have some other kinds of paper on hand if possible, and a few of the following materials:

1. A penknife or dull paring knife, rubber bowl scraper

2. Matchsticks, twigs

3. Sandpaper

4. Table salt, sand

5. Kleenex, blotter, rag, sponge

6. Plastic wrap (or bag)

7. Paraffin wax, wax crayon (white), candle butt, wax paper

8. Masking fluid, opaque white paint

9. India ink

10. A volatile fluid such as nail-polish remover (acetone)

11. Bristle brush, toothbrush, small wire strainer

You will *need* only black paint, but you may use color as well.

A. Textures obtainable with "normal" materials.

Rough Brushing (as discussed in Lesson 1). Review by making patches about three inches square of each of the chief rough-brushed variations: wet, dry, fast, slow.

Whisking Stroke. Whisk two three-inch squares; when one of the squares is dry, crosshatch it with a second set of whisked strokes. Note: this can be done with two or more different colors.

Wet Blending. Wet a three-inch area with clear water and drop paint onto it. This can also be done with more than one color. Draw into a wet area with a heavily loaded brush.

Oozles. Paint a middle-value wash and drop clear water into it before it dries. Note that the degree of spreading varies with the degree of wetness of the paper. As has already been discussed, you can draw lines of clear water into a wet wash for more specific oozle effects. Try various wetnesses of the brush as well as different patterns—circles, crosshatching, and so forth.

Splatters. Try this on a wet surface as well as on a dry one. Load your brush and hold the hairs over the area you wish to splatter. Strike the brush briskly against the index finger of your other hand. You can practice this until you find that you are able to control the placement and size of the splatters fairly well. Different brushes will produce different patterns.

Try each of the above exercises on smooth watercolor paper, making a note of the variations in technique and effect.

B. Textures resulting from abuse of the paper.

Knifing. Paint a three-inch square wash and let it dry until the gloss is off the paper. Hold a knife tilted toward you (*opposite* to the snowplow position) and then draw it toward yourself with a firm stroke. Practice making broad and narrow strokes by varying the amount of blade touching the paper. Try curved lines and crosshatching. Notice that if you go over a line a second time, you spoil it; and that if the color floods back into the knifed line, you will get a dark, rather than a light, mark. This occurs because the knife has dislodged the paper fibers, making the abused area more absorbent. The knife principle operates for any tool that can be used like a squeegee, including single-edged razor blades, combs, and rubber or plastic bowl scrapers. A razor blade can be notched to provide particular effects (as can a small piece of mat board).

Sandpaper Dots. Lightly sandpaper a small area of your rough paper and brush off any debris. Paint a medium-value wash on it and observe how the roughened high points of the paper absorb more pigment, making them darker than the low points. (Incidentally, this should help you to recognize the necessity for keeping your paper free from unwanted abrasion.) You may also sandpaper a dry wash to obtain dots lighter than the base wash.

Crumpled Paper. This works best with 90 lb. or 72 lb. paper, but you can use 140 lb. as well. Take a small piece of your paper—about six inches square—and crumple it as if you were going to throw it away. Be sure your hands are clean and grease-free (or wear gloves), and be careful not to tear the paper. You may want to crumple it several times. Flatten it out and paint a wash on it. You will discover that the pattern of folds is visible. If you want to try a full-sized painting on crumpled paper, you may find it helpful to wet it after crumpling and then stretch it by tacking it to a board to dry and flatten.

C. Textures made with special tools and materials.

46. Texture Study, *1961. 11¾" x 16½", 3-ply smooth paper. O'Hara experiments with salt textures as he plays with the effects of the rocky walls of the cave at Lascaux. Wet blending of heavily laid-on paint suggests the broad, slightly diffused contours of the white bull. Irregular textures are created by stippling the wet paint with a piece of crumpled plastic wrap or cellophane.*

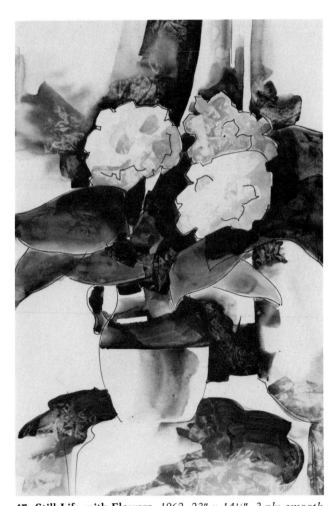

47. Still Life with Flowers, *1962. 23" x 14½", 3-ply smooth paper. In this exploration of textures, O'Hara combines a sparingly used, even ink line with the hydrangea-like effect of crumpled plastic wrap. In this case, he applies it to the wet wash and leaves it until the wash is dry or nearly dry. Note that around the base of the vase the same texture suggests a lace doily.*

Sticks, Twigs, and Fingers. These tools will make interesting marks in a wet or damp wash. Experiment with their different effects. Particularly useful are fingerprints, which can be used to make grapes and stones in a wall or on the ground as well as special effects in foliage and blossoms.

Salt and Sand. Make two small areas of wash. Before each is dry, sprinkle some salt on one and some sand on the other. When they are thoroughly dry, brush off the crumbs. The salt will leave what looks like small oozles; the sand will leave a similar texture except that the dots will have a dark center. These textures are more evident on smooth paper.

Blotters, Sponges, Rags, and Kleenex. Each of these tools may be used to pick up wet or damp paint from a wash. Their effects vary: a blotter can be employed to produce straight light edges that may or may not blend back into the value of the wash; sponges used on damp surfaces will leave their own pattern; rags may be used, like sponges, for wiping out an area; Kleenex can also be used to wipe out lights, but it creates especially interesting effects if torn and allowed to remain on the paper until the wash has dried.

Plastic Wrap. A wash may be variegated by laying a piece of crumpled plastic wrap on it while it is damp and leaving it there until the wash has dried. Effects may be controlled by the degree of crumpling of the plastic (as well as by the thickness of the plastic itself). Somewhat similar effects may be had by putting a paper with a fresh, wet wash on it into a freezer. This is more difficult to control but often very interesting. You must prepare a flat place to lay the paper beforehand, and it is easier if you paint the wash near the freezer. The paper must remain in the freezer until it is dry, usually within twenty minutes or a half an hour.

Wax Resist. You may preserve whites on your paper by covering the desired area with a layer of wax. A piece of paraffin, a candle stump, or a child's white wax crayon will provide varying kinds of coverage. If you want thin lines, lay a piece of wax paper over the area and draw the lines on it with a pencil, bearing down firmly. The wax will adhere to the watercolor paper and prevent paint from holding on those areas. You may also use this technique to preserve a color already painted on the paper, once it is dry, of course. Smooth and rough papers allow different effects with wax resist, the rough making for much coarser textures.

Masking Liquids and Opaque White. Commercially prepared masking fluids have largely replaced rubber cement as a tool for the watercolorist. They are extremely useful for reserving small or intricate white

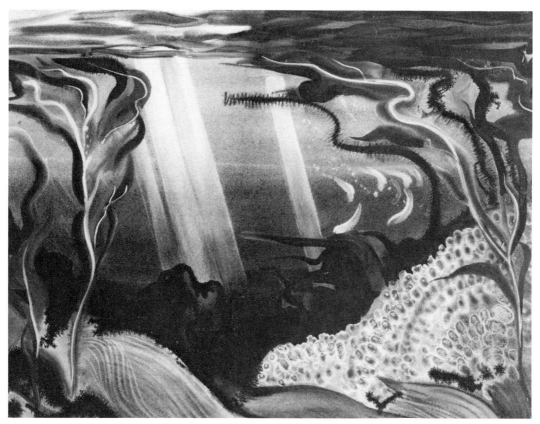

48. Under Water off Laguna, *1952. 22" x 29½", 140 lb. rough paper. This is basically a wet-blended picture (see Lesson 21). In addition to creating soft edges with this technique, O'Hara has formed a sponge at lower right by using thumb and fingerprints in the wet wash. At upper right and lower left you can see India ink creeping into moist washes. Some of the long lights are—believe it or not—knifed out!*

areas. Be sure to wet your brush in soapy water before using these products and to wash the brush well immediately after using it. Otherwise, your brush will be ruined.

Although opaque white does not generally have a place in the kit of a transparent-watercolor painter, it can be used occasionally for special purposes. A small amount unmixed with other color is frequently useful for highlights, small flowers, and similar purposes. Be careful not to use too much, and remember that—like the masked white area—you can color it lightly when it is dry.

India Ink. Black India ink (and other colors of commercial non-water-soluble inks) may be extremely useful to the watercolorist. You can obtain textural effects with them in two distinct ways: you can float water into a drying ink area, or float ink into an area wet with water.

Acetone and Other Volatile Fluids. Any fluids that do not mix with water and that evaporate rapidly will be useful for textural effects in watercolor. They may be painted or splattered onto a damp wash; each technique will give a somewhat different result. Experiment with what you have available and if the effects seem appropriate to your needs, obtain other fluids and try them as well.

Spattering. This is a slightly finer and more controlled splatter. Use an oil brush or an old toothbrush, load it with paint, and try shooting drops onto your paper by rubbing your finger or thumb across it. Finer spots can be made by rubbing a brush through a metal sieve. You can protect parts of your picture surface by using paper templates, or stencils, cut to appropriate shapes.

Varied Papers and Brushes. The range of textures available to you can be infinitely extended if you experiment with papers not normally used for watercolor. These include printing papers, absorbent papers, clay-coated papers, and so forth. The only warning is: if you plan a work of hopefully permanent value, be sure that the paper you are using provides a permanent support. Your dealer can help you decide.

Oil brushes have long been among the watercolorist's tools, but look also at varnish brushes, dusters and mottlers, and brushes made for nonpainting purposes (a bristle pastry brush can be very helpful).

O'HARA'S SOLUTION

After your exploration of the preceding esoteric surface treatments, you may find *The Eiffel Tower* (Color Plate 16) something of a comedown. It is deliberately included here, however, because textures alone do not a painting make. Textures, like all the effects in the watercolorist's arsenal, must be employed appropriately and with restraint.

The Eiffel Tower is a semiabstract, very quickly executed sketch. O'Hara begins painting directly, with no preliminary drawing. Sky tones at left—slightly neutralized ultramarine blue, cadmium red medium,

and cadmium yellow medium—are placed separately, in arbitrary areas that fade off toward the center of the paper. Similar tones, more violet and orange, are painted in at right and center.

While these washes dry, a warm neutral made of orange, ultramarine blue, and a little raw umber is laid in for the middle ground. At right a higher proportion of raw umber gives it a slightly yellow cast. A kindred tone, but bluer, provides a base color for the walk and wall in the foreground. O'Hara carefully leaves a "dam" of white paper between these two areas: it will later serve to indicate sky reflection along the top of the wall.

Next he puts in the tower itself. Its elegant ironwork is simply suggested by quick strokes of a rather dry brush. The color is a slightly neutralized violet made from ultramarine and alizarin crimson. The sweeping curves of the beautifully engineered building are drawn with quick strokes of the 1¼" brush. Across the initial structural strokes, O'Hara now whisks lines which stabilize the tower and attest to its complexity. The two lower observation floors are set in with attention to changing perspective. Quite light and varying little in value, the tower is differentiated from the softly blended sky by its dominant rough-brushed appearance.

A distant line of silhouetted buildings and trees is painted next, again a very simple series of shapes, mainly rough brushed, and varying from orange and burnt sienna through alizarin mixtures to a violet largely composed of ultramarine blue. While these tones remain wet, O'Hara knifes out branches and trunks that identify the scale of the middleground trees and by contrast make evident the immensity of the tower.

On the right, he paints a few areas of thin foliage, rough brushed with sepia and orange. The dark tree trunks, which establish the foreground plane with reference to the tower, are drawn with a fairly wet brush loaded with sepia and alizarin crimson. With a small round brush, O'Hara supplements the branches, making a quiet allusion to the similar lace-like structure of the trees and the tower.

This picture is not more than thirty minutes in the making. O'Hara concludes it with the touches of blue, sepia, orange, and burnt sienna that articulate the foreground, evoking patches of fallen leaves and echoing the hues employed throughout the upper sections of the painting.

COMMENT

Learning to use textured surfaces skillfully takes time. It is not difficult to make a variety of interesting surfaces, but to use them for the enhancement of your purpose requires the judgment of experience. As a rule, you will find it wise to soft-pedal textures, to try and use only those belonging to a given "family" in any particular picture and to be very sparing of arbitrary textures—those that animate the paper without reference to any felt need. Once again, controlled restraint is the key: if you don't have a reason for doing it—don't!

LESSON 17

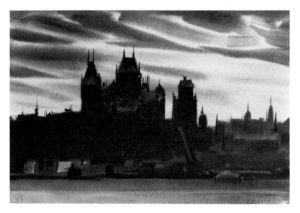

KEYED COLOR

This lesson presents means of overcoming the color limitations inherent in paint. (For O'Hara's solution, see Color Plate 17 on page 97.)

PROBLEM

As has been pointed out, paints do not approach the range of hue and value in nature. In Lesson 2 you learned one method of controlling the proportionate relationship of values, which helps to create on paper an impression corresponding to your perception of what exists in nature. For countless generations, artists have employed what is called "keyed color" (or "simultaneous contrast") to create an appearance of a greater range of hue (and value and intensity) than pigments actually exhibit.

The principle upon which the keyed-color effect is based is very simple. With virtually no exceptions, everything we see is perceived relative to one or more other areas; that is, the notion we form of anything we see depends upon what we see it against or what it is surrounded by. As a direct result of this, you can control to a surprising degree the appearance of any given tone in your painting by surrounding it or juxtaposing to it a tone selected to "push" it in the desired direction.

Here is the basic rule: surround the tone to be altered by a tone that is the *opposite of the effect you want*. For instance, suppose that you have on your paper a gray that appears too cool, too green, and too dark. In order to make it appear less cool, surround it with a tone still cooler. To make it appear less green, surround it with a tone still greener. To make it appear less dark, surround it with a tone yet darker. You will, therefore, paint adjacent to or around the offending gray a cool, intense, dark green.

PROCEDURE

This is a good project to do on a rainy day or when it is too cold to paint outdoors. You will be doing a number of exploratory exercises and then you will make an experimental painting that can easily be based on a picture you have already done.

You need not use your best watercolor paper for these exercises; the backs of a couple of abandoned paintings will be fine. Be sure that your palette is reasonably clean, because you will need to be able to mix colors fairly exactly.

Mix a middle-value gray. Paint ten squares with it, making them an inch to two inches on a side and about four or five inches apart. Place them in two vertical columns, so that you have five pairs.

You now have five sets of identical grays on your paper. Your task is to see how different you can make them look by surrounding them with one-inch bands of varied tones.

As a guide, see whether you can make the top-left gray look relatively pink and the top-right one look relatively green. Make one of the second pair look more intense than the other. Try to produce an appearance of lighter versus darker in the third pair. Experiment with other effects on the last two sets.

As a second exercise, paint three or four pairs of grays that vary slightly in hue, value, and intensity. Each patch on your paper should be a little bit different from every other one. When they are dry, surround them with one-inch bands of tones that make each pair seem as nearly identical as possible. Suppose that your uppermost pair, for example, has a lightish, bluish gray at left and a darker, greener gray at right. Try a very light, red-violet band around the left one to make it seem greener and darker. Around the right gray a darker orange band will create the impression of a paler, bluer tone. You may have to make some quite subtle adjustments to achieve the identity in color you are after; and you may not achieve it, but this experience nonetheless has a really valuable carry-over to actual painting.

These exercises require a lot of visual energy and

concentration. If you are not too exhausted, here is a third. Divide a half sheet of paper in half the short way with a pencil line and draw two identical sketches. The subject should include a colored object such as an orange jug, a bunch of yellow bananas, or a blue boat. You may use a previously painted picture as a model.

Paint the main colored object in each little picture as nearly the same as possible. As you continue painting, try to make the central object in the left-hand picture appear more intense and lighter, the object in the right-hand picture more neutral and darker. You will have to think carefully about the ways in which you adjust the tones that lie next to the contour of the object in order to achieve this distinction of appearance.

O'HARA'S SOLUTION

O'Hara first conceives that *Sunset Silhouette* (Color Plate 17) will depend on an interesting dark shape against a lighter area, and then he determines that it shall be painted in the wet-blended technique (see Lesson 21). It is late evening and drying will be very slow in any event. An obvious solution is to take *advantage* of the slow drying rather than fighting it and being prevented by darkness from completing the picture. Besides, the soft edges created by this method will enhance the feeling of distance and pro-

vide a subdued, romantic atmosphere.

The artist begins, then, by soaking the paper with water. (He makes no preliminary sketch because he has just finished another picture of the same scene.) He starts setting in the sky with a brush heavily laden with phthalocyanine blue and only a little water. He is careful to leave areas of white between the strokes, and as he moves down the paper he adds separate strokes of green and yellow. To indicate that the clouds are illuminated only by afterglow they must be darker than the sky. He does not want them either too dark or too intense, however, for then they might claim the viewer's attention to the exclusion of the focal buildings. He uses a rather neutral warm, therefore, which he mixes from raw umber and alizarin crimson, to which a little ultramarine blue is added at right. The phthalocyanine blue of the sky above and the green lower down are very intense and key these comparatively low-intensity tones, making them seem bright enough to suggest the warm glow just following sunset. The narrow edges of white paper augment the dark effect of both the clouds and the sky itself.

Now, his brush quite dry and loaded with almost pure pigment, O'Hara starts putting in the mass of buildings. For the towers he uses a mixture of black, sepia, and alizarin (still visible in the tower at right). Moving down toward the shore, he increases the

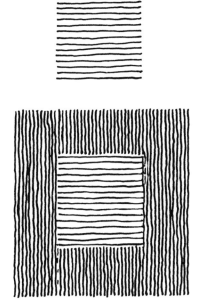

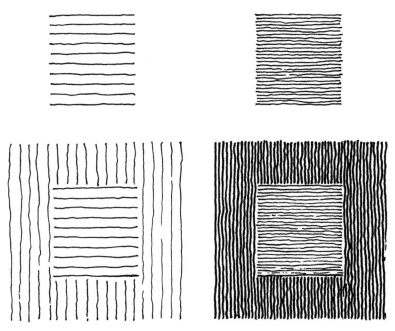

49. *Keyed Value 1, by Carl Schmalz. Two patches of gray, both of the same value, will appear different if one is surrounded by a much darker value (the patch on the right). The right-hand patch, because of the surrounding dark, looks lighter than the left-hand patch.*

50. *Keyed Value 2, by Carl Schmalz. Here, two groups of distinctly different values are made to look similar. The darker patch at right is surrounded by a yet darker tone, lightening its appearance. The lighter patch at left is surrounded by a tone of the same value, robbing it of the contrast with white which makes it appear darker above. Focus on the point between the two lower patches to see how nearly identical the values seem.*

amount of alizarin and then shifts to a tone containing a good deal of cobalt blue. A similar mixture goes in at right for the more distant buildings. Rinsing and drying his brush, he picks up almost pure phthalocyanine green for the verdigris-covered, copper-sheathed roofs.

It is time now to articulate the dark area and to provide more visual interest within it. O'Hara does not want very much value differentiation because it will distract from the silhouette effect; he must create interest with variation of hue. First, to increase the greenness of the roofs, he supplements the buildings' color with vermilion. He works this in fairly well except for a horizontal brushmark near the center of the painting. Several smaller vermilion horizontals are set in lower down and toward the right. These create a rhythmic swing akin to the shape of the main cloud at the top of the painting. Strokes of vermilion and burnt sienna are put in at right, and to give them a little more punch a rectangular stroke of ultramarine blue goes in adjacent to them. Cobalt blue strokes create a sense of hanging smoke or mist just below the main group of buildings, and some wiped-out lights at lower left animate the river's shore.

The water itself goes in quickly with raw umber, a touch of alizarin crimson, and some very neutral ultramarine blue. O'Hara uses sepia and black to place a number of dark accents along the edge of the river and to provide a sense of the elegant pinnacles and ornamental spires of the city.

By using red/green contrasts, and—to a lesser extent—blue/orange contrasts, O'Hara is able to make a very dark area interesting to the eye without losing the dominant effect of the silhouette.

COMMENT

It is profitable to look at paintings deliberately to determine the ways in which artists employ keyed color: it is one of your most valuable tools, so learn all you can about its uses. Examine, for instance, Color Plates 3, 4, 6, 7, 13, and 32 to see other pictures in which O'Hara has made keyed color work for him.

Another way of using keyed color is illustrated in *Sunset Silhouette*. This is its utility in the creation of special or controlled color harmonies. More will be said about this in Lessons 27 and 29, but it should be clear that one of the problems you could encounter in a prearranged color scheme is that of boring, unchanging areas. As in the silhouetted buildings just discussed, keyed color can help enormously to animate such areas, normally without disturbing a harmony of low intensities or dark tones.

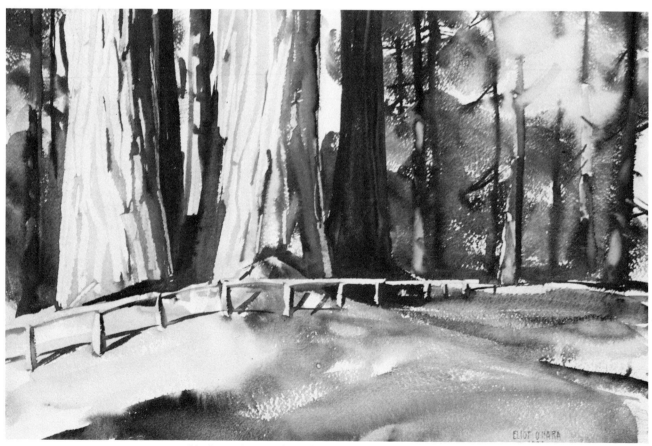

51. Santa Cruz Redwoods, *1937. 15½" x 22½", 200 lb. rough paper. You cannot see how the brilliant yellow and orange trunks have been keyed by purples and blues, but the striking contrast of values does show. Keying color is just one application of the principle of contrast, which is discussed from other points of view in Lessons 10, 22, 25, and 31.*

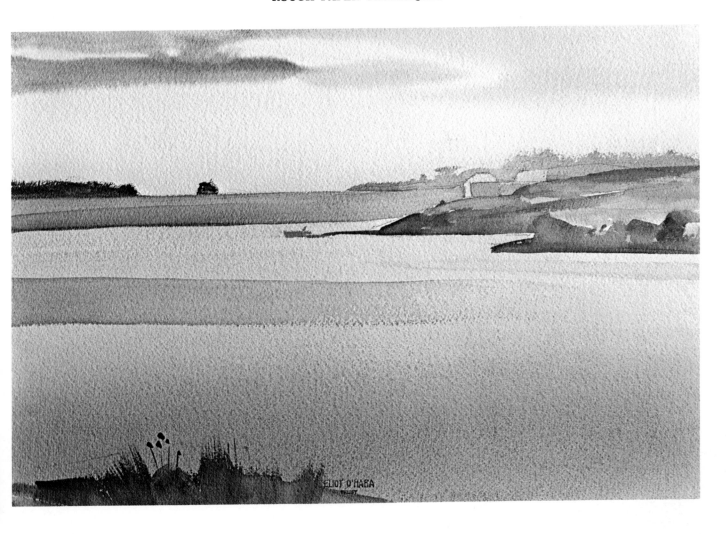

Color Plate 1. Land's End, *1968. 14¾" x 22", 300 lb. rough paper. This painting shows how the brush techniques discussed in Lesson 1 apply in an actual painting. For example, the sea is basically a graded wash. It is darker at the bottom, where O'Hara also adds a warmer tone to form a transition of hue (Lesson 6). Along the horizon he uses the rough and smooth stroke to indicate distant trees. Wind ruffling the water is suggested by a single stroke of a 1¼" brush, which O'Hara moves slowly at first and then more rapidly, to make it trail off in rough brushing to the right. Detail is indicated in the foreground by whisking strokes, and both the boat and the shack are added with a single short 1" brushstroke.*

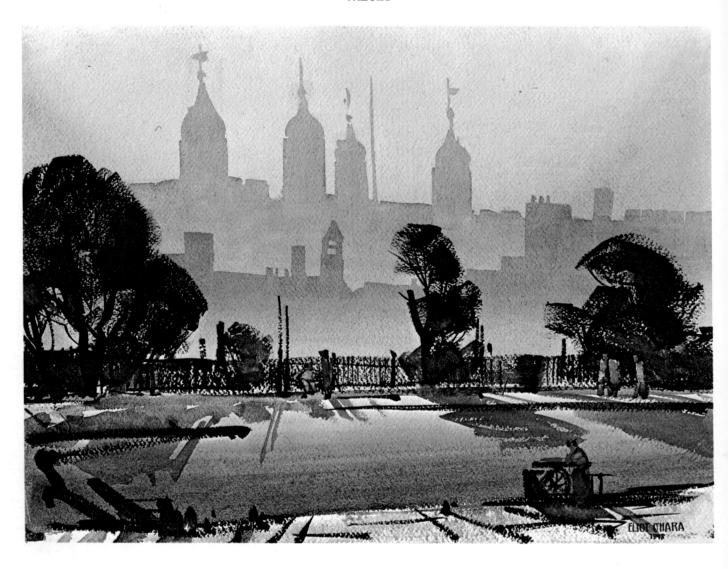

Color Plate 2. Chestnut Vendor, *1948. 15½" x 21¼", 140 lb. rough paper. In this subject, which illustrates Lesson 2, O'Hara exploits dark silhouettes against lighter tones to achieve especially strong value contrasts. Sky, buildings, and pavement are handled as graded washes that vary in value from white paper for the sun to about value #6 in the pavement. The trees are painted at value #9, so that contrast is as great as possible without loss of hue in the darks. Note that the distant buildings are rendered with warm tones, a means of indicating both dense haze and late afternoon light. (See Lesson 10.) The darks at the lower left are quite arbitrary brushstrokes that help to contain the composition by counteracting the directional lines of the shadows. (See Lesson 19.)*

Color Plate 3. Patio, Tucson, *1940. 16¾" x 20¾", 140 lb. smooth paper. O'Hara creates a powerful impression of bright winter sun by using almost all the hues in the spectrum, at very high intensities. (See Lesson 3.) He avoids garishness by keeping the larger tonal areas fairly similar to each other, reserving complementary juxtapositions for details like the blue gateposts against the orange shadows. (See Lesson 17.) The painting is remarkable also for the strong design of its light and dark shapes. Note especially how the sunlit surface of the stair wall helps to join the shape of the lighted patio with the shape of the light sky. The dark, vertical cacti at right act as a barrier, stopping the movement of diagonals toward that side of the paper.*

Color Plate 4. Roadside Elm, *1951. 16¼" x 22¼", 140 lb. rough paper. The characteristic branch structure of the elm is carefully suggested, and the large, rather drooping masses of foliage are modeled to give the tree three-dimensionality and bulk. (See Lesson 4.) Notice that O'Hara draws branches only* between *the leafy sections, and that most of the branches, as well as the upper trunk, are in shade. Shadows cast by the branches on the lower trunk follow the contour of its cylindrical shape. The tree is rooted to the ground by its cast shadow. O'Hara emphasizes the elm's unique shape by contrasting it with the more compact forms of the cedar trees at left.*

Color Plate 5. Morning Sun, *1961. 15" x 21½", 140 lb. rough paper. This picture was re-painted from an actual demonstration for O'Hara's film* Painting Shadows. *It provides an authentic version of his developed treatment of shadows on white. (See Lesson 5.) Notice, first, that he does not tamper with the white paper where it represents sunshine on white paint. This is a device for exploiting to the fullest the narrow value range afforded by paint and paper. It is a good general rule: let the pure paper stand for white in sunlight. Second, he makes the sky very dark relative to the value of the shadows on white. At its darkest, at upper left, the sky is close to value #5. The darkest shadows go only to about #4. This enhances the illusion of brilliance, as explained under "Procedure" in Lesson 5.*

Color Plate 6. Autumn Tide, Maine, *1962. 22¼" x 30", 300 lb. rough paper. O'Hara empha-
sizes gradations of hue and value in the large areas of sky, sea, and sand to make the
broad washes visually interesting. (See Lesson 6.) Changes of tone in the sand model
the beach as well. To introduce varied pigments to a wet wash successfully, the brush
with the new load of paint must be no wetter than the paper. Notice how O'Hara repeats
in the dry seaweed of the left foreground the shapes of the sand spits in the center distance
above, a device that helps to unify the composition. The tiny figures provide a clear
indication of scale, underscoring the sense of an expanse of space.*

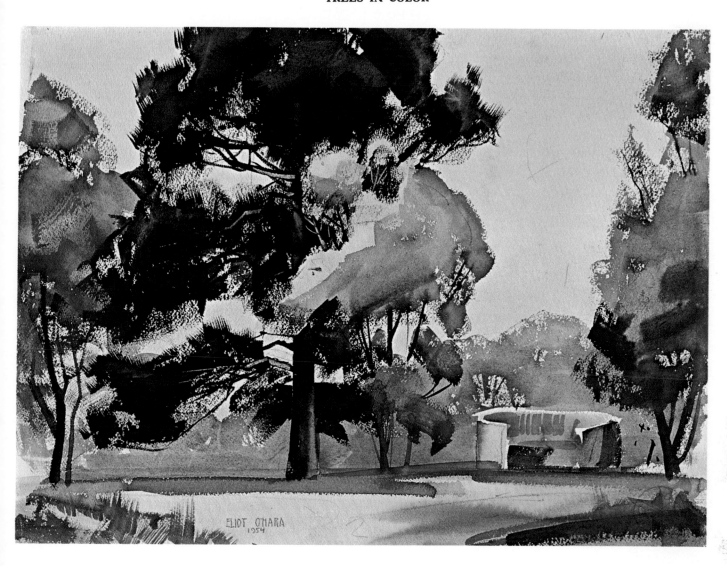

Color Plate 7. High School Yard, *1954. 16" x 22¼", 140 lb. rough paper. This painting is an actual class demonstration for Trees in Color (Lesson 7). O'Hara varies the greens from relatively blue, in the illuminated sections of the pine boughs, through yellowish to quite orange, in the tree at left. He also varies the values, making the strong contrast of light and dark foliage in the center the main focus of his picture. Changes of tone in the distant trees add further interest. Reds in the sky, the pine shadows, and the tree trunks enhance the greens by simultaneous contrast, or keyed color (Lesson 17).*

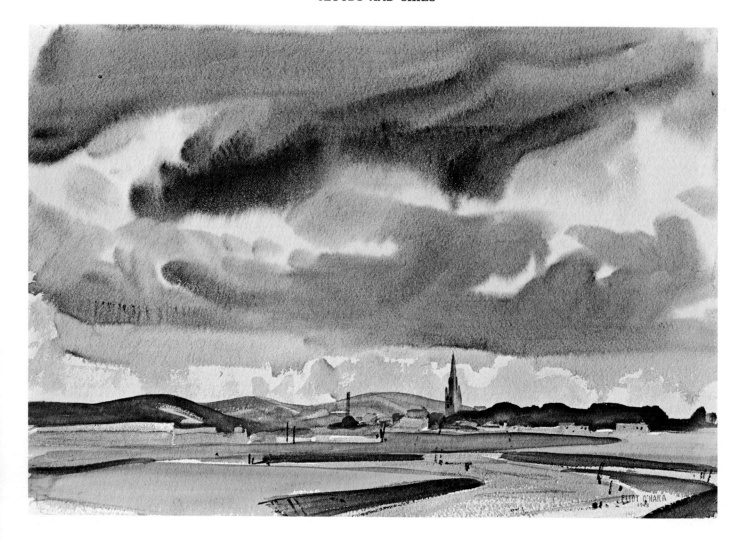

Color Plate 8. Tralee, County Kerry, *1948. 15" x 22½", 140 lb. rough paper. When, as here, the main subject of a painting is sky, the celestial "events" must look possible as well as fit the design of the particular picture. (See Lesson 8.) O'Hara tells the viewer that these are fracto-cumulus clouds by drawing them at the horizon. He suggests the effect of perspective with the horizontal above the steeple. And he provides a sense of the clouds' soggy bottoms at the top of the page. The main directions in these dark areas are paralleled by the shadowed banks of the tidal river in the foreground. The composition is further structured by placing the steeple (which was not drawn initially) directly under a drip in the dark cloud tone above it.*

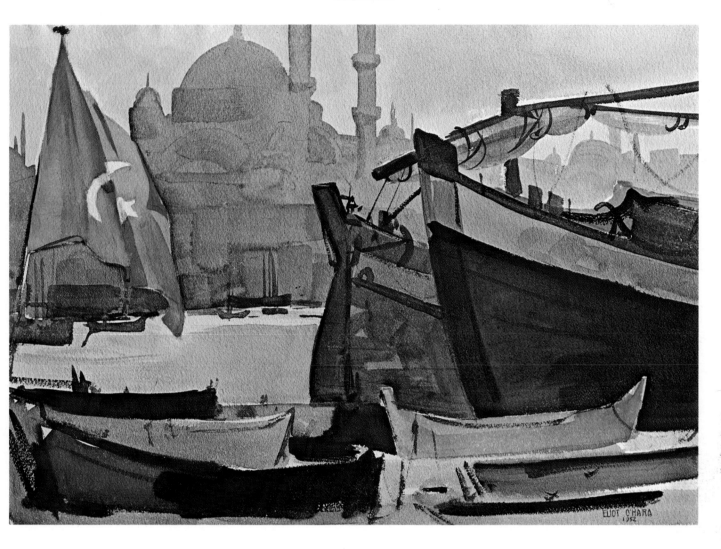

Color Plate 9. Mosque on the Bosphorus, *1952. 15" x 22", 140 lb. rough paper. O'Hara designs this picture, illustrating Lesson 9, not just by spotting darks against lights, but color repeats and areas of intrinsic interest. The color scheme is based on the near complementaries, vermilion and phthalocyanine blue, with a number of very neutral tones. Note how the three vermilion spots are linked by a diagonal from upper right to lower left containing nearly all of the more intense blues. The inherently interesting flag is countered by the furled sail at right, and the gray mosque is balanced by the central ship's bow and the strong value contrasts below it.*

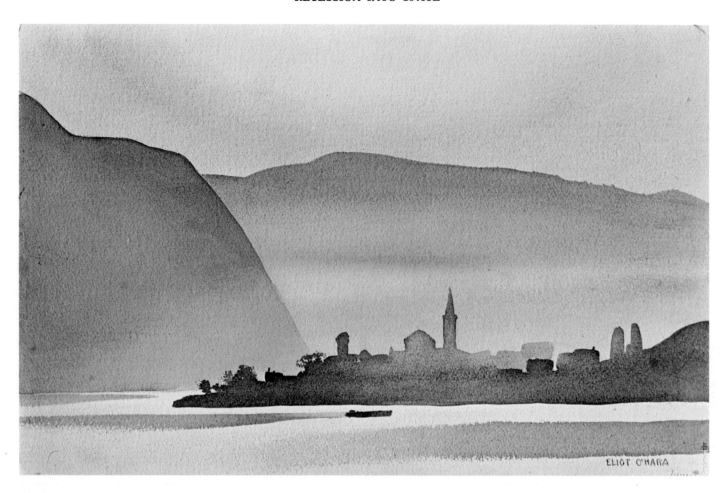

Color Plate 10. Rhine at Braübach, *1967. 14¼" x 22¼", 300 lb. rough paper. Patience is a major ingredient in this picture (Lesson 10). O'Hara had to wait for each of the major washes to dry before he could lay new washes over them. As each wash went on, however, he worked rapidly to modify them for the effect of hanging haze. The small, warm dark of the barge identifies the foreground and makes the bluer, less-detailed distant planes hold their place in the sequence of receding elements. Especially skillful is the lightening of the town towers, a device that models the whole peninsula at the bend of the river.*

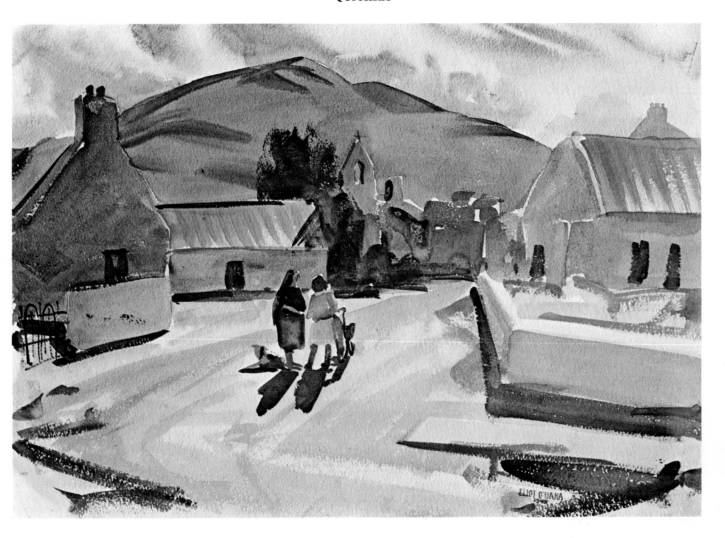

Color Plate 11. Castle Gregory, *1948. 15½" x 22½", 140 lb. rough paper. Executed in virtually quickie style (as described in Lesson 11), this painting shows how effective a rapid and summary technique can be. Some of the brilliance and dash of the brush communicates itself to the viewer as animation and sunshine; the very freshness of the air is conveyed. To prevent washes from running together, O'Hara left "dams" of dry white paper between some of the tones. These sparkles of white enhance the feel of glittering early sunlight. Quite arbitrary brushstrokes in the lower corners of the picture are simply darks to contain the composition. Notice how the blues at lower left echo the angles of the clouds.*

91

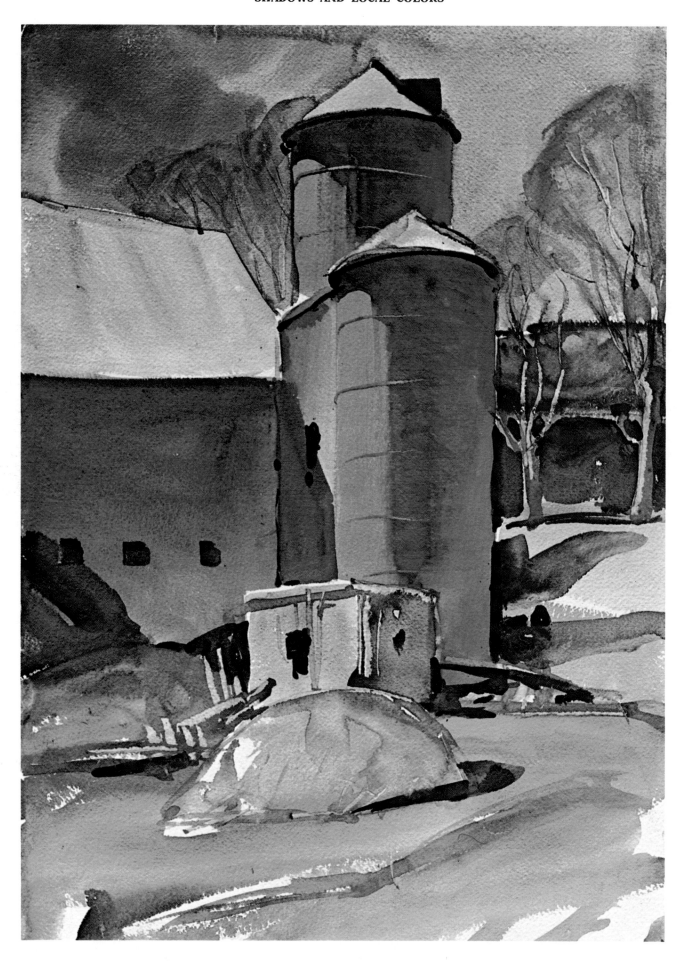

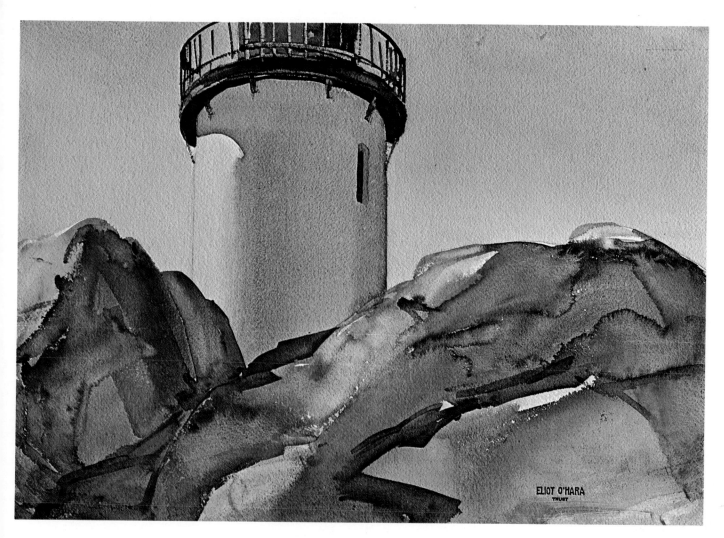

Color Plate 13. Goat Island, *1937. 15½" x 22½", 140 lb. rough paper. There are two very important things to notice in this painting that illustrates Lesson 13. One is the extreme breadth and freedom of treatment O'Hara employs for the rock section of the picture. The other (squint at the reproduction) is the simplicity and consistency of the light effect. It is this, primarily, that holds together the loose and varied patches of color that stand for the sea-worn granite outcrop. You might also observe how the placing of the darker warms—the C lighting—helps to indicate the general direction of the formation as well as the shapes of individual parts of it.*

◁ **Color Plate 12. Connecticut Barn,** *1937. 21½" x 15½", 140 lb. rough paper. This unsigned painting is a class demonstration for Lesson 12. It illustrates perfectly a solution to the problems of shadows on local colors dealt with in this lesson. Observe that the A lighting on the silos is much lighter—and more intense as well—than is the ordinary "barn red" that O'Hara actually saw. Secondly, the B lighting on the silos picks up a violet cast from sky reflection, and the much lighter and more intense C lighting accurately suggests the reinforcement that occurs when warm light is reflected into a warm local color.*

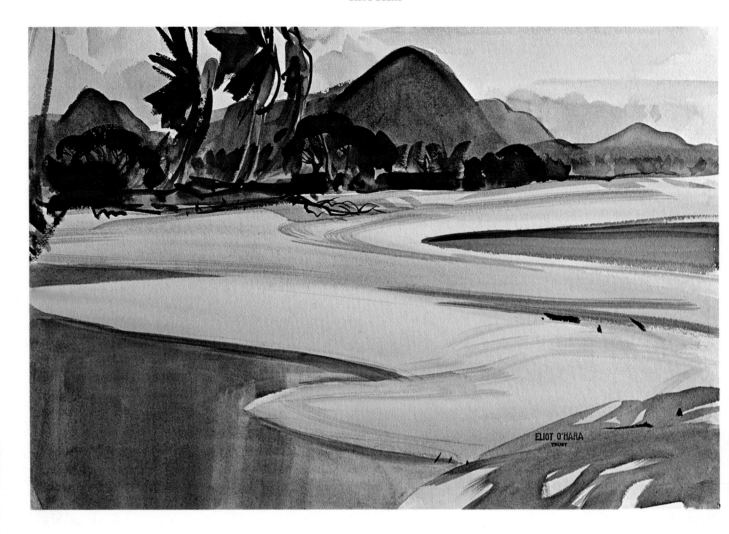

Color Plate 14. Korolevu Sands, *1953. 15" x 22½", 140 lb. cold-pressed paper. This is a painting full of dynamic rhythmic elements, as discussed in Lesson 14. They are, here, basically linear—the horizontal curves of the sand and water. If you arbitrarily take the wedge of green water at right as a basic statement of the theme, you find its variations not only in the sand spits at center and left, in the sweep of darker sand along the beach, and reversed in the wedges of still water pointing in from the left; its variations are also present in the curves of the palm trunks and—in modified form—in the sugar-loaf mountains of the background. The result is a composition of extraordinary vitality and unity.*

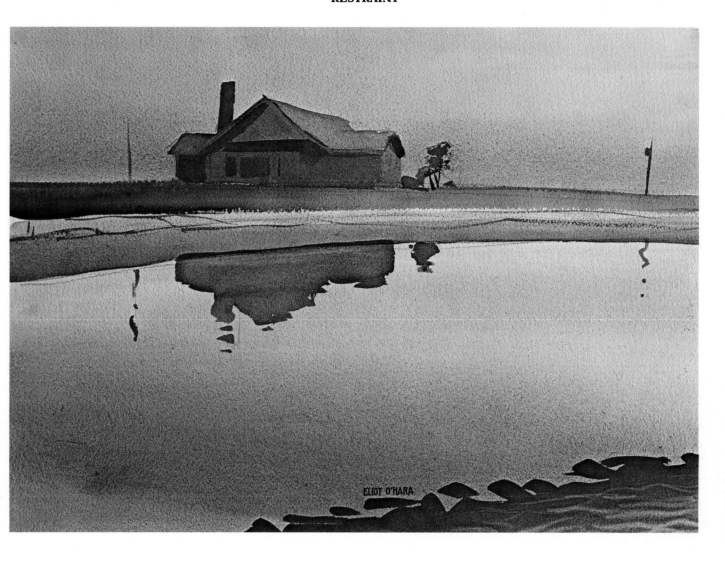

Color Plate 15. Shore Home, *1968. 15½" x 22¼", 140 lb. rough paper. Unlike the quality of mercy, which is alleged to drop from heaven, the quality of restraint must be sought after. (See Lesson 15.) A simple painting is the result of deliberate effort. You must omit and suppress all that is irrelevant to your intention. But it is worth the trouble, for when severe restraint is successful, as with this picture, the result has a breathtaking purity, an almost epic calm. No matter what your stylistic preferences, you will learn a great deal about yourself and about painting by conscientiously practicing restraint.*

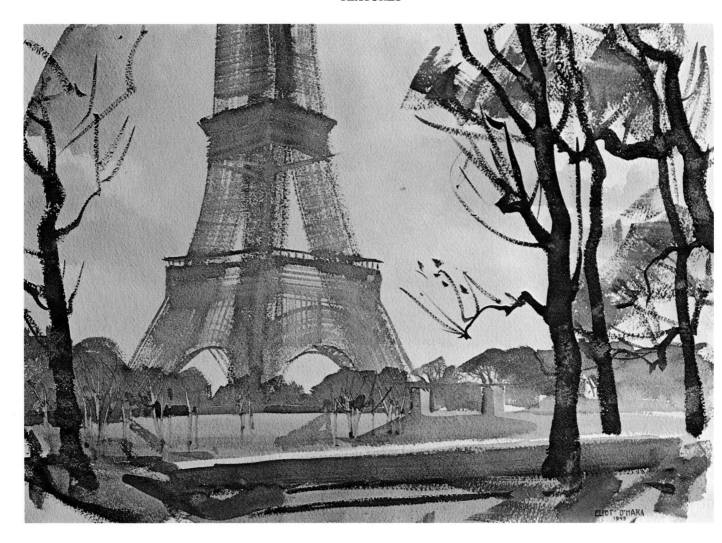

Color Plate 16. The Eiffel Tower, *1948. 15" x 21¾", 140 lb. rough paper. In his own painting, O'Hara rarely used any but "normally" obtainable textures. (See Lesson 16.) He tended to be impatient with more complicated procedures, and in any case he preferred the direct look of pure transparent watercolor. As this picture illustrates, however, he employed the "normal" textural treatments with supreme skill and judgment. Here he uses wet-blended edges, rough brushing, and knifestrokes. Though each type of surface alludes to a parallel visual phenomenon, O'Hara does not merely imitate. On the contrary, he translates what he sees into watercolor and lets painted surfaces* stand *for actual ones. For this reason the picture holds together as a coherent image.*

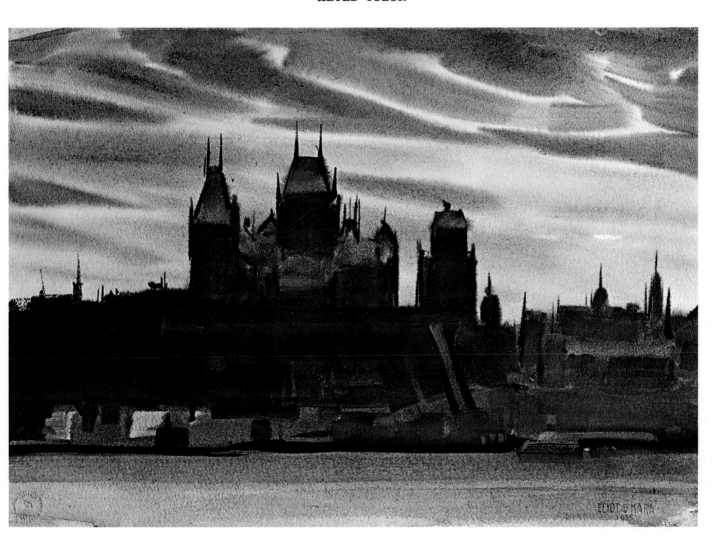

Color Plate 17. Sunset Silhouette, *1955. 15¼" x 22", 140 lb. rough paper. O'Hara here relies on keyed color (Lesson 17) in two significant ways. He uses intense blues and greens in the sky to make the rather neutral warms of the clouds seem hotter. The sky then does not steal attention from the focus of the painting, the silhouetted buildings. These are extremely low in value and would normally be correspondingly low in intensity. To give the darks liveliness, O'Hara includes red/green as well as orange/blue contrasts within them. The result is a richly animated picture.*

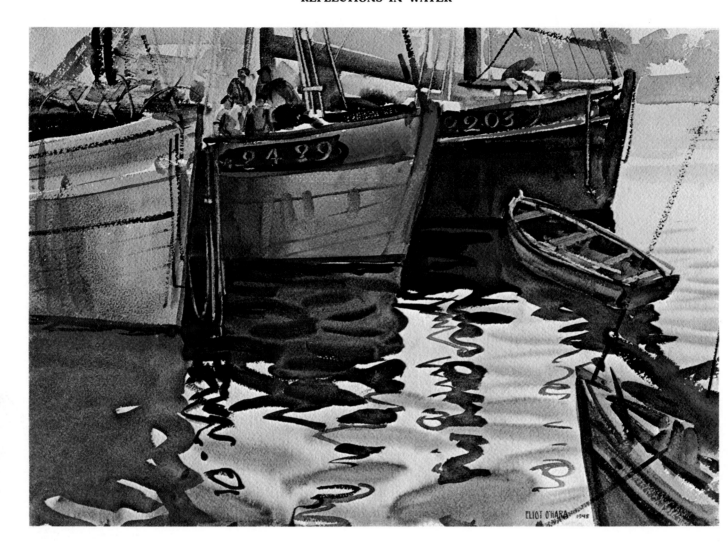

Color Plate 18. Brittany Boats in Cornwall, *1948. 15¼" x 21¾", 140 lb. rough paper. This painting is a fine example of O'Hara's technique for handling reflections in water. (See Lesson 18.) Observe that as the reflections come forward, they show only on the far side of the ripples. O'Hara breaks them by leaving visible the near sides of the ripples, which he wet blended into the water early in the painting. The picture also illustrates a solution to the compositional problems often encountered in reflection subjects. Notice that the dark bulk of the boats is doubled by their reflections. In planning for that, O'Hara included the bow of the boat in the right foreground as a foil for the dark shapes at left. The mast and its reflection provide a strong vertical in the design; but O'Hara omits the reflection of the central boat's mast to avoid cluttering the foreground.*

Color Plate 19. Flatiron Building, Boston, England, *1952. 22" x 16½", 140 lb. rough paper.* ▷
O'Hara handles the challenge of divergent roads into the picture depth with a path-of-vision type of composition. (See Lesson 19.) With a stable scaffolding of central verticals and horizontals, he encourages the viewer to enter the painting at lower left, move down the road to the right, and then up to the signs. From there he is attracted by the TV aerials and follows their diminishing size down the road at left. It is an easy trip across the open space to the tobacconist's shop, and so around the picture again. O'Hara's arrangement nudges the viewer over the entire surface of the painting, as well as in and out of its illusory depth.

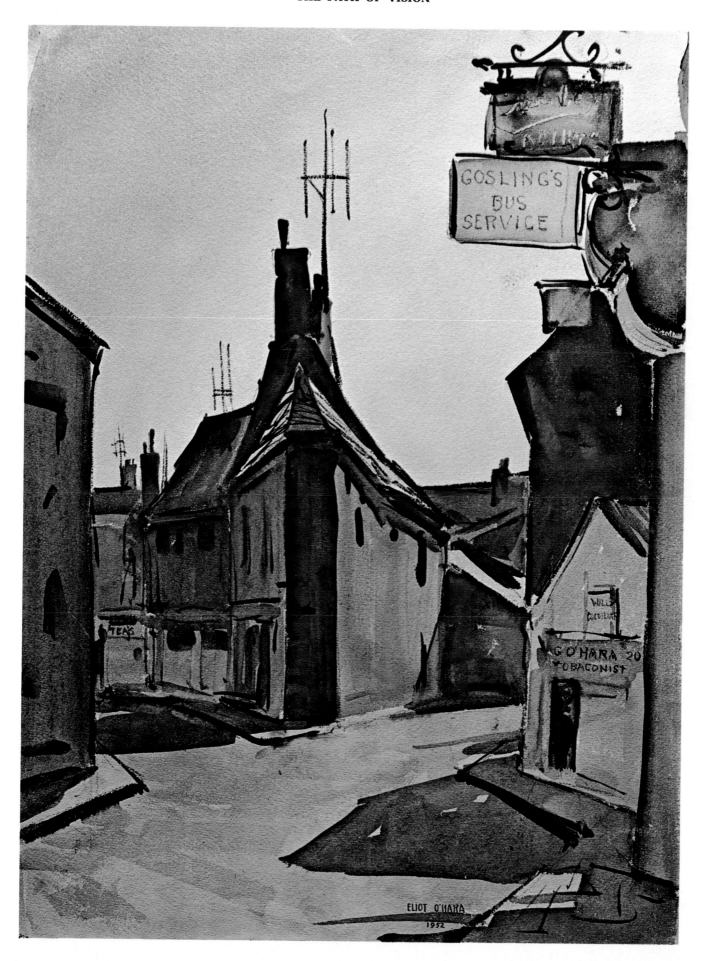

ELIOT O'HARA
1952

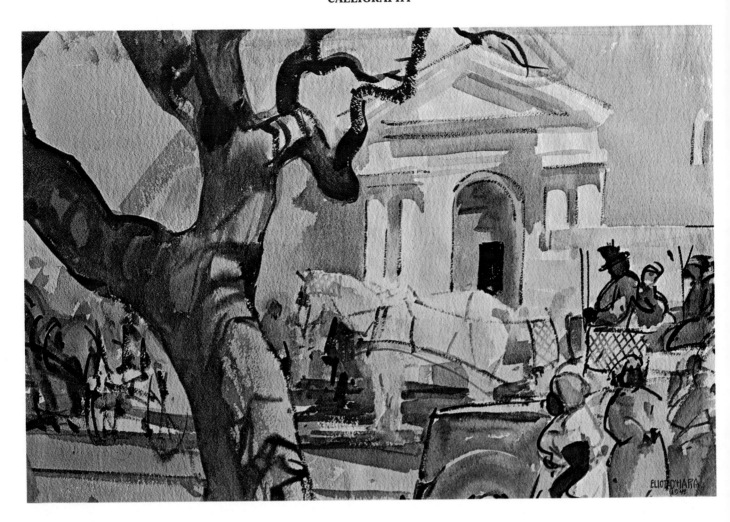

Color Plate 20. St. Augustine, *1948. 14½" x 21", 90 lb. rough paper. (First Prize, St. Augustine Art Association, January, 1951.) O'Hara was a master of the acutely seen calligraphic sign, and he employed this form of abstraction throughout his career. (See Lesson 20.) In this painting he clarifies the wet-blended horse at left by symbolic curves in burnt sienna and black. The lady with the green hat at right is determined by black lines on the shadow side, but pale violet ones suggest the illuminated right side of her figure, thus preserving the sense of light effect. Try to imagine the white horse in the center without the brief indications of harness and trappings; and observe how calligraphy carries the feeling of activity among the figures in the surrey.*

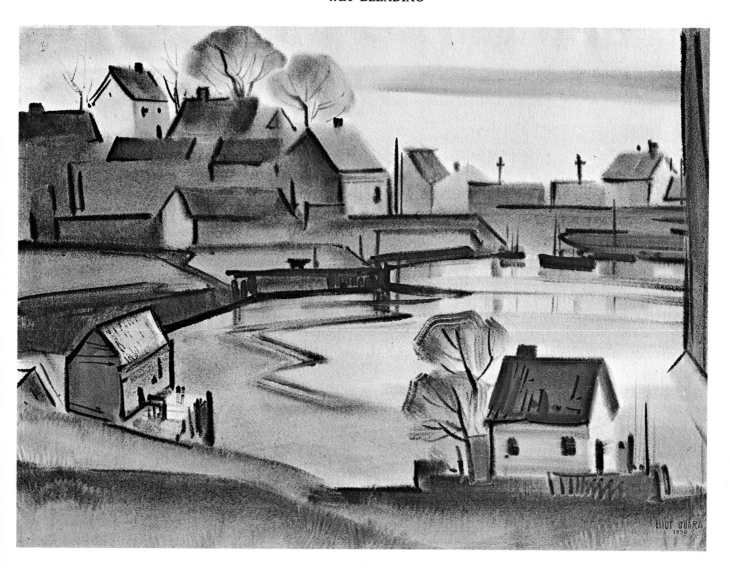

Color Plate 21. Port Clyde, *1950. 22¼" x 30½", 140 lb. rough paper. There are two major difficulties to overcome when using the wet-blended technique: too rapid drying of the paper and pale, lifeless darks. But this method also offers unusual flexibility of paint application, permitting you to put on and take off pigment as long as the paper remains wet. (See Lesson 21.) Notice here how O'Hara wipes out color as he deposits a new tone in the wind ruffles on the water at right. Lifted-out lights help to model the foreground wharf and buildings. The uniform soft edges give wet-blended paintings unusual coherence.*

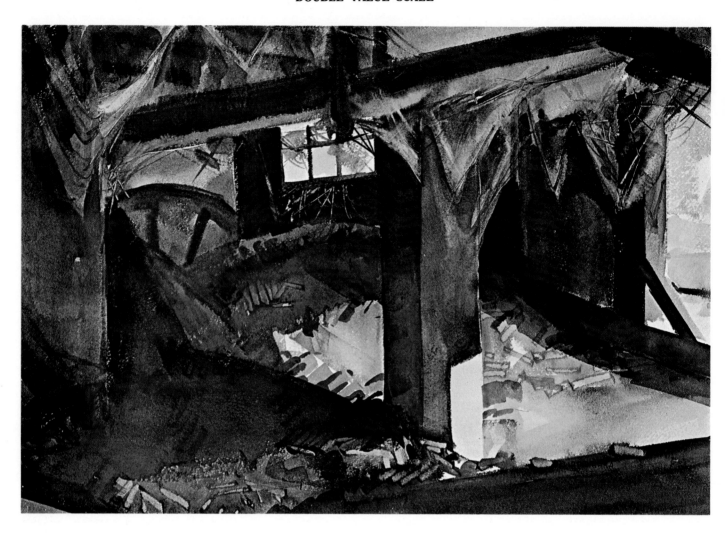

Color Plate 22. Barn Interior, *1945. 15½" x 22¾", 90 lb. rough paper. This painting, a demonstration for Lesson 22, illustrates plainly how effective O'Hara's device for handling the double value scale can be. The very light, undetailed door and window areas leave the artist a range of nearly eight values with which to suggest reflected illumination within the building. Omitting a value or two ensures that the contrast between exterior and interior will be sharp and clear. In painting this kind of subject, it is important to utilize paint almost straight from the tube to guarantee sufficient variation in the deep darks.*

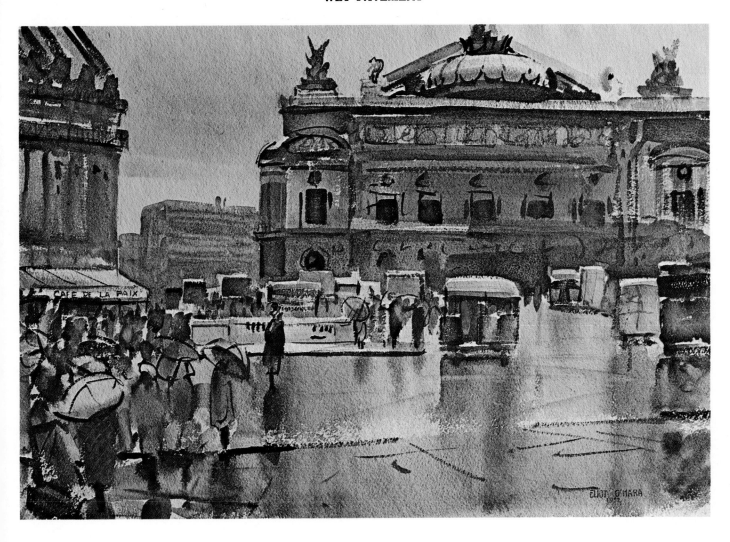

Color Plate 23. The Opéra in the Rain, *1952. 15¼" x 22¼", 140 lb. rough paper. The effectiveness of this picture is due partly to O'Hara's splendid recording of color and value relationships. (See Lesson 23.) Rough brushing is used throughout to suggest reflections from rain-drenched surfaces. You might also study the painting's design, especially the spotting of the greens, reds, and areas of calligraphic drawing. Movement into depth is subtly induced by the oblique curbing in the foreground, but the composition as a whole is supported by strong vertical and horizontal axes, signalized by the square back of the central bus.*

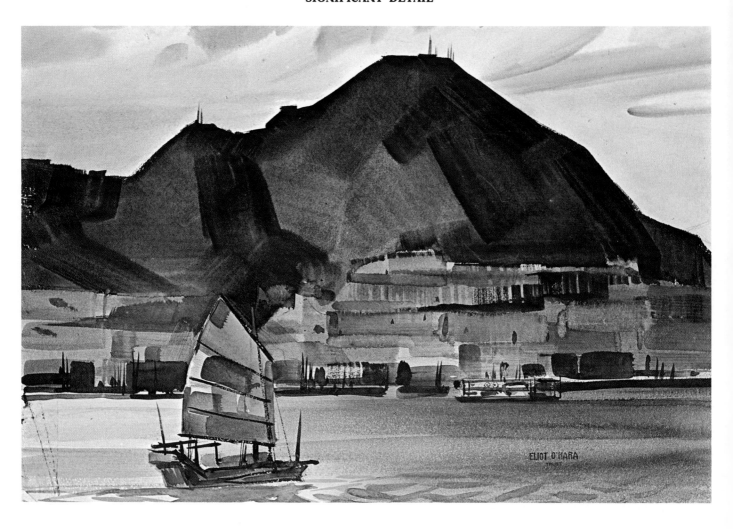

Color Plate 24. The Inland Sea, Japan, *1953. 15¼" x 22¼", 140 lb. cold-pressed paper. O'Hara uses very little drawn detail in this painting illustrating Lesson 24; as much as possible is conveyed through brushwork and texture. This is especially true of the city, which is subordinated as secondary detail. Most of the water is simply depicted, so that it serves as a foil to the more descriptively handled sections. The result is a picture in which absolute conviction is achieved with tremendous economy of means. By choosing only that detail which is significant within his aims and treating it within the terms of watercolor, O'Hara produces a fine and trenchant image.*

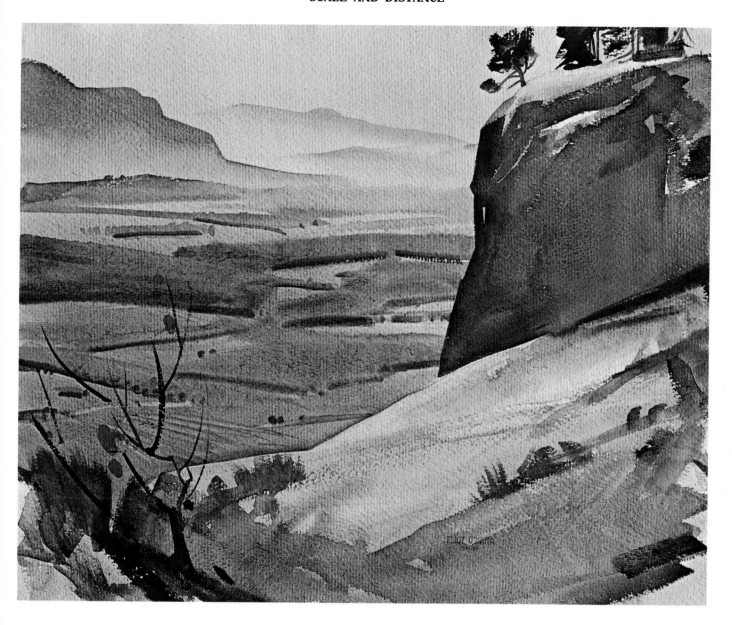

Color Plate 25. From Cathedral Ledge, N.H., *1946. 18¼" x 22½", 140 lb. rough paper. In this painting, an illustration for Lesson 25; O'Hara skillfully uses scale to augment a representational treatment of space. He employs the familiar devices for recession, but also emphasizes the magnitude of the ledge at left with the small pines atop it, indicating its distance from us by making the shrub at left as tall as the ledge itself. A good deal of wet blending softens edges in the distant valley floor, while contrasting rough brushing suggests the actual texture of the crystalline granite foreground.*

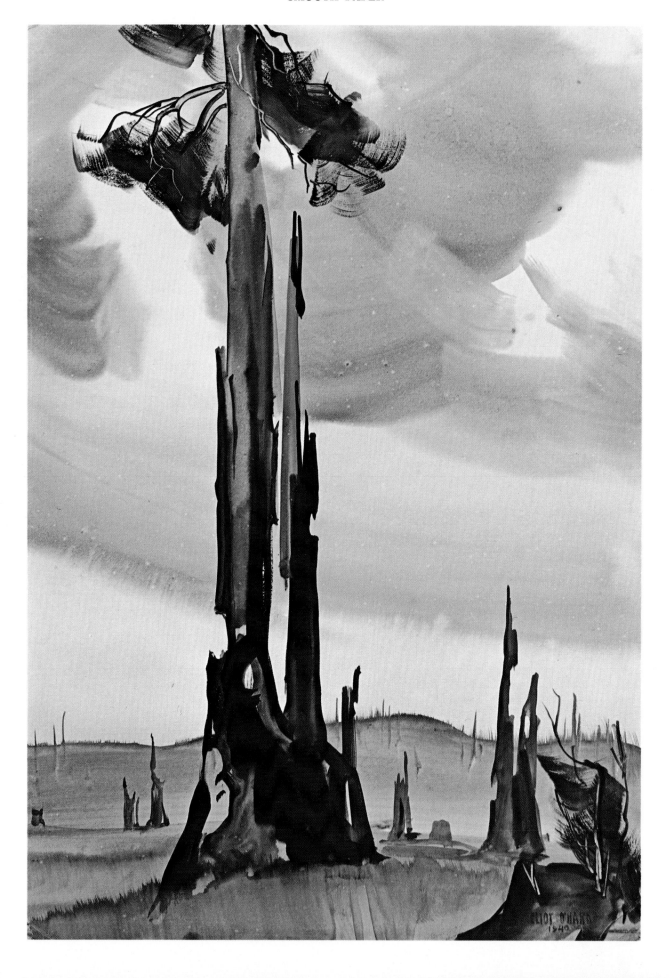

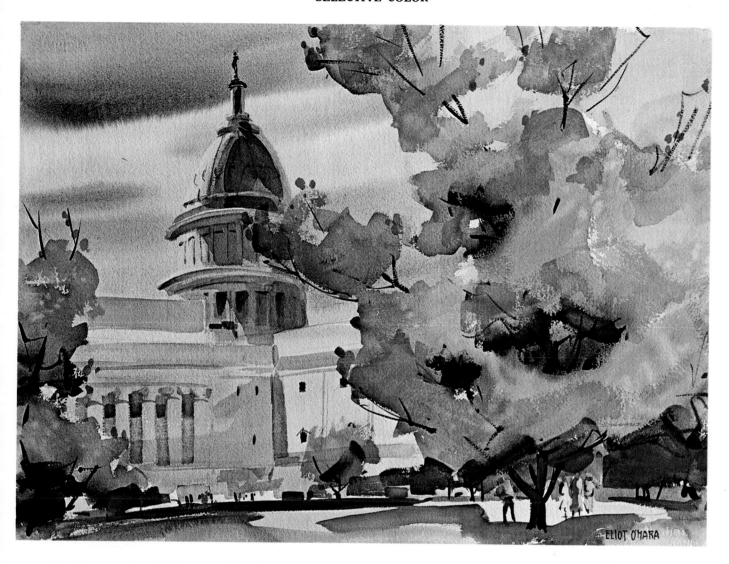

Color Plate 27. Capitol Cherries, *1966. 22¼" x 30½", 300 lb. rough paper. O'Hara chooses to change the pale pink cherry blossoms to violet and to use a harmonizing blue and a contrasting orange to build his color design in this illustration for Lesson 27. A few accents of intense reds, yellows, and greens underscore the basically neutral tones of the sky and buildings. The painting is unusual and distinctive in color, while successfully calling to mind the original scene. Although selective color is commonly adopted for moderately abstract paintings, there is no reason why it cannot also be used in representational contexts.*

◁ **Color Plate 26. Sequoia Sempervirens,** *1940. 22¾" x 16", 3-ply smooth paper. Smooth paper is more receptive than rough to subtle nuances of color, and it permits greater intensity of hue as well. (See Lesson 26.) It has the practical advantage of drying more rapidly than rough and so is sometimes preferable for use in wet or humid weather. O'Hara used it here for both these reasons. Rough brushing, on the other hand, is much more difficult on smooth paper and other treatments must be substituted for it; O'Hara uses whisking strokes, done with a very dry brush, for the foliage in this picture. The disadvantages of smooth paper can be overcome, and you may find that the paper serves your personal expressive needs even better than does rough.*

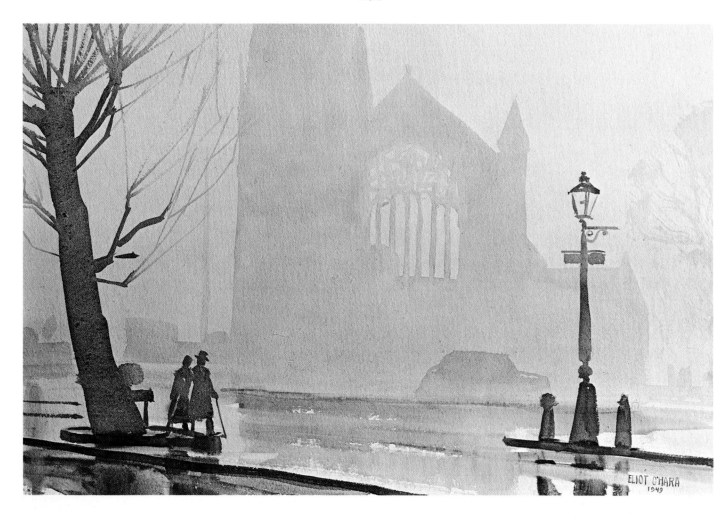

Color Plate 28. London Fog, *1949. 15" x 22", 140 lb. cold-pressed paper. O'Hara manages to maintain the silhouette of the bombed-out church as his center of attention, even though it is very pale in value. He does this partly by bluntly placing the building in the center of the paper and partly by setting the darks well over to the sides of the picture, where they enframe it. Particularly effective here is the obvious transition from light orange to darker blue in the background fog. (See Lesson 28.) It successfully persuades the viewer that the sun is up there above him. Because of the humidity, O'Hara uses the smoother, harder-surfaced cold-pressed paper for this picture.*

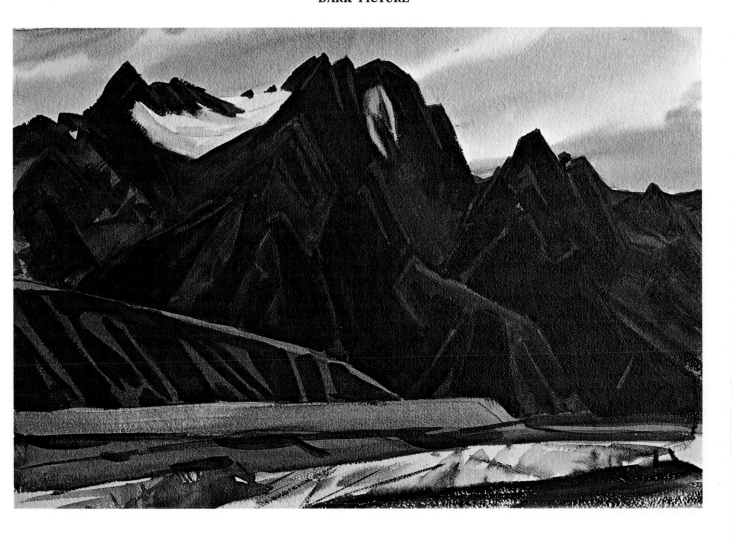

Color Plate 29. Moraine of the Tasman Glacier, *1953. 15" x 22¼", 140 lb. rough paper. A dark watercolor (Lesson 29) tends to claim the special attention often reserved for paintings in other media. This is partly because dark, transparent watercolors are difficult and therefore rare. To avoid unnecessary opacity, or muddiness, you must play intense dark hues against each other and use opaque body color sparingly. Notice here how the reds and blues of the mountains keep those dark areas lively and rich. Touches of opaque Venetian red and cadmium yellow medium are introduced to provide relative lights that help to model the rocks.*

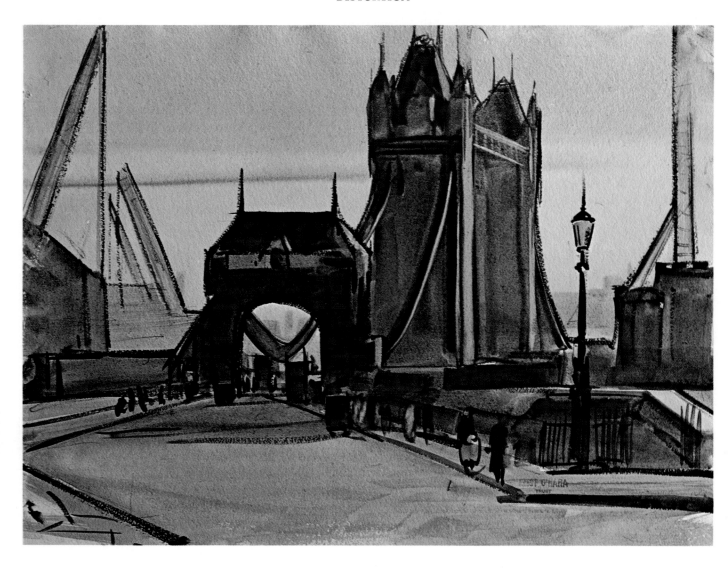

Color Plate 30. Tower Bridge, London, *1952. 16¼" x 22", 140 lb. rough paper. O'Hara's favorite sort of distortion was planar simplification of objects, usually with dynamic tensions or counterforces set up among the planes, and between them and the picture plane. (See Lesson 30.) In such compositions, as here, he frequently limited color as well. Although he enjoyed experimenting abstractly with planes, his planar pictures invariably derive directly from his subject. So, in this instance, the horizontal road and contrasting axial plane of the towers and cables contribute to the observer's sense of the balanced forces of the bridge itself.*

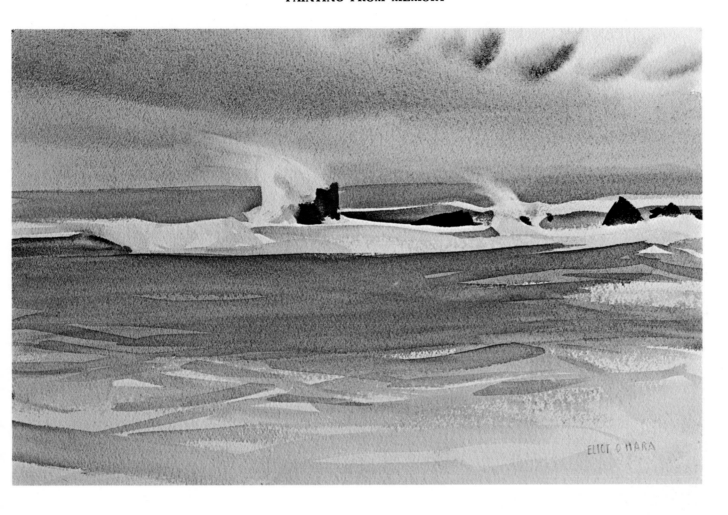

Color Plate 31. Seal Rocks, *1963. 14¼" x 22¼", 300 lb. rough paper. This picture, a demonstration done from a sketch like the one illustrated in Figure 91 (page 167), exemplifies the purity of focus and clarity of statement that are among the great advantages of painting from notes. (See Lesson 31.) O'Hara relies on memory and experience for his color, in this case; but the sense of wave movement and the shapes of the rocks are derived from on-the-spot studies. Painting from notes can provide a useful filter through which inessential detail is eliminated, especially with subjects that are inherently complex, like surf.*

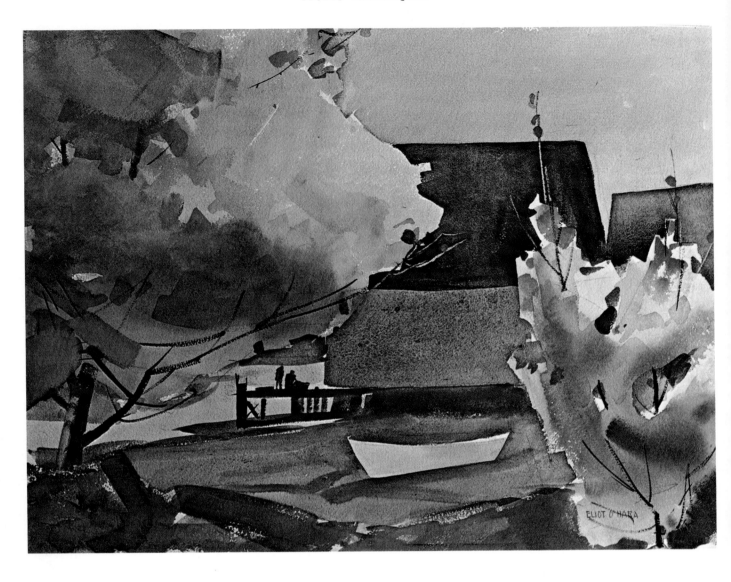

Color Plate 32. Swamp Maples, *1968. 22" x 30¼", 300 lb. rough paper. Painting in the studio was, for O'Hara, an active means of exploring his subjects, of developing his technical handling, and of refining his color. (See Lesson 32.) In this painting he changes a relatively straightforward fall scene into a blazing statement of back-lit red maples by drastically enlarging the area of foliage and by keying that color powerfully with green. All other elements in the original picture are eliminated or reduced to mere accessories. In this more forceful final version, the figures on the wharf are added as a counterbalancing focus of interest.*

LESSON 18

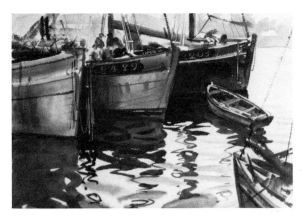

REFLECTIONS IN WATER

This lesson introduces the theory of reflections and discusses a technique for painting them. (For O'Hara's solution, see Color Plate 18 on page 98.)

PROBLEM

The problem with reflections in water is that they are visually complex phenomena. As with other complex elements in the natural world that attract artists, reflections can be most easily handled when the painter is aware of some of the fundamental physical laws governing them. If he knows what to expect, the artist can better discern what he sees and spend more of his time dealing with matters of technique, design, and expression.

We will start with reflections in smooth water, which affords the simplest approach to all reflections. Begin by laying a mirror face-up on a table. Get some objects, including, for example, a saltcellar, a candle-stick, and a pencil. As you stand at the table looking down into the mirror, you will see the ceiling reflected. Now stoop slowly, observing that more and more wall appears, until your eye is nearly at a level with the mirror. From this point of view, you see things that are located very low on the wall, or furniture. This experiment demonstrates that the angle from which you view a reflecting surface has something to do with what you see reflected on it. In fact, in optics there is a law that states that the angle of incidence equals the angle of reflection. This means that the angle at which a hypothetical line from your pupil encounters the mirror surface will equal the angle from that point on the surface to the objects you see reflected. The first diagram in Figure 52 may make this clearer. Your eyes and head move as you look at a reflecting surface, resulting in your seeing a variety of things reflected.

Now, what exactly is it that you see? Not, as you can quickly check, the same shapes you observe above the reflecting surface. This is because what is reflected toward you comes from the reflecting surface. In other words, you see reflected objects as though your eye were at water or mirror level at the point where that angle from your eye hits the surface. You will therefore generally see much more of the *under-side* of an object—or, if the thing being reflected is cubical, like a house, a perspective from below.

How much will you see? If the object is in or on the reflecting surface, all its reflection will be visible. On the other hand, if it is behind the reflecting surface only part of it will be visible. This occurs because the reflection must be calculated as originating from a point where the surface, if extended, would meet the base of the object. You can test this by placing your saltcellar at different distances behind your mirror. See also Diagram 3, Figure 52.

A reflection is, literally, a mirror image: it is reversed. This means that an oblique profile will reflect at an angle opposite to the angle it assumes in the air. Hold your pencil on your mirror and tilt it to either side. Notice that when you tilt it to the right, the angle of the reflected tilt is precisely counter to the angle of the pencil. A moment's thought will explain this, and give you another useful rule. Because the reflection bounces off the surface in a straight line from your eye to the object, any given point on an object will reflect directly below that point.

When you are fairly close to a body of water, there is a point along its surface near your feet where reflections disappear and instead you begin to see *into* the water. This happens because when the angle of incidence is large, the transparency of the water becomes visible and you see light *refracted* from the water itself, or from the bottom if it is shallow

enough. This is the reason for the darkening and warming of the water that can be seen in the foreground of Color Plate 15.

Water generally has some local color of its own. Very clear water, like thick glass, is greenish. But it may also contain varicolored mud and other materials in suspension. Hence, glacial runoff water is milky white, ocean harbor water is often khaki-colored, and some river water is sort of raw sienna in tone. The local color of the water will, of course, affect the color of the reflections, so it is necessary to observe this influence carefully when painting them. However, there is a good rule of thumb to remember: lighter objects invariably reflect darker, and dark objects reflect lighter. This is because in each case the reflection takes on some of the value of the water itself. The reflections will also take on some of the local color of the water, and this you must observe with each subject.

The effects outlined so far apply to smooth water, a mirrorlike reflecting surface. They also apply to rippled water. The chief difference to be understood about rippled water is that with it, you are dealing with a series of tilted mirrors, as it were. From this circumstance flows a number of necessary consequences.

Among the most important is that the ripples are subject to the laws of perspective and will appear

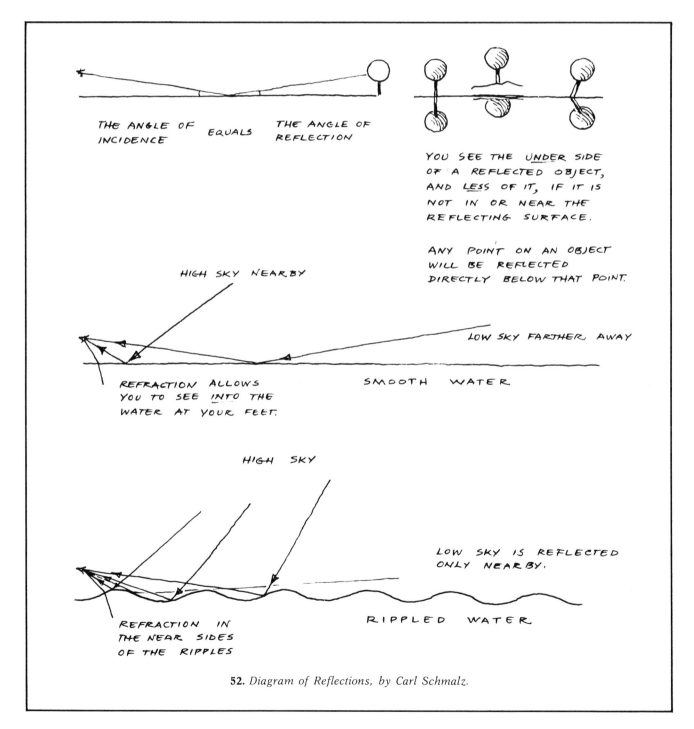

52. *Diagram of Reflections, by Carl Schmalz.*

smaller and closer together the more distant they are from your eye. Secondly, because the "mirrors" are tilted, the angles of incidence and reflection vary more than they do on smooth surfaces. Diagram 5 in Figure 52 may help you to understand this more clearly, but a simple explanation is this: ripples close by present a near surface *into* which you see because the tilt makes the angle of incidence large. There you will see local color refracted from the water. As the wave or ripple turns, you will see some high-sky reflection. Similarly, high sky will be reflected in the near side of ripples at some distance away. The far side of the ripples will not be visible at all after a short distance, but nearby they will reflect at a very small angle of incidence and you will see in them low sky or objects near the horizon.

If the reflected object is on or in the water, its closeness to the surface will cause it to reflect for a short way in the near side of the ripples. The reflection will continue to be visible in the far side of the ripples as they extend into the foreground. The reflection will therefore be longer than you would expect.

A concluding observation: erratic breezes across both smooth and rippled water surfaces alter the reflecting properties of those surfaces and often appear as lighter or darker swaths. They are often useful to help denote the actual surface of the water in your picture.

PROCEDURE

For this lesson it is really important to paint on location. Reflections are such complex phenomena that your attempts to simplify them—to separate their various components according to what you know about how they work—will be most valuable if undertaken in an actual situation. Furthermore, because rippled water is both more usual and more difficult, it will be desirable for you to find a subject that includes rippled water. If possible, choose something exceedingly simple: remember that you are going to paint it twice, once in the air and once in the water!

Composing a picture with reflections requires a little special thought because with many things in the picture mirrored immediately below, the patterns of light and dark are altered. This time, however, do not worry too much about design. Sketch in the ob-

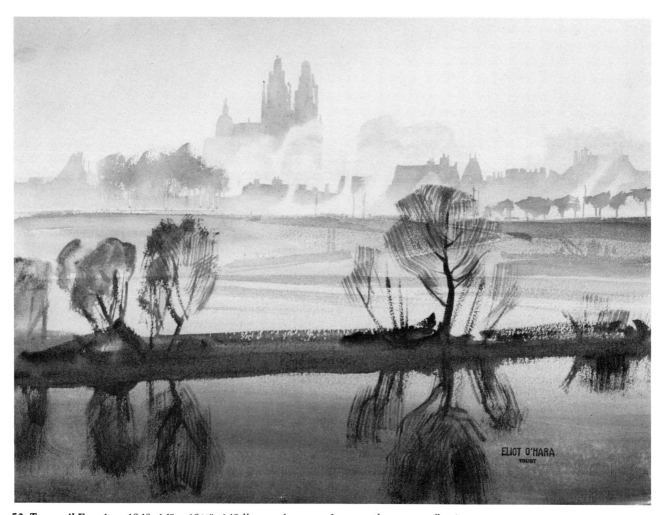

53. Tranquil Evening, *1948. 14" x 19½", 140 lb. rough paper. In smooth water, reflections are literally mirror images. Notice how O'Hara carefully and exactly reproduces the foreground trees in the water: each element above is reflected directly below itself. This painting is also an excellent example of recession; although you cannot see the color, the cathedral towers are a warm gray, due to the evening light.*

jects you will paint, being careful to place them well up the paper so as to leave ample space for their reflections. Number the values as usual and begin painting from light to dark.

Ordinarily, it is prudent to finish painting the objects that are to be reflected before painting the reflections themselves, because there may be some changes in the location of elements during the painting of the upper part of the picture. However, when you come to paint the reflections you will want a dry surface on which to put them. Therefore, paint the water in the value sequence. Usually this will be fairly soon, since most of the water will reflect sky colors that are relatively light in value.

To paint the water, wet the area with clear water. Be thorough, because you have to do three operations in a single drying time. Add appropriate color— darker at the horizon, if it shows in your picture, lighter nearby where you see more of the low sky reflected in the far side of the ripples. While the wash remains wet, load your brush with high-sky color; make sure that the brush is quite dry, since there is enough water already on the paper. Beginning with the nearest water, make fish-shaped strokes in a kind of weaving pattern. Let the nearest ones be large— much larger than you see them—and gradually become smaller and closer together as you move up the paper. Let them become lighter, too, as the brush runs out of color. (Later you can practice reloading the brush and making ripples of various sizes and colors over a large area of paper). Clean the brush and dry it once more. Load it with a color for the *refracted* light in the nearby water. This may be the color of the water itself, or the color of the bottom, or a mixture. While the larger, near ripples are still wet, add the refracted color to their lower, or nearer, sections. (When you are surer of yourself, you may find it more efficient to paint these near ripples with a double-loaded brush.) Let the whole area dry while you attend to the upper part of the picture.

When you have finished the section of the picture in air and when the water is dry, you are ready to do the reflections. Again, proceed from light to dark, and let edges between tones be hard. It may help if you have roughly located the reflections and indicated their angles in your original drawing. You will notice that all of the reflections partake somewhat of the color of the water. Remember that light objects reflect a bit darker than they appear above, and that dark objects will be a bit lighter in reflection. As you paint the edges of the reflections, let your brush follow the ripples already indicated, and *do* recall the effect of perspective, making the wobbles nearby progressively larger than those farther away. Pay special attention to the proper angle of reflection of any oblique lines in the picture. Use a small brush for the reflection of any ropes or rigging you may want to include.

O'HARA'S SOLUTION

After the usual simple drawing, O'Hara begins *Brittany Boats in Cornwall* (Color Plate 18) with the water. The summarily indicated background will go

in easily later. You might notice how little sky he includes—the subject is the animated surface of the water. He wets the paper thoroughly and evenly and with a dry brush puts over it a pale tone made largely of ultramarine blue and raw umber. A touch of alizarin reduces the impression of greenness. The same colors—easily perceptible on the paper—are used for the middle and background ripples. You can see how he lets the brush run out of paint and narrows the strokes at right. For the larger foreground ripples, in which refraction plays a part, he adds some yellow.

He lets this wash dry for a few minutes before starting the boats. These he paints in the usual order, from light to dark, and beginning with the left bow, which is cobalt blue with a little sepia. He leaves the bumper rail, just below the gunwhale, white paper. Rust streaks are put in with burnt sienna while the blue wash is still wet. The second boat, nearer the center of the picture, goes in with pure ultramarine blue. Here the rust stains are also more intense, being painted with vermilion. The right boat is a dark, somewhat neutralized phthalocyanine blue. Its bumper rail is knifed out. Notice how simply yet effectively he models the hulls by lightening them just aft the bows. Working very rapidly, O'Hara returns to the left side of the picture, indicating the bundled sails and other detail with yellow, raw umber, and burnt umber. He models this material with broad knife-strokes and suggests the ropes with knifed lines. A light, neutral vermilion and sepia mixture colors the bumper rail, and a small brush with ultramarine, then sepia, provides a hint of the planks of the hull, and hanging ropes. The sailors and the details of the other two boats are set in with similar colors and equal speed. Particularly noteworthy is the knifing-through black with which O'Hara so skillfully indicates the ships' numbers. A warm gray mixture of ultramarine, alizarin, and raw umber stands for the distance. Through all of these tones O'Hara knifes bits of rigging.

The dinghy and the bow at right go in quickly. Again O'Hara paints on a base tone—for the dinghy, burnt umber—and knifes out major details. When the area is dry, he returns with darker shadows of alizarin, ultramarine, and burnt umber. The foreground bow is very boldly executed with raw umber for the deck; some details are set in with paint so thick as to be virtually body color—yellow and raw umber, and alizarin and burnt sienna.

Now for the reflections. O'Hara starts at left, using cobalt blue, raw sienna, and a little burnt umber. Observe how he breaks up the reflection: the lighter parts of the water stand for the far sides of the ripples, where the reflections will be seen as they waver and fragment. The reflection of the central boat is painted mainly with ultramarine and raw umber. Some darker strokes of the same mixture suggest ripples within the reflection and knifestrokes through it continue the hanging ropes. The same color again is used for the third reflection, and that of the dinghy. O'Hara goes back into this with black and

phthalocyanine blue to animate the area and suggest the shaded area between the two boats. Reflections of masts and rigging are done with a smaller brush and tones of phthalocyanine blue with varying amounts of raw umber. The irregular ovals indicate places where the linear reflections extend over the rounded tops of the ripples. A few rough-brushed lines complete the effect of rigging and seal the nautical flavor of the picture.

COMMENT

The reflection phenomenon remains one of the most difficult of subjects in watercolor, and mastering the ability to produce fresh, wet-looking water requires practice. Once you can handle the problem, you will discover that there are other parts of a reflection scene that you will want to include. Primarily, these are shadows cast on the water, and reflections from the sun on the ripples that sparkle in the shadow sides of objects near the water's surface. The first may be treated exactly as shadows cast on a solid object, with due attention to the shaping of the edges in accordance with the rippled surface. The second is effectively suggested by using a dried-out brush to pick up linear flecks out of a wet wash.

You may also decide that you prefer to treat the near side of the ripples as they actually appear—that is, with hard edges. Experiment with the technique: you need simply to wait for the wash that stands for the color reflected in the far side of the ripples to dry. Be wary, though, of overcomplexity with this method, and try to retain clarity by overstating the size of the ripples.

With reflections in water, as with any other subject: when in doubt, trust the evidence of your own eyes.

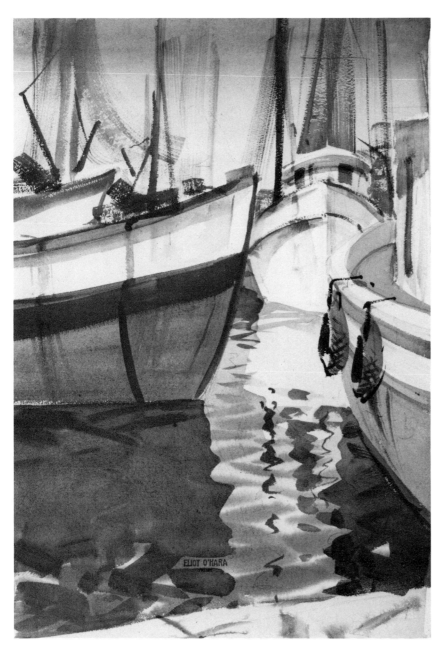

54. Calm Harbor, Florida, *1965. 22" x 15", 140 lb. rough paper. A late demonstration for reflections in water, this painting shows clearly: (1) the near side of the ripples wet blended into the tone for the far side of the ripples, and (2) light things reflecting darker, dark things reflecting lighter, owing to the local color of the water. Compare this treatment with O'Hara's 1939 painting, Figure 82 (page 155), which is much less broadly handled.*

LESSON 19

THE PATH OF VISION

This lesson introduces one approach to unified pictorial design. (For O'Hara's solution, see Color Plate 19 on page 99.)

PROBLEM

You may at first be attracted to a picture because it stands out from things near it, exhibits a gripping pattern, contains some cherished colors, or reminds you of the place where you spent the summer as a child. You will continue to look at it and return to it, however, only if its various parts hold your interest. And you will find that you tend to look at those parts in a fairly constant sequence. As an experiment, flip through the pages of a magazine until some picture arrests you. Examine it, trying consciously to remember how your eye moves around the image. You will probably discover that there are a number of focal points to which you return—perhaps in varying order. There may be a tendency, however, for you to start near the bottom center and to move counterclockwise around the picture.

Human beings acquire visual habits early in life. It is natural to look from the ground up, and—for Western man, at least—from left to right. But these patterns may be offset by a number of factors within the artist's control. For example, a viewer's eye will move toward and examine any thing or area that is high in intensity or that exhibits a strong value contrast. Equally attractive is an area of irregular or unusual shape (within the context of the particular picture). Parallel lines, axes, and especially lines that converge or exhibit a rhythmic relationship to each other will also provide an area to which your eyes will return and by which your eyes may even be directed.

By your placement of such eye-catchers you can exert considerable control, in both subtle and obvious ways, over which "path of vision" a viewer will most frequently follow in looking at your picture. The path of vision is, therefore, one of the means you may adopt to organize your work. It has a number of advantages. In the first place, it makes you think about the timing and sequence of the visual encounters that will most clearly present your meaning. Second, because it is based on the dynamic act of looking, it provides an important alternative to more static means of composition. Third, it offers the possibility of introducing a temporal rhythm into a painting.

PROCEDURE

Begin this lesson by getting out six to ten of your old paintings and examining them from the point of view of a path of vision. Check to see whether or not some of them display a more or less unconsciously designed sequence for the eye to follow. Look further at any that do and try to figure out what elements in the picture are producing that tendency. You may find that a series of similar shapes, that change in size, prod your eye along in a given direction. One thing you will certainly discover is that anything having to do with mankind—a figure, a building, a car or boat, a tool or utensil—will exert an almost irresistible pull. Planes, such as the sides of buildings, will push or pull your eye along them, and barriers such as fences or walls will tend to impede progress.

Working either on location or on the basis of a painting already completed, make a series of small sketches in which you deliberately plan your scene to emphasize a particular path of vision. Remember that your composition exists not only on the paper's surface, but also in the illusory depth you create. You may therefore direct the eye of the viewer in and out of space. You will find that the perspective effect of parallel lines—furrows in a plowed field, for instance—can be especially useful in leading the

eye into pictorial depth. Such devices are extremely powerful and usually must be counteracted at their focal point by something of great visual attraction at or near the picture surface: a strong value contrast, irregular contour, intense color, or a man-related object.

The corners of your picture may present special problems since oblique lines there will often exert some pressure to lead the eye *out* of the picture. Fortunately, both skies and foregrounds permit a certain arbitrariness of treatment, and you may find it helpful to plan some angular shapes at the corners to cut off such oblique lines. O'Hara has done this in the lower left of Color Plate 19 and in the upper right of Figure 55, as well as in numerous other pictures reproduced in this book.

From among your sketches choose one that seems promising and paint your picture in the usual manner. When it is finished, set it up and cast a critical eye over it. To what degree does your planned path of vision seem to work? Is it too obvious, pushing the eye in an overbearing fashion? This may well happen with a first effort.

On the other hand, your path of vision may be so weak as to leave the eye floating around the picture on its own; or you may have unthinkingly set up barriers that impede interesting progress—an unfortunately placed stone wall or a set of telephone wires. Having successfully maneuvered your viewer's eye around the picture, perhaps you discover that you have not in fact shown him much that is interesting. These are all problems you can solve once you become aware of them. Remember, when you ask your viewer to travel in a direction contrived for him, you must provide a logical and engaging reward.

Finally, this is a good lesson in which to observe something that applies to all pictures: namely, that you will invariably respond at first to your picture in terms of its failure to be what you hoped or envisioned it would be when you started. Keep your pictures around, in easy view, for several weeks before making any final judgment of them. Very often they have good qualities that you initially overlook in your disappointment at failing to meet your original goal. Don't throw out paintings for at least a year.

O'HARA'S SOLUTION
Flatiron Building, Boston, England (Color Plate 19) exemplifies a superb solution to one of the most difficult of compositional problems: divergent roads

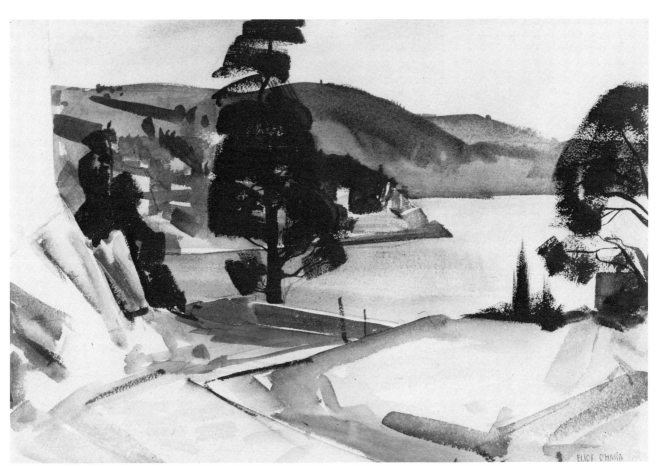

55. The Bosphorus from Rumeli Hisar, *1952. 15" x 22", 140 lb. rough paper. One of the simplest kinds of path-of-vision compositions includes a road winding into the picture. Here O'Hara zigzags the angles of the road in to the left. A crag running out of the picture top contains the line of the wall and the shadows on the hill beyond. Repetition of the shadow angle in the central hill brings one to the right side of the picture, through the foliage there, and to the foreground again.*

into depth. O'Hara's method is to adopt the path-of-vision type of design, so that the eye is led effortlessly around the picture without getting caught in cul-de-sacs at the end of each of the streets.

Although there is room for disagreement about the order and direction of the eye in this painting, most viewers will "enter" at lower left, easily overleaping the arbitrary brushstrokes on the road. The force of perspective on the streets is strong. Most viewers, however, through habit, will take the right fork, going back into space and then forward, again, attracted by the complex shapes and lettering of the upper-right corner of the paper. From there the TV aerial and chimney pots draw the eye, and diminishing aerials conduct one to the end of the left street. The eye moves comfortably down and forward into the central sunlit area and then across to the dark doorway and sign at lower right. Notice that this interesting, rather angular route causes you almost to overlook the strong vertical-horizontal architecture of the painting, which is established by the central vertical motifs (echoed at either side) and the horizontal of distant roofs across almost the exact center of the picture. These stabilizing elements encourage the viewer's eye to move about the picture with innocent freedom, allowing him to absorb the contrasts that form the picture's basic subject.

What has O'Hara planned for you, the observer, to see on your trip around his picture? You are introduced to twisting streets that stand for the picturesque architecture of the old town. Their turns do not permit you to look down them very far and you are brought immediately back to the foreground, where the sign for bus service alerts you to the contrast between old and new. In the same area you are asked to note the contrast between old ornamental ironwork and the contemporary silhouette of the central antenna (itself contrasting with the elaborate old chimney pots). This theme is repeated on a smaller scale in the distance to the left. Below, the sign "Teas" again evokes traditional England. And so across the brightly illuminated streets to the little tobacconist's shop, whose proprietor's sign may have initially motivated O'Hara to paint the picture. Whatever the case, you are once again confronted with a witty conjunction of past and present as G. O'Hara, shopkeeper, enters the world of Eliot O'Hara, artist, and vice versa. Indeed, the journey around this picture arouses sufficient interest to lead you on again and again, to contemplate and consider the implications of the work.

O'Hara first lays in the sky wash, using phthalo-

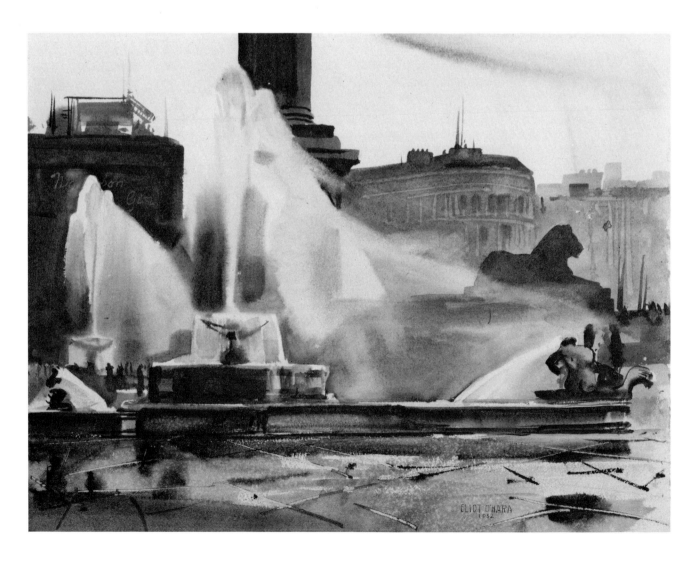

120

cyanine blue slightly neutralized with alizarin, and blending into it yellow, then alizarin, as he moves to the right. Note that the change of tone will reinforce the general angle of the receding roofs at left.

While this wash dries, he paints in the sunlit color for the pavement with a warm neutral, mainly sepia and burnt umber. A few touches of yellow and vermilion are introduced for variety. Again largely using vermilion, O'Hara introduces the sunlit sides of the roofs and buildings at center, and the blue of the shadowed roof reflecting sky just to the left of the top of the "flatiron building."

The lighter tones in the shadows go in next. Yellow, orange, and alizarin, variously neutralized, compose the storefronts at extreme left and right; orange and yellow is used for the reflected light under the architectural fancy at upper right. Blues and violets for the shadowed roofs go in next, followed by the richly varied tones of brick in shadow. These colors are chiefly sepia, alizarin, black, Venetian red, and vermilion in different combinations. Cast shadows on buildings and pavement are set in with cobalt blue in admixtures of vermilion, orange, and yellow. Notice especially how O'Hara provides extra interest in the shadow in the right foreground by allowing the paints to remain incompletely mixed, and by

quite deliberately leaving sparkling lights within the shadow area. The relatively muted color scheme of the painting is greatly enlivened by keyed color: oranges and blues, yellows and violets.

Outlines and details define the edges of forms and the tracery that makes up a significant part of the picture's subject. These are mainly done with sepia and black. Some final brushmarks on the foreground road help to keep the viewer's eye from drifting out of the lower-left corner.

COMMENT

It should be stressed that (as is the case with others of his devices) O'Hara intends the path of vision to be understood as a suggestion, a concept by means of which you may think in a useful way about your pictorial design. Only the most blatant path of vision will command everyone who looks at a picture to follow in the same way. This is clearly not your purpose. Rather, by thinking about one or more paths of vision, you may study your subject with a view to composing an arrangement that will invoke some logic and temporal rhythm in the placement of individual parts, thereby enhancing your content.

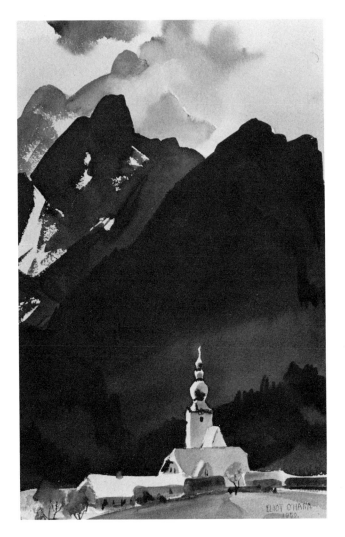

(Opposite Page)

56. Trafalgar in the Wind, *1952. 16¾" x 22", 140 lb. rough paper. A less obvious path of vision is set up in this painting. Knifed lines in the foreground gently lead the eye to the vertical fountains and column. Windblown spray (paralleling the cloud above) carries the eye to the lion, where it moves back into the picture along the jet of the lower fountain. For wet pavement techniques, see Lesson 23.*

57. Bavarian Alps, *1959. (Left) 21½" x 13½", 140 lb. rough paper. The path of vision is less important here than is repetition of shape: the verticals and gables of the buildings are echoed in the peaks at top left. The wet-blended darks in the mountains, however, aid the eye in moving up the tall, narrow paper to the peak and down the right to the church again. Photo by Gerhardt.*

LESSON 20

CALLIGRAPHY

In this lesson you will investigate the nature of calligraphy and some of its uses in painting. (For O'Hara's solution, see Color Plate 20 on page 100.)

PROBLEM

Calligraphy literally means "beautiful writing." The word applies to fine script, most often that written with a brush, such as Arabic and Oriental script. By extension, it also denotes the brushstrokes traditionally cultivated by Chinese and Japanese painters to stand for elements in the natural world. Such signs, frequently developed and refined over centuries, stand for a variety of leaf, rock, water, and drapery patterns. They add elegance and clarity to the visual image; and at the same time they provide the artist with an economical means of rendering complex forms.

In Western art, calligraphy has not been a culturally shared phenomenon but rather a pictorial device selected by individual artists and adapted to their personal expressive needs. Raoul Dufy and Paul Klee both employed calligraphic signs in ways fundamental to their mature styles. Dufy used calligraphy in a manner reminiscent of Oriental usage, repeating within the painting the same signs for the same things. Klee, on the other hand, tended to employ calligraphy less methodically, fitting his signs to the special purposes of each work. Joan Miró's use of signs falls somewhere between Dufy and Klee. In addition, the drawing styles of many Western artists, notably Rembrandt, draw heavily upon the principles of calligraphy.

Calligraphy is generally linear in character. You should recognize, however, that it is above all simply another kind of abstraction—that is, a means of translating effects seen in nature into the terms of pictorial materials and techniques. It can perhaps

be best understood as a systematic contraction of the more usual brushstrokes, themselves, of course, already abstractions from nature according to the limitations and demands of paints and brushes.

Traditional calligraphy is a deliberate and consistent shorthand, which you may find incompatible with your particular artistic needs. Nevertheless, explore its uses, since a bit of calligraphy is frequently effective within a painting that is largely done in some other mode. It can be used, for example, to clarify abstract color areas, to provide textural or patterned points of interest, or to deal simply with areas of great complexity.

PROCEDURE

Decide upon a subject. Any subject will do, because your principal concern in this lesson is to extract *from* the subject a group of linear symbols to label areas of color that will be otherwise undifferentiated.

Before you begin your drawing, take out your sketchbook (or use the back of a sheet of watercolor paper) and pencil. Study your subject carefully to determine the sort of color patterns that will most adequately express its salient qualities. While you are thinking about the colors, begin doodling a little to see if some calligraphic signs don't suggest themselves almost automatically. You may find, for instance, that your hand starts to draw repeated series of triangles or scallops to stand for the edges of foliage masses; or a set of right angles may serve to indicate windows. Note down as many of these signs as possible. Are there sections of the subject where textures could be indicated by signs? Perhaps a gravel road may be suggested by some small circles or ovals. A building's shingles might be evoked by a pattern of L's.

When you have set down as many calligraphic

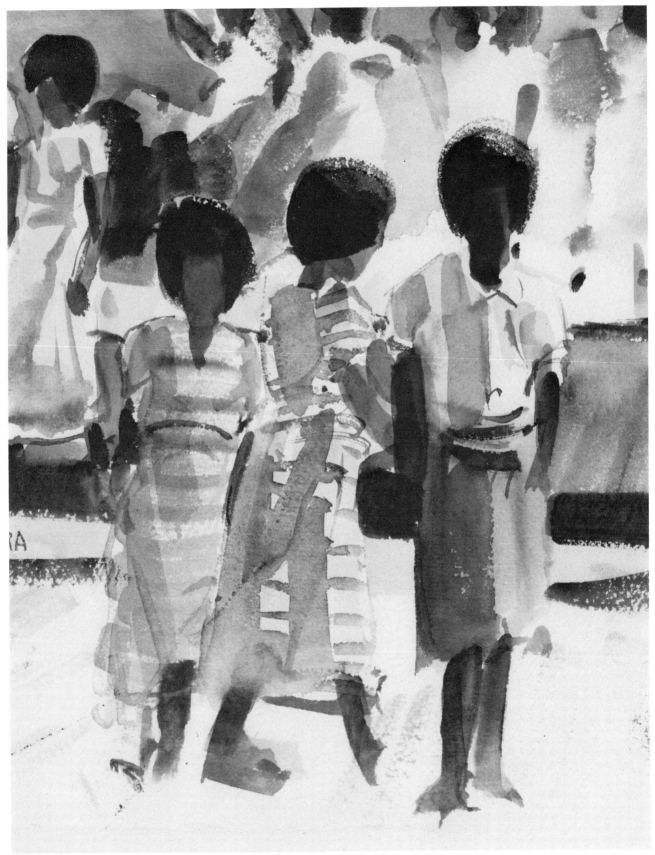

58. Kids on a Wharf, *1953. 7" x 9" (actual size), 140 lb. rough paper. This detail from a harborside sketch shows how O'Hara handled figures in a representational context. Observe his attention to light effect and texture, and his ruthless supression of background figures. Each of the three main women, however, is given a special dignity, stance, and movement, largely through modeling and light.*

signs as you can, pause to look at them. Remember that what you are after is not a miniature drawing but an abstraction, a simplification that either by itself or when repeated will conjure up the whole. Eliminate any signs that are too complete, but select, if you can, from those overexplicit signs the significant lines that connote the quality you wish to suggest.

You may find you have included some rather common signs—scallops for waves or flat-bottomed bubbles for cumulus clouds. These are not necessarily useless. After all, you are searching for means to clarify your picture and familiar signs will help. On the other hand, signs that are frequently used may not carry your *particular* feeling about the thing denoted. Consider critically whether or not these signs say what *you* want to say, and if they don't, try to invent more personally expressive ones.

When you have in hand a set of signs, start your painting. You may sketch lightly and very abstractly the main areas of the picture, but be careful not to indicate anything in detail. Begin painting from the lighter areas to the darker, placing the colors with an eye to their pure design. Do not draw exact contours, for the calligraphic signs to go on later will define the tones. You may allow white paper to show between some of the colored shapes, and in other parts of the picture the tones may blend together if you like.

Although it is not necessary that all the calligraphy go on after the color areas have dried, you will find that most of the paper will in fact have dried by the time you can get to them. You will need your rigger or highliner for much of the calligraphic drawing. Using the notes in your sketchbook, "label" the unarticulated areas of your painting. Try to remember that here, as elsewhere in art, a measure of restraint will prove rewarding. Do not think that all your calligraphy must be done in black or dark brown. Light lines will sometimes be more effective than dark ones, and often colored lines will add to the feeling you are after. If some blended signs would be better than sharp ones, quickly dampen the proper area and draw in the calligraphy before it dries. Indeed, if you have been fast enough, you may find that you can employ oozled lines in some parts of the picture.

Before you think you have finished, get up and look at your picture for a few minutes. If what you were after is there: *stop.* It is perhaps even easier with this sort of painting than with a more usual representation to overwork the paper. Too little calligraphy will, on the whole, serve better than too much.

O'HARA'S SOLUTION

O'Hara starts *St. Augustine* (Color Plate 20) by painting the lightest tones in the portal, using a mixture of raw sienna, yellow, and a touch of cobalt blue. The pale shadow that models the center horse goes in with the same colors, but with a touch of alizarin crimson moving the tone toward violet at the edge of the illuminated sections. The surrey canopy is a variant of this mixture. He next puts in the wall of the build-

ing, starting at the left with a somewhat darker mixture of raw umber, yellow, and cobalt. The tone varies across the painting, lending interest to the flat background. O'Hara is careful to paint around the lighter parts of the tree and the architecture.

Some of the shadows detailing the entrance go in with the wall tone, but the artist moves quickly to a cobalt, yellow, and alizarin mixture to indicate cast shadows and uses a stronger yellow for reflected lights. These are adjoined by the alizarin, ultramarine, and burnt umber mixture of the doorway. A similar color, darker and with unmixed ultramarine, articulates the shadow within the portal.

O'Hara uses burnt sienna and ultramarine blue with a little sepia for the tones of the tree trunk and the pavement in sunlight at lower left and center. He paints the automobile hood and fender with burnt sienna and black, and continues to the right with almost completely abstract strokes that will later be defined as figures by means of calligraphic signs.

Ultramarine and alizarin brushmarks angle in at the left to indicate tree shadows on the wall, and the wet-blended burnt sienna horse goes in immediately afterward. Patches of yellow and of intense yellow green are spotted about the paper, standing for clothing and leaves. O'Hara then paints the tree trunk in sunlight. While it is still moist he indicates both its shaded side and the shadows cast on it by branches.

For these he uses an alizarin and ultramarine mixture, and raw umber mixed with a bit of sepia. These strokes blend into the still-wet trunk. Working in the shaded area, he uses more burnt umber and burnt sienna to create a rich effect of reflected light. Similarly, on the lower trunk to the left, yellow indicates powerful light reflection from the pavement. The darkly silhouetted branches of the upper-central portion of the picture are set in with sepia and a touch of alizarin on a very dry brush deftly moved. Some defining and clarifying shadow tones go in next: around the white horse's forelegs and under his belly, behind his rump and in front of the surrey, and in front of the car and around the horse at left.

O'Hara is now ready for the calligraphic clarification. He uses a rigger brush for these lines and is mainly concerned to bring out from the shapes and tones on the paper the full feeling of morning sparkle and the tempered bustle of the Southern town. He uses pale brownish violet paint for the definition of the white horse, amplifying this with yellow and burnt sienna lines for the surrey shafts. The carriage at left is indicated with a series of ovals that stand for wheels and then, when moved further to the left, suggest the horse's harness. At right vigorous and agitated curving lines are employed to animate the figures; and crisscrossed lines form the body of the surrey and the white horse's neckcloth. Notice that lines in the figures echo the shape of the heavier branches above.

Some final rough-brushed darks accent the architecture. Surveying the picture, O'Hara notes that the tree trunk goes into shadow too abruptly and he brushes over the light section with a warm tone, roughly applied, to soften the transition.

COMMENT

The distinction between calligraphy and various kinds of outline drawing in watercolor is often hazy. *St. Augustine* shows that they can be effectively combined within the same picture, however, as long as there is no abrupt contrast between the two ways of defining forms. The thing to aim for is consistency — consistency of treatment, and consistency between the treatment and the aspect of the subject that you are emphasizing. Above all, avoid thinking of calligraphy as a means for saving a picture gone wrong. Though you can sometimes pull it off, the usual result is a painting that appears to be done haphazardly in several modes or a picture seemingly overlaid with a proliferating growth of lines.

Do remember that if its manner accords with your own vision of things, calligraphy, a serious mode with an ancient and honorable lineage, will be well worth your cultivation.

(Opposite Page)

59. Damascus Gate II, *1959. 22¼" x 15¼", 140 lb. rough paper. O'Hara first tried to portray this scene quite realistically, but was displeased and made this second effort. Here the flying awnings are more summarily handled and the figures — masses of white paper and cobalt blue — are given some identification by calligraphic line.*

60. Damascus Gate III, *1959 (Left). 22¼" x 16¾", 140 lb. rough paper. On the third try, also unsigned, O'Hara further simplified the market bustle. The awnings are increased in number, but are much less complicated in total shape. Color in the figures is further reduced; one has an impression of white and blue only. Calligraphy in the figures is more constant and more telling. Busyness is sacrificed for clarity of composition and expression.*

LESSON 21

WET BLENDING

This lesson introduces an alternative technique for direct painting in watercolor. (For O'Hara's solution, see Color Plate 21 on page 101.)

PROBLEM

The wash and rough-brushing technique of direct watercolor is by far that most commonly used by American painters. A substantial minority, though, have found that for their special message wet blending offers a more satisfactory result. Its uniformly soft edges minimize the problems of awkward juxtapositions of tone and at the same time provide a consistent handling that unifies the picture. Despite the overall blending, strong images may be made by this technique, and particularly harmonious coloration may be obtained through the flow of tone from one area to another.

Whether or not you wish to work exclusively in the wet-blended technique, however, familiarity with its difficulties and advantages will benefit you. As with calligraphy, wet blending may be used within the framework of a picture painted primarily in another mode; and it is not uncommonly a logical choice for special subjects or effects.

PROCEDURE

Two technical difficulties are peculiar to wet blending: first, keeping the paper wet long enough to permit prolonged work on the picture; and second, learning to get values dark enough to obtain a satisfactory result when the entire paper has dried. The first problem is fairly easily solved, but the latter can be mastered only with the acquisition of judgment through practice.

To begin, select a subject and on a new half sheet of rough paper make your sketch indicating the general disposition of shapes and areas. Make the draw-

ing somewhat darker than usual because the wetting of the paper, plus the painting, will subject it to more than normal abrasion. You will also be wise to number values carefully; they constitute a special problem.

Now, to keep the paper wet; you may soak it for about half an hour in a sink or bathtub. (If you soak it much longer than this, some of the paper fibers may loosen and make your picture extra fuzzy). Before painting, place the wet paper on a thickness of soaked newspapers. They will help to supply the back of the paper with moisture and so maintain its wetness. Usually between sixteen and twenty sheets of newspaper will do the trick. Soak them well.

Or, you may prepare your wet newspapers and then drown both sides of the watercolor paper with your brush, applying the water as tenderly as possible to avoid dislodging the fibers. Needless to say, your largest brush will hasten this job, or you may prefer to use a sponge. In either case, let the paper dry a little and then wet it once more on both sides.

You have two other options, though each is probably best used in conjunction with the procedures described above. First, you can choose to do a wet-blended picture on a humid day. When the atmosphere is moist, your drying time is naturally extended (if you plan to work inside in the winter, this advantage may be canceled by dry artificial heat). Second, you can put a drop or two of glycerin in your painting water. This will retard drying by perhaps half again the usual drying time.

For this project it will be well to soak the paper, because while it sits in the tub you can do a quick exercise to introduce yourself to the value problem.

Take a quarter sheet of paper and wet both sides thoroughly. Even out any pools of water. Remember that you will want to use a fairly dry brush here, since your paper is already wet. Pick up some pigment

and push it around a bit on your paper. Notice how quickly the paint begins to bleed out into the moisture on the paper. If you want any fairly precise lines or edges, you will have to wait until the paper has dried somewhat and you will have to be *sure* that your brush has no excess water in it.

Try some areas of middle and lighter values and some of what you hope will be about values #7 or #8. Watch your drying by checking the reflected gloss on the paper: when the gloss leaves, you are just about finished, so beware of individual areas that are drying faster than others. As long as some gloss remains, you can also pick up paint with a rinsed, dried brush. This is a special advantage of the wet-blended technique, for it permits a great deal of subtle modeling.

By now you will have covered your quarter sheet and the serious paper will be well soaked. Remove it from the water and hold it over the tub to drain off excess water. Take it carefully to your table and lay it on the wet newspapers. Wet your brush with clean water, dry it between your fingers, and then smooth out the surface moisture. Your drawing should still be visible. Perhaps by this time the small exercise sheet will have begun to dry thoroughly. Look at it,

in any case, to see whether you had enough paint in your brush to achieve final values as dark as you had planned them. If not, resolve to put on plenty of paint this time.

The painting process for wet blending is basically the same as for wash and rough brushing: work from light to dark, and from top to bottom. You will have less lightening of dark values the less water there is on the paper and less "bleeding" or softening of the edges, too. This means that your last accents, either applied darks or picked-up lights, will naturally be more precise than the first areas you lay on. Keep this in mind as you paint so that you can paint details last. But try to complete the more rapidly drying upper sections of the paper first.

Because, as you add new pigments, your brush will continue to move the paint already on the paper, you will find that you can quite easily go right over areas previously painted. For this reason you may find wet blending a good deal more flexible than the method you have been using.

As your paper begins to dry—and it inevitably will regardless of your precautions—you must begin to enter any details or clarifications that you may need. Generally, these will be dark. It is imperative that you

61. Willows, *1950. 15½" x 21", 200 lb. rough paper. This is a rapidly painted wet-blended picture, largely in tones of muted yellow-green and blue-violet. O'Hara put in the foliage areas first, allowing them to bleed out, and introduced notes of sepia and vermilion for the nearer branches when the paper had dried a little. The light grasses in the foreground wash were put in at the last minute, with cadmium yellow pale used almost from the tube.*

62. Above the Clouds, *1945. 15½" x 22½", 140 lb. rough paper. This painting, a real tour de force, shows how wet blending can be applied to representational problems. O'Hara painted the sky and distant mountains, drying the blended hill bottoms as he went. He then wet the lower two-thirds of the paper and set in the color for the valley, reserving the soft-edged clouds. While the valley tones were still wet, he put in trees and details.*

63. Alpine Winter, *1960. 14¾" x 22", 140 lb. rough paper. This is another example of the way in which wet blending can be used to solve a real problem. O'Hara first painted the mountain at left, then did the sky and low-hanging clouds in one drying period. He had to wait before he could finish the slope at right and set in the foreground, but the crisp edges and clear detail were worth it.*

use something very close to raw body color for these accents or they will dry to pale ghosts of themselves. The rich darks on your wet paper will have a tendency to flatten out to nothing, so in these last moments add any dark, pure colors you think you may need for keying or for enlivening dark sections of the painting. Likewise, if you need any lights, now is the last possible moment to pick them up.

Do *not*, under any circumstances, fiddle with your paper after the gloss is gone. If you do, you may commit an irremediable botch.

Remove the paper from the damp newspapers to dry. Clean up. When the picture has dried thoroughly, set it up and consider your successes and failures. There should be a few lovely sections, at least—places where blended colors form soft contours and juxtapositions. Some hard edges in the final details will do no harm. But there may be a sameness to the darker values that is dull, or in your haste you may have miscalculated some color mixtures and produced pap or worse.

Should you wish to go back and alter parts of a wet-blended picture, you can wait until the paper is thoroughly dry—generally in two or more hours, depending upon atmospheric conditions—gently re-wet the paper, and then make such changes as you feel are necessary. It is also possible to paint a wet-blended picture section by section. In this case you must wait until each part has dried completely and then carefully blend the new section to former ones by wetting the dry areas and blending in the new paint so that the seams softly overlap.

O'HARA'S SOLUTION

With the paper previously well soaked and the drawing for *Port Clyde* (Color Plate 21) indicated, O'Hara starts spreading paint—paint with almost no water intermixed—over the sky area. The pigments include yellow, orange, alizarin crimson, and cobalt blue. The tones vary because the artist intentionally does not blend them fully on the paper. These tones are carried down the paper into the section that will be the water of the inlet.

Again with a very dry brush, this time with quite a lot of pigment, O'Hara streaks in the cobalt and black clouds. The same tone is used for some of the roofs in the distance. With primarily raw umber, admixed with a little cobalt and black, the main tones of the distant buildings go in. Accents of alizarin and ultramarine form a few roofs and shingled gable ends of houses. Leafless trees are indicated with the same color, to which some Venetian red is added. Next, he begins to model and shape the ground below the buildings and to define the edge of the water with raw umber and phthalocyanine green in rather heavy strokes.

Before shifting to a smaller brush for the distant details, O'Hara dries the 1″ brush and picks out some light planes in the buildings. Roof edges, chimneys, windows, and branches are quickly indicated with the rigger, quite dry, dipped in ultramarine blue and black paint. Reflections from the more-distant houses

are shown by vertical strokes of phthalocyanine green and raw umber; cobalt and raw sienna darken the water at left. A larger round brush is used to draw in the boats and wharfs in the middle ground. Sepia, nearly straight from the tube, with burnt sienna and alizarin, provides a contrasting warm tone for these points of interest. Reflections of masts and utility poles are set in with the same pigments. O'Hara further articulates the water by using a very dry brush holding a touch of cobalt blue and black. With a couple of long horizontal strokes, he picks up the original warm tone of the water at right and the reflections, and at the same time lays down the lighter blue. A brush more heavily charged with the same blue and black is used for the dark zigzag in the water at left center.

O'Hara prepares for the foreground elements by first wiping out four lights: the two roofs and the pier at left, and the gable end of the house at right. A clean, well-dried brush does the job. Using raw sienna, primarily, he indicates the buildings, gables, and walls of the foreground. The darkest of these tones are painted with almost pure paint. The roof and reflections on the dock at left are set in with cobalt, and the roof at right goes in with pure ultramarine blue. The trees to the left of this house are painted with a mixture of burnt sienna, alizarin, and ultramarine. O'Hara employs a dry brush with split hairs to enhance the effect of leafless twigs. This same color adds interest to the blue roof and forms the chimney. Outlines and architectural details for all the near buildings go in with a small brush holding black and alizarin crimson. With added ultramarine, this color serves for the tree branches.

Some sweeping areas of phthalocyanine green, black, and Venetian red provide a sense of the foreground bank, and oozles, chiefly of orange, yellow, and yellow-green, label it grass. At the right, O'Hara enters some vertical strokes of ultramarine, alizarin, and raw sienna. Supported below by very light touches of a gray made from cobalt and sepia, and clarified by dark-sepia lines, this area becomes the side of a nearby fish house.

Some final determination of textures on the little building at left completes the painting.

COMMENT

As an exercise, wet blending provides extremely valuable practice in learning to control two aspects of technique fundamental to skillful watercolor painting: judgment of the relative amounts of water on the paper and in the brush, and estimates of value change in drying. Beyond that, however, it is an inherently delightful mode of working, displaying some of watercolor's most charming characteristics—fluidity, freshness, and lyricism. While it lends itself especially well to some kinds of subject—rainy weather, undersea scenes, certain portraits, and figure studies—it is adaptable to nearly all themes because of the enormous power attainable through contrasting values and rich darks.

LESSON 22

DOUBLE VALUE SCALE

This lesson will help you learn to deal effectively with high-contrast subjects, especially interiors with windows. (For O'Hara's solution, see Color Plate 22 on page 102.)

PROBLEM

Because the value range of paper and paint is, as you know, far narrower than the range of values in nature, you face special difficulties in treating subjects with very strong contrasts of value. A typical problem is that presented by an interior that includes windows or open doors. To solve this problem satisfactorily, you must create a convincing illusion of the distinction between interior and exterior light effect. You will find it helpful to omit completely one or more of the middle values, thereby intensifying the contrast.

Such a value omission must be deliberately planned, for when you actually look at the scene, your eyes will adjust first to the value range of the interior, say, and then to that of the exterior: your eyes will adapt so that you see each part of the scene with a nearly full value range from dark to light. While your eyes' ability to adjust to complex lighting effects is clearly an advantage to you as a human being, it can be misleading to you as a painter, since you must learn to see relative values accurately and to simplify them to produce a coherent picture.

PROCEDURE

Select a subject: your own kitchen will do. Sketch the composition broadly. Pay extra attention to designing the size, shape, and location of the light areas, because this picture will be darker overall than the average subject and the lights will tend to become centers of interest.

Now number the values of the lightest major areas. Places like windows or doors to the exterior should remain as nearly white as possible: Plan to paint them no darker than value #2. If direct sunlight is falling inside the space, the areas where it appears should also be numbered #1 or #2.

Omit values #3 and #4. Make the lightest values of the interior #5. Proceed toward the darkest values in the normal way. This may require simplifying or eliminating certain in-between values you see inside the space. You will observe that the very darkest values include door and window frames and those areas of wall adjacent to the light sources. (But this is not invariably the case with areas next to spots of sunlight coming *into* the space.) Be wary of your eyes' adjustment to the interior value range; stick to your intention to keep the inside space dark.

Begin painting your picture with the exterior areas, since their value is lightest. If there is sun outside, make these areas generally yellowish. This will increase the sense of sunshine by keeping the value level up and, at the same time, will permit those light areas to be fairly intense in color, since yellow at full intensity is the lightest of the intense hues. Be sure to keep these patches very generalized. Resist any temptation to draw in trees or buildings.

Now skip two values to the lightest section of the interior and continue painting down the value scale to the darkest darks. Remember that these darks will dry lighter than they look and that you can apply some of your darks as body color to keep the values low enough. It is often good to exaggerate the warmth of the interior tones a little, to help increase the sense of reflected light.

O'HARA'S SOLUTION

Barn Interior (Color Plate 22) is a directly painted picture, with no preliminary drawing. It conveys convincingly the glowing luminosity of a barn cellar filled with reflected light.

64. Archway, Texas, *1937. 22¾" x 15½", 140 lb. rough paper. O'Hara gives himself a maximum value range for the nearby walls and road by making the distant hills only half a value step darker than white paper. He employs the knife successfully in the cobbles and the railing at upper left. Figures are more fully rendered than in some later works.*

131

65. Under the Bridge, *1931 (Above).* 14¾" x 21½", *72 lb. rough paper. In this view up-sun (as in Color Plate 2), O'Hara omits some middle values to increase the effect of contrast. Here, where he seeks the glare of midday, there are almost no patches of the values between #3 and #8. The pale Manhattan sky-line is painted with pure cobalt blue, which gives it considerable visual clout.*

66. Palm Springs, *1939.* 15½" x 22¾", *300 lb. rough paper. Painting a foreground in cloud shadow presents the same problem of value contrast as painting an interior with windows: the adjustment of our eyes confuses our perception of the overall value relationships. O'Hara forces the nearby darks, making even the sand very low in value; none of the background darks is darker.*

O'Hara begins with the lights at the door and window. Notice how effectively he uses rough brushing to suggest both foliage and sparkle at right. To provide contrast he paints the light values within the barn in relatively smooth washes. Black is wet blended with a little yellow for the floor, and vermilion slashed on for the illuminated brick pile. Tones of black, ultramarine, and sepia are used for the lighter interior walls and ceiling.

The nearer brick pile and the crest of the farther one are set in promptly, and darker shadowed areas on both follow. O'Hara mixes alizarin, ultramarine, sepia, burnt sienna, and vermilion for the rear bricks; black, sepia, and burnt sienna, for the near ones. Before these washes are dry, he moves in with the knife to scrape out lights that identify the heaps as indeed bricks. Some short, darker strokes of the 1″ brush add variety to the texture.

The darkest darks of walls and beams go in next. O'Hara makes them of heavy sepia—especially where they adjoin the window and door—in order to obtain the richest possible color at value levels of #9 and nearly #10. Note the single sharp accent of the window mullion. Powerful reflected light on the doorsill and central pier is worked in with raw sienna, also used as a body color.

The festooned cobwebs on the ceiling and beams diffuse reflected light from the floor throughout the upper section of the picture. They are done partly with the knife, partly by wiping out, partly by rough brushing, and by drawing with a rigger brush, as in the small window at center. In the upper left O'Hara adds some medium-value sepia and burnt umber to outline them further. Note that the softly illuminated spider webs are all of the same value, about two steps darker than the value used for the exterior areas.

Ultramarine blue, with a little alizarin crimson, serves as the shadow of the sill and frame falling on the bricks at left. Observe how the artist models the two "labeling" bricks with this cast shadow by neatly stepping over them with his brush. A few touches of nearly pure vermilion stand for reflected lights among the bricks.

The composition of the picture depends chiefly upon a balanced arrangement of light and dark shapes, most of which mark a significant axis within the surface pattern. The color is relatively modest. The major color accents are the red shadowed bricks and the edge of ultramarine shadow in the right foreground. With such strong contrasts of value, the artist is able to forego bright and varied color.

COMMENT

Deliberately omitting one or more value steps is, of course, simply a device that helps the artist to solve a representational (or design) problem more easily. You will certainly find additional applications for this device. One obvious possibility is the picture of a scene *through* a door. In this case, the door frame will act as a kind of mat or interlining for the scene outside. The dark frame will enable you to omit at least one value between the darkest object in your outside "picture" and the enframing doorjambs. Reversed, this device will aid you in painting a picture looking *into* a dark area around which are sunlit elements. Skipping a value or two is also useful in natural situations such as a view through trees.

LESSON 23

WET PAVEMENT

In this lesson you will deal with some of the special problems that arise when you paint rainy streets and pavements. (For O'Hara's solution, see Color Plate 23 on page 103.)

PROBLEM

A watercolorist in the rain? The idea seems preposterous. Yet the diffused reflections of buildings and people — or of golden maple trees in fall — exert irresistible attraction for painters. The soft light of a rainy day enhances color, for without the strong value contrasts of sunlight your eyes perceive more fully the wonderful range of subtle hues in any subject. Ordinary things, doubled by reflection, offer a stimulating variation on the usual street scene.

But there *are* some difficulties. The most obvious, of course, is the technical matter of avoiding a rain-bespattered paper. If you are an inveterate on-the-spot painter, you will simply have to be satisfied with a scene visible from some sheltered spot — a covered porch, the back of a station wagon, or a convenient awning. Do not overlook the advantages of putting up with such awkwardness: you may find an unusual and effective viewpoint that you might otherwise have failed to notice. An alternative solution to rain on the paper is to paint from sketches and notes made on location (see Lesson 31).

Another difficulty arises from the considerable complexity of the subject you will attempt to represent. You can help yourself here by reviewing the principles outlined in Lesson 18 on reflections in water, for the same principles apply to land when it is wet. But there is a distinction. The surface of asphalt or concrete is made up of thousands of tiny facets that reflect in infinite directions. This means that reflections in those surfaces are soft-edged and indistinct. To add to your problems, there are very

often puddles of standing water dispersed over a wet pavement. These will reflect just like smooth water except that any sky reflections in them will normally be very pale owing to the light gray color of the rain clouds above.

A method for handling these difficulties is discussed below.

PROCEDURE

As with reflections in water, selecting a subject and designing your picture are particularly important for this lesson. You face similar problems of duplication of colors and values in the lower section of your paper and must, therefore, give extra thought to the arrangement of the elements of your painting. In general, since your concern is the upside-down world in the roadway, it will be a good plan to emphasize that part of the scene before you. If you intend to paint at home from notes, be sure that you have your composition well worked out before you leave the scene, and that you have adequate indications of color, values, and interesting details. It may be helpful to read through Lesson 31 before beginning.

Make your drawing on a half sheet of rough paper. Locate clearly the contours of all objects that will be reflected below. Likewise, draw in any puddles of water in the street and lightly indicate the edges of reflections in the surfaces of the pools. You may feel more confident if you also mark the general location and direction of reflections in the damp pavement as well. In short, set down with pencil as much as you can without getting caught up in details. This is so that you will not have to make any more decisions than necessary while you are actually painting.

Paint in the upper part of the picture as usual. Keep in mind that the humidity of a rainy day will

make drying slow and use as dry a brush as you comfortably can.

Now, the damp part of the pavement is reflecting bits and pieces of everything around it. Although this is primarily sky, there will be hints of all the surrounding colors in it. If it is asphalt, there may be also a grayish violet tinge from the local color of the material. Mix an appropriate tone to suggest what you see and apply it as rough brushing, being careful not to let the edges show too obviously as brushmarks. Do leave occasional rough-edged lights, however, for they will stand for glinting highlights on the irregular surface of the pavement. *Do reserve the puddles.*

Before this rough-brushed wash dries, paint the diffused reflections into the area. Follow your penciled indications of direction but emphasize verticality in your strokes. Adjust color to match the things being reflected. The value of these reflections will be somewhat lighter than most of the things being reflected, and any light objects will have reflections that take on some of the tone of the pavement. You may find that these can be satisfactorily rendered by picking up paint with a clean, dried brush. Don't let the reflection colors get into the puddles or the highlights. To preserve the highlights, paint on the reflections with a brush held almost horizontally, as for rough brushing.

These reflections should blend out into the surrounding wet-pavement tone. When the entire area is quite dry, you may proceed to paint the reflections in the puddles. For these reflections, though partial rather than relatively complete, you will follow exactly the same rules as for reflections in smooth water. Attend to the relationship between the diffused reflections and their continuation in the pools so that your final pavement displays a coherent set of soft and sharp echoes of the objects above.

O'HARA'S SOLUTION

O'Hara starts *The Opéra in the Rain* (Color Plate 23) with a fairly careful drawing that locates the objects in the upper section of the paper. Notice that although the picture is divided almost in half horizontally, the sweep of buses and vans to the left and the diminishing size of the figures up the left-hand side of the composition pull your eye back into the painting, thereby balancing the interest of the reflections in the open pavement at lower center and right.

The artist begins with the sky, painting in a pale-yellow wash, which he keeps as dry as possible. Ultramarine blue, added at left, makes the sky more interesting and suggests the lowering rain clouds. To minimize drying problems further, O'Hara does not extend the sky under the buildings. While the sky dries, he begins putting in tones of raw umber, cobalt blue, and sepia, rough brushing them on the opera house. Lights help to create an impression of the building's wetness. At the lower edge of the structure he is careful to leave white shapes that will later be sky reflections on the tops of the vehicles.

The building at left goes in next. O'Hara rough brushes an initial tone of ultramarine and raw umber, going back into it with burnt umber to articulate the wall. The distant buildings are bluer and less detailed. He uses ultramarine, alizarin, and burnt umber for them, and introduces a few oozles to provide variety.

Returning now to the *Opéra*, O'Hara draws in the upper cornice and a rough-brushed stroke, double-loaded with raw umber and neutralized ultramarine. Cobalt and phthalocyanine green are rough brushed in for the dome, and a second stroke of green and raw umber gives it form. The winged sculptures at the corners of the façade go in with variations of the same mixture. A number of darker colors begin to define the very complicated architecture of the building—suggesting rather than specifying its eccentricities. At the base, cobalt and raw umber are augmented by some strokes of ultramarine and

67. Rain, Honolulu, *1939. 22½" x 15¼", 140 lb. rough paper. Notice the variation of reflections from the tower; they range from very soft near the level of the park to quite sharp at the bottom of the picture. In between, wetter and drier parts of the pavement are suggested. O'Hara is careful to conform the darker, sharper parts of the reflection with the lights that indicate pools.*

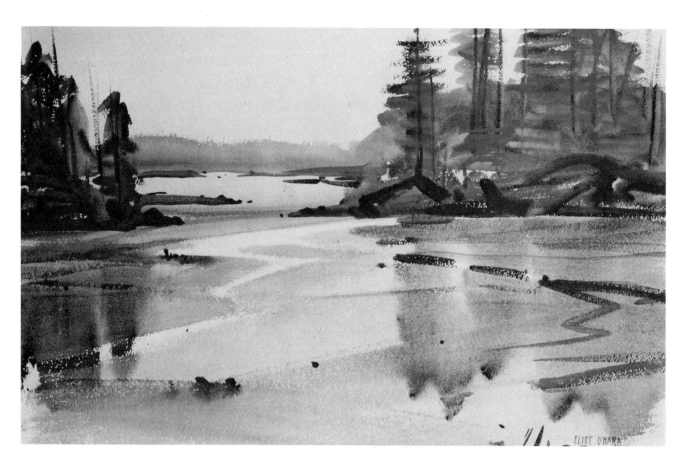

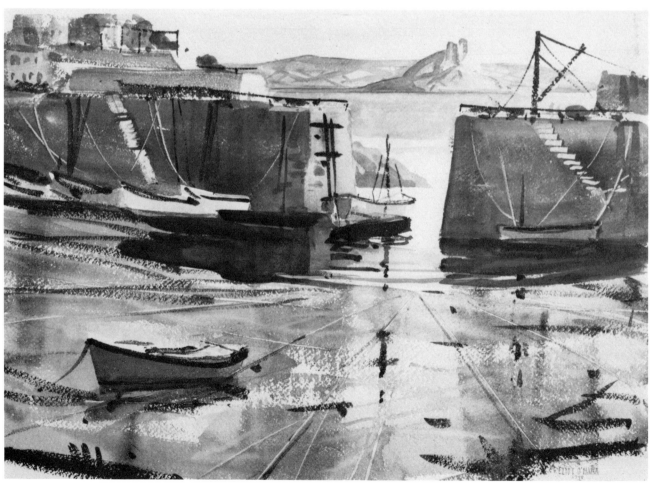

136

alizarin. This helps to strengthen the silhouetted buses. Similar violet tones are used to draw the roof of the left-hand building.

Some generalized violets and blues begin to determine the traffic, and a raw umber and phthalocyanine green mixture indicates the balustrade at left center. A few slashes of blue, phthalocyanine green, and cadmium red medium locate key figures in the crowd.

O'Hara uses a variegated wash, made mostly of ultramarine blue, alizarin crimson, and sepia, for the pavement that reflects sky. He applies it quickly, leaving plenty of sparkling lights and reserving such things as the umbrella at the left. Hints of the reflected opera house are immediately introduced below the pedestrian balustrade, and also at the right. With colors appropriate to the objects reflected, O'Hara sets in diffused images of people and vehicles, and before the complex of paint has dried he uses a dried brush to sweep across the open pavement of the square, picking up paint in lines that indicate tire marks.

At the left, with a very dry brush, some quite abstract strokes are used to suggest the nearer figures and reflections. They blend into the pavement wash, but people will later be clarified with calligraphic line.

While the pavement dries, O'Hara begins working with a small round brush and a rigger, putting in final architectural details on the opera house, the awning and lettering at left, the gaps between the balusters at center, umbrellas and details of figures at center and right, and the shadowed edges of curbings. Last, he sets in the sharp-edged reflections of two figures in the puddle at the lower-left margin of the painting, the cracks in the foreground sidewalk, and the vermilion hatching on the figure at lower left.

COMMENT

You may have a little trouble at first with this representational problem. There are a number of things to think about as you paint, but if you plan ahead as much as possible you will quickly find that you can handle the subject with considerable ease.

The method described here, like most of the specific treatments developed and taught by O'Hara, has other applications. It will clearly be useful for situations like melting ice on ponds and winter roads. It works for wet piers and docks, as well as for reflections of chimneys, TV aerials, and so forth, on wet roofs. Without puddles (usually!), it offers a model for the painting of waxed floors, tables, and similar interior reflections.

68. Turn of the Tide, *1950 (Above Left). 15" x 22", 140 lb. rough paper. O'Hara's method for handling wet pavements is equally applicable to exposed mud flats because they behave in almost exactly the same way. Rivulets of retreating water are equivalent to the pools on pavement and reflect either sky (lighter than the flats themselves) or objects (darker than the mud). Reflections on the moist mud are diffuse. Photo by Woltz.*

69. Penzance from Mousehole, *1948 (Left). 15¼" x 22½", 140 lb. rough paper. In this treatment of mud flats O'Hara uses very coarse rough brushing to suggest a more pebbly bottom. Knifestrokes indicate mooring lines to absent boats and help direct the viewer's attention to the harbor entrance. Knifing also defines stairs down the quays.*

LESSON 24

SIGNIFICANT DETAIL

This lesson addresses the selection and treatment of telling detail in painting. (For O'Hara's solution, see Color Plate 24 on page 104.)

PROBLEM

Pictorial details correspond to adjectives or modifiers in language. As we noted in Lesson 15, a measure of restraint is desirable in all things pictorial, but perhaps especially as regards detail. A sentence overloaded with adjectives becomes obscure—or merely pretentious: so does a picture. The kind and amount of detail you select to include in a painting and the way you handle it are vital; for detail not only affects the design of your work and its appearance of consistency, but it also plays a part in determining the final expression or message your picture will convey.

Faced with the intricacies of the visual world, it is not always easy to determine what detail is significant to you and to your picture. It may be helpful, therefore, to divide the problem and systematize your thinking about it. Some detail may be thought of as *primary*, or essential to creating the illusion or mood you are after. *Secondary* detail is that which is necessary in a supporting function, but which should be prevented, by more summary treatment, from challenging primary detail. Finally, unless there are sufficient areas of simplicity in your picture to provide foils for the chosen detail, your effort will be lost in a welter.

Another way of organizing your thinking about detail is to regard it from the viewpoint of technique. For example, some detail is basically representational. Here one would include such things as identifiable rock shapes, which "label" a more abstractly treated area of color, or lobster-pot buoys, which clarify the location of a scene. Much detail is basi-

cally linear. As you have seen, this can be quite representational or as abstract as some calligraphy. A third kind of detail is basically textural: it is not specified but merely suggested by surface treatment.

The details you choose to include and the way you handle them will loudly proclaim the clarity or confusion of your vision. Try always to select only as much as your pictorial idea requires, and to limit yourself to what is significant to the development of that idea.

PROCEDURE

For this project you will need your sketchbook in addition to your usual equipment.

Select a subject that includes a range of detail, if possible. Weeds along a roadside, shadows cast on the side of a building, a house with much ornamentation, or a market or harbor scene might be the answer.

Sit yourself down and look at the problem, trying to decide what you want to emphasize. Consider the tone or feeling you wish to establish, as well as the more strictly representational and compositional elements you intend to stress. To select the detail that is most significant to *your* purposes, it may be useful to ask yourself a series of questions. For the best results, answer the questions not just in your head but in practical terms. As you come to each decision, try it out in a thumbnail drawing in your sketchbook. You may discover that some notions that seemed perfectly proper in your mind are impractical or unimpressive when translated into visual terms.

Here are five questions. You will certainly think of others:

1. Is this detail essential to characterizing the place or atmosphere I want to create?

2. If so, how *little* of it do I need?

3. Should this detail be included—but subordinated?

4. Would a representational, calligraphic, or textural technique accord best with my total expressive intention?

5. Am I including enough simple surfaces for contrast?

When you have answered these questions and any others you may have put yourself, and when you have checked out your answers by sketching them, you are ready to outline your composition.

O'HARA'S SOLUTION

O'Hara was a master of significant detail, and you will find it rewarding to examine any of the illustrations in this book from that point of view. His detail is always very spare, justly chosen, and painted with a sure sense of its consonance with the techniques used in the rest of the picture.

To begin *The Inland Sea, Japan* (Color Plate 24),

O'Hara makes a rough pencil sketch (note an "unused" hill at the extreme right margin). He first lays in the sky, having wet the area beforehand and evened out the wash of clear water. Cobalt blue, blending lower down into an ultramarine/alizarin-crimson mixture, goes on behind the mountain, overlapping it. Above this he adds some black to the ultramarine and alizarin mixture, using the tone to stroke in the sweeping lower clouds. A bit of orange fringes the clouds at left, a color that will later be picked up by the junk below. Finally, a few dabs of phthalocyanine blue along the left and center upper margin of the paper define the tops of the clouds.

While the sky is drying, O'Hara sets in a very pale wash of raw umber and phthalocyanine green for the lighter parts of the water. Leaving a "dam" of dry paper, he moves up to the basic tones for the city. The lightest color is a mixture of cobalt blue, raw umber, and a touch of red, mostly alizarin crimson. This tone remains visible just to the left and above the ferry. A darker, slightly neutralized cobalt blue is painted into the first wash while it remains wet, creating soft-edged shadow areas. Toward the right

70. Canterbury Cathedral, *1948. 15" x 21½", 140 lb. rough paper. The expressive thrust of this picture is the sense of approaching the cathedral. Foreground detail is textural and calligraphic; its function is limited to giving the viewer a feeling of closeness. The cathedral is silhouetted, but its contour is detailed by represented pinnacles and fretwork. Hence it claims the viewer's attention as the object of his advance.*

this blue indicates a fully shaded section of the hillside city.

O'Hara moves again to the water: phthalocyanine green and blue, with some raw umber and alizarin crimson, is painted in from the left in two strokes of the 1¼" brush. O'Hara draws the brush quickly across the paper to achieve a little rough brushing. Drying the brush between his fingers, he picks up some of the paint from the further swath at the left. Again working rapidly, he adds to the water at right some darker paint, black and alizarin mixed with the color already in the brush. In the foreground, ultramarine blue is blended with the other tones. These transitions and variations in the sea may be thought of as a type of secondary detail, formed by exploiting the natural possibilities of the watercolor medium.

O'Hara starts painting the mountainous background with a mixture of cobalt, black, and raw umber, simplifying and emboldening the contours by straight and angular shapes that will pick up and echo the shapes of the boats and buildings. Notice that he puts the paint on rather dry, so that some hint of the direction of the brush remains. To model the mountains, he uses ultramarine and black, again with firm, dryish strokes that suggest but do not fully describe their strong, rocky substructure. Take note of the arc of raw umber that goes from the center of the picture up to the right, clearly reinforcing the sail shape from the left foreground.

Now O'Hara paints the rest of the city, using quite abstract strokes to build up a textural area that counts effectively as secondary detail. It creates a setting without stealing the show from the more descriptive detail of the waterfront, ferry, and junk at

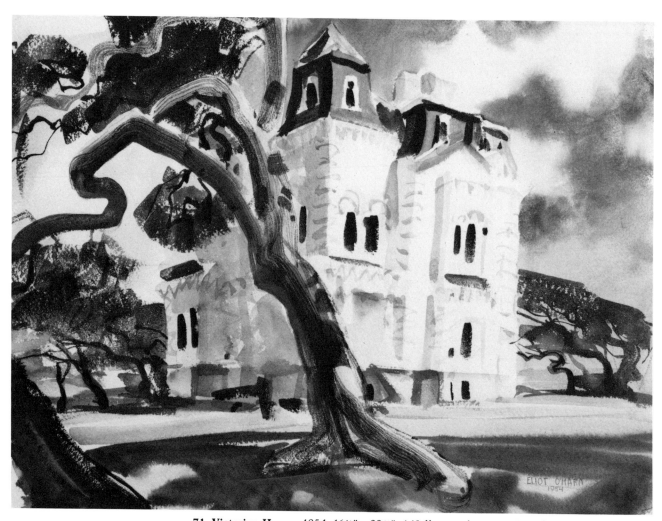

71. Victorian House, 1954. 16½" x 22½", 140 lb. rough paper. Detail in this lively picture is chiefly linear. The split-hair stroke, dragged along the center tree trunk, is descriptive, or representational. The elaborate ornament of the house, however, is rendered with brisk calligraphy, in this instance a kind of secondary detail.

left. Verticality in the buildings is suggested with split-hair strokes of varied color and value. These are then hooked together with horizontals, some of which blend into the wet paint already on the area. The tones range through mixtures of raw umber, cobalt, ultramarine, alizarin, and black. The sail of the junk is reserved.

With raw sienna and burnt sienna, O'Hara starts setting in the junk and its sail, using separate strokes that will suggest the patches on the sail. The warm colors contrast with the blues and violets around them and emphasize the boat's forward position. The waterfront detail goes in with a dark violet made from alizarin, ultramarine, and black. Some strokes of the same color, added to the sail, help relate it to the color design of the rest of the picture.

The ripples, which provide a powerful indication of the sea, are painted with a small round brush. Observe how very few there are. O'Hara uses this primary representational detail chiefly to "anchor" the junk in the foreground, by suggesting its reflection. Taking up a rigger brush, he then draws, in green, brown, and yellow, the details of the ferry and the specifying details of the junk. Touches of burnt sienna warm the stern of the junk, and vermilion body color provides a bit of the mast top and the pennant.

COMMENT

Clearly the focus of this lesson is related to matters considered in others, especially Lesson 15, restraint; Lesson 16, textures; Lesson 20, calligraphy; and Lesson 25, scale and distance. You may want to look them over in the context of significant detail.

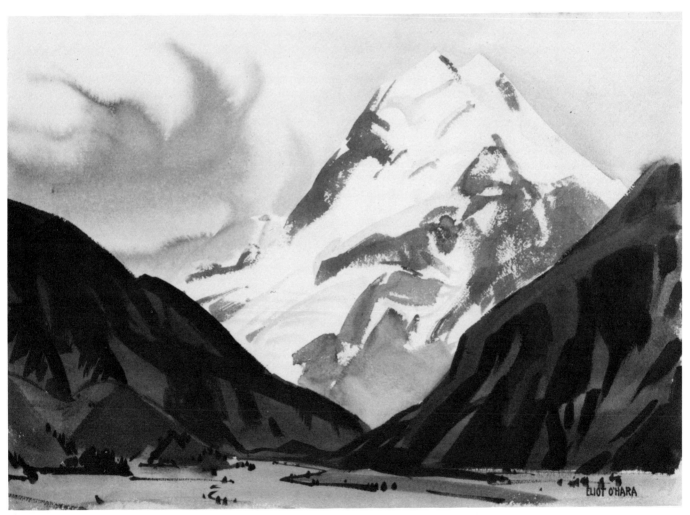

72. The Rockies, *1955. 15" x 21¼", 140 lb. rough paper. The main subject of this picture is the snow-covered mountain, but because it is in the distance O'Hara uses textural detail to indicate rocky outcrops. Anything more descriptive might have brought the mountain too far forward. Abstract lines and dots establish the foreground without diverting our eye from the mountain.*

LESSON 25

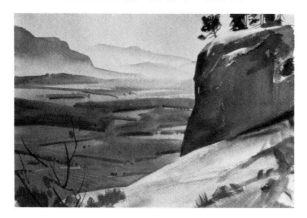

SCALE AND DISTANCE

In this lesson you will consider means by which an effect of distance may be controlled through manipulation of scale. (For O'Hara's solution, see Color Plate 25 on page 105.)

PROBLEM

In painting that is basically representational, the question of scale is largely resolved through observation and application of the rules of perspective. You always have a choice, however, as to emphasis. Your intended emphasis may be augmented by careful consideration of the possibility of altering relationships of scale. For example, if you are painting a barn and your expressive focus is the large rectangular solid of the building, you can make doors and windows proportionately smaller than they appear in actuality. This will give an observer the impression that the barn is more massive than you have drawn it.

Or, again, suppose that you wish to make a strong statement about the powerful interplay between sea and rocky shore. If you make the oceanside cliffs relatively larger than you perceive them and the waves bigger than they actually are, you may produce an impressive composition; but unless you introduce some object of known and familiar scale by which your viewer can measure the size of the cliff and waves, you will not achieve your intention to the fullest. You might, for example, include a fishing boat at normal, or reduced, scale. In this new context, the waves and shore suddenly acquire monumental proportions.

In short, both the conviction of your rendering of distance and the concentration of your expression depend upon a knowing use of scale. And, as is nearly always the case, scale is not merely a matter of initial drawing: it depends to a serious degree upon your ability to translate your perceptions and intentions into paint. Scale is not just a matter of how you plan things, but of how you paint them.

As you may have noted in the last lesson, secondary detail may be easily accommodated to the requirements of perspective. This sort of unobtrusive "setting of the scene" may be treated as painterly texture. From the viewpoint of the present lesson, then, you should note that you can create an effective illusion of distance by painting objects—beyond some point upon which you decide—in reduced scale by means of texture.

Indeed, scale is primarily a matter of seizing upon our need to interpret what we see in terms of relative size. And since you will be expressing your sense of what you see in visual terms, painterly textures will be one of your most valuable means of indicating scale.

PROCEDURE

Almost any kind of subject will do for this exercise, but you may find it simpler to emphasize the lesson's main point if you can choose something that includes a distant vista as well as some nearby object.

Start with a clean half sheet of rough paper. You may use the back of an old painting, since this lesson is not likely to produce a "work of art."

Divide your paper down the center with a pencil line to form two quarter-sized areas about 15" by 11". Sketch your subject lightly in both halves of the paper, making the drawings as nearly the same as you can. Number your values on both drawings. Now paint one in your normal way.

When you have finished and the picture is dry, consider for a moment what changes of scale you might make in order to place greater emphasis on your center of interest, or the particular quality of the scene that you found most compelling. Remember

that you can easily exaggerate the size of your primary object or objects a little, with very small consequence to the believability of your total picture. Apart from that, are there other significant alterations in relative size that you might make? If you do not see anything to do, pick one or two things, but not more, and change their size quite arbitrarily in the second drawing.

Examine the first painting again, this time with an eye to what you can suppress by using a paint texture rather than a descriptive treatment. Or what you might make seem larger and nearer by handling it more descriptively, instead of painting it as a simple wash or rough-brushed area.

Now paint your second sketch, incorporating two to four changes of scale and texture within it. Try to make everything else as nearly as possible identical to your first version.

When you have completed the second picture and it has dried, compare the two paintings. In what ways do they appear different? (Remember this is neither a beauty nor a popularity contest: you are not deciding which picture you like most or which is better.) Have your changes successfully altered your perception of relative size and changed the emphasis of the painting?

O'HARA'S SOLUTION

Painted in 1946, in a thoroughly realistic manner, *From Cathedral Ledge, N.H.* (Color Plate 25) displays the extraordinary skill O'Hara brought to the handling of distance. Not only does he achieve a quite remarkable effect of great depth by using the devices discussed in Lesson 10, but he also employs contrasts of scale to clarify the observer's understanding of that depth.

O'Hara starts this painting with very minimal drawing and immediately lays in the sky wash. He moves from yellow at left, gradually adding phthalocyanine blue to form the greenish tone at center. This color will allow him to contrast the cobalt and ultramarine distance with the sky.

While this first wash dries, he puts in the light of the ledge at right and the initial tones of the exposed rock in the foreground. For these areas he uses Venetian red, ultramarine blue, and raw umber in varying proportions.

As soon as possible, the farthest mountain is paint-

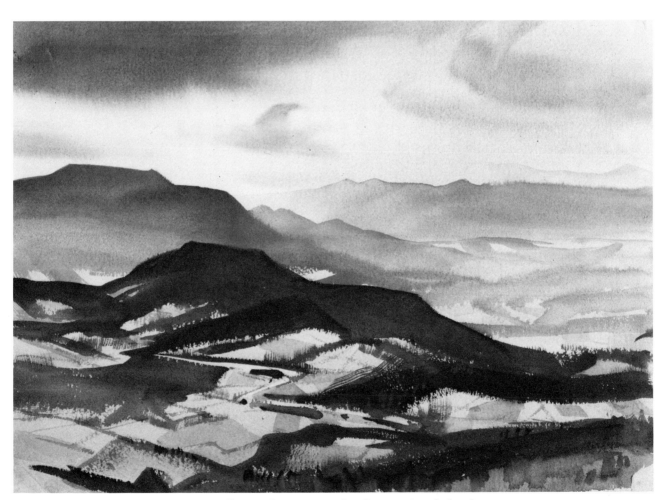

73. Valley View, *1965. 16" x 22½", 140 lb. rough paper. In this fine, unsigned sketch O'Hara tackles the tricky problem of a valley full of cloud shadows. He reserves rough brushing for the land, painting the sky entirely with wet blending. Patches of light read as fields. They are given scale by the mountains. In the foreground, whisking strokes make trees.*

143

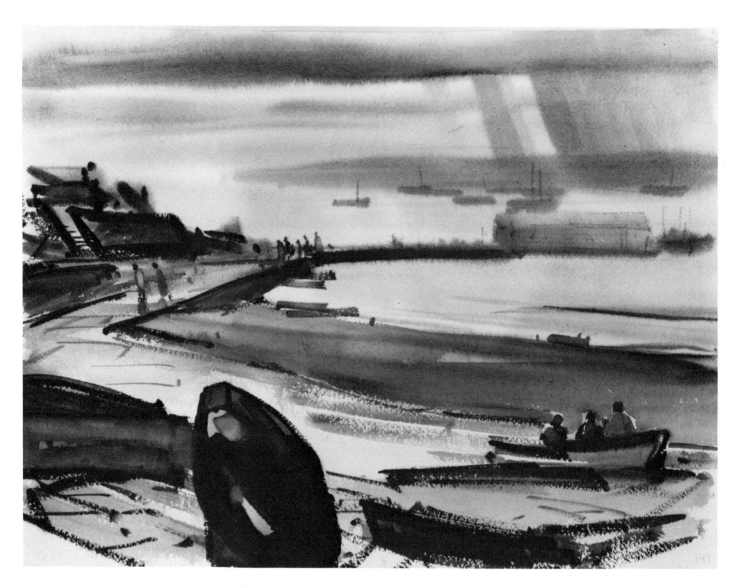

74. Channel Coast, Rain, *1958 (Above). 15½" x 21½", 140 lb. rough paper. Heavy rain often blurs distant edges (see Lesson 28). O'Hara gives the distance authority and clarifies the middle ground by including the large form of the woman coming toward us. Most of the rest of the foreground is handled quite abstractly because this single figure establishes scale for the picture.*

75. Mount St. Michael, Cornwall, *1948. 15½" x 22½", 140 lb. rough paper. O'Hara includes the cliffs at right to provide a reference by which the viewer can gauge the height of the island cliffs. Cover them and see how much less impressive the scene is without them. The causeway and dots for people help confirm our grasp of the tall, rocky islet.*

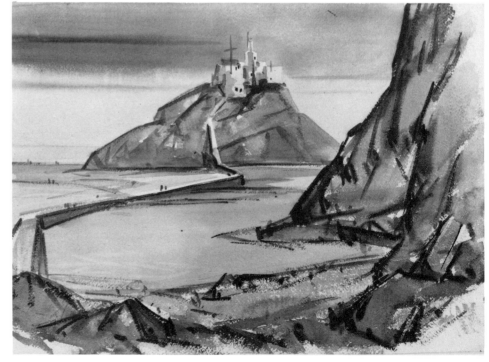

ed. O'Hara uses pure cobalt for it and carefully blends it out into as dry and transparent a base as he can. The ultramarine of the nearer mountain at left goes in next, and it too is blended out at the bottom. So is the lower hill in the center. He wipes the lightest sections of this tone at the base with a cloth to hasten drying.

O'Hara paints the small, wind-stunted pine trees on top of the ledge with phthalocyanine green and black, and emphasizes reflected light from the sunlit rock with straight raw umber. The trunks and branches are drawn in with a rigger brush and black pigment that is grayed with a little water.

The artist can now turn to the sweep of distance. He begins it with a pale wash made from phthalocyanine green, a little ultramarine blue, and some raw umber. As he pulls the wash down the area, he adds more ultramarine and then increases the raw umber as well. The wash is a good deal darker and warmer, therefore, where it adjoins the nearby rock. While this wash is still wet, O'Hara goes back into it with variants of the same mixture, which form gently arced suggestions of wooded hills among the open fields. Rough brushing and a few dabs with the corner of the 1″ brush help to reinforce the impression of distant trees. As he moves nearer, he introduces a bit of Venetian red in the fields at left, partly to help anchor them in the relative foreground and partly to prevent the distance section of the picture from becoming too coloristically distinct from the rest of the painting. A few oozles and wipe-outs indicate furrowed fields and modeling in the lower left.

The bottom edge of this wash is now dry enough so that O'Hara can begin introducing textural detail in the exposed sheet of glaciated granite that forms the foreground. Carefully watching the edge of that wash (notice the light seam along the juncture), he sets in a wash of raw sienna, ultramarine, and Venetian red, leaving some rough-brushed bits where the earlier wash shows through. While this new wash is still wet, he paints some darks with sepia. They blend into the wet wash, lower center, and stand for soft shadows.

He quickly turns to the shadow tones on the ledge at right, starting at the top with a mixture, predominantly of cobalt blue but with a little raw sienna and alizarin crimson added to neutralize it. He picks up raw sienna and Venetian red for the strong reflected light lower down but is careful to reserve areas of the first tone to simulate glancing bits of sunlight. For darker tones in the shadow he uses ultramarine with a little alizarin. This color, especially as he masses it along the silhouetted edge of the cliff, establishes a warm blue-violet dark to contrast with the cool, more neutral blue-green of the distance.

The foreground now requires some detail. Most of this O'Hara accomplishes by rough brushing and whisking strokes made with the warmest colors used in the picture: raw and burnt sienna, some orange, and Venetian red. The darker washes at the very bottom margin of the paper form a shadowed area. O'Hara paints them in quickly with ultramarine, alizarin, cobalt, and orange in varying proportions. When this has dried sufficiently, he sets in some darks—black and sepia, with a little burnt sienna, to form deep shadows and the branches of the shrub at lower left. A few dabs of Venetian red along the branches indicate leaves.

A scene like this, in which a vast distance must be shown in abrupt contrast with near ground, is one of the most difficult to paint convincingly, and O'Hara has reached deep into the artist's bag of devices to achieve it. Observe, for example, that he not only contrasts warmer and cooler blues, but that he contrasts textures as well. The distance is largely wet blended while the foreground is largely rough brushed. The texture of the near granite is neatly played against the apparent softness of distant foliage. Measure off the area covered by the shrub at left: it is nearly the size of the ledge in the middle ground. From this the viewer apprehends the distance to the cliff. O'Hara plays this bush against the mere dabs we see as distant trees behind and below it, too—and instructs us as to the grand dimension of the ledge by means of the small pines.

COMMENT

From Cathedral Ledge, N.H. is an example of scale knowingly employed for realistic effect. Try using it to manipulate the apparent size of things toward other ends—to dramatize a front gate or a set of grain elevators, to increase the poignance of a child's abandoned toy. And remember that when any picture seems a little "wrong," scale may be an offender.

LESSON 26

SMOOTH PAPER

This lesson discusses some of the pleasures and pitfalls of working on smooth paper. (For O'Hara's solution, see Color Plate 26 on page 106.)

PROBLEM

In Lesson 1 it was pointed out that paper is among the materials you may employ selectively to control the appearance of your picture. Although most watercolorists in this country have traditionally preferred to use paper with some tooth, increasing numbers of artists are finding that smooth paper better answers their representational and expressive needs.

The switch from rough to smooth paper for those who have not yet made its acquaintance, however, can be a bit "rough." Unlike rough paper, which is made on a screen that allows the wet, pulpy mass of fibers to bulge through in little humps that persist after the paper is dried, smooth paper, while still wet, is passed between warm metal rollers. This process "irons" the paper, smoothing its surface. (This is why the paper is often called "hot-pressed.") The polished rollers not only smooth the surface of the paper, but also compress the fibers, so that the resulting paper is almost always less absorbent than rough paper. Besides these general distinctions, there are, of course, a number of special differences among smooth papers made by various manufacturers.

For the watercolorist, the practical results of these two general distinctions between smooth and rough papers are:

1. Smooth paper dries much faster than rough: the lack of little "lakes" held in the depressions of the paper prevent it from remaining workable for so long a time.

2. Rough brushing on smooth paper cannot be achieved as easily, nor are the results the same. Speed, and a very dry brush, will provide some rough-brushed effects, but the characteristic pebbled rough brushing attainable on rough paper cannot be achieved on smooth.

3. The wet-blending technique, a problem on rough paper, is even more difficult on smooth paper because it dries so rapidly.

There are benefits to using smooth paper, too, that may offset the disadvantages listed above.

In the first place, smooth paper responds better to subtle color and to intense color (see Color Plate 3). Because the humps in rough paper cast individual shadows, color laid on it tends to be neutralized, and some of the soft distinctions of grays or the brilliance of high intensities may thus be lost.

Second, because smooth paper is usually less absorbent than is rough paper, paint can be more easily removed from it. Wiped-out lights are fresher and cleaner, and they have sharper edges. Greater detail is possible by this means. For the same reason, brush strokes may be left on the paper and the track of the artist's hand incorporated more fully into the final effect of the painting. This means that if you like the look of a "drawn" painting, you may find smooth paper more suitable for you.

Finally, there are some practical reasons why a faster-drying paper can be useful. On a rainy or overcast day with high humidity, for instance, the use of smooth paper will minimize your waiting time and at the same time offer you a better forum for the subtle nuances of color that are so often a prominent feature of that type of day.

All other techniques applicable to rough paper are equally effective on smooth. Indeed, for those who wish to work in a more formal fashion, building up

tones slowly by overpainting, smooth paper is almost a necessity. It allows the artist to use underpainting and to rough out the modeling before applying full color in a technique similar to that traditionally developed for true fresco.

PROCEDURE

The best way to learn to deal with the contrariness and brilliance of smooth paper is to try it. Although the smooth, or "hot-pressed," papers sold by different manufacturers will each be distinctive, all will possess the main characteristics mentioned above. It does not matter a great deal, therefore, which particular sort of paper you use for this lesson. Do, however, get paper of the recommended weight: 140 lb. or its equivalent (2-ply, at least, though you will be very happy with the slightly heavier 3-ply). This is very important because buckling can be even more of a bother with smooth paper than with rough.

In selecting a subject, keep in mind the outline of pluses and minuses you have just read. For example, do not choose a subject full of trees and foliage of the sort you usually handle with rough brushing. Do think about working on this lesson on a damp day. Do not plan on trying a wet-blended picture. Apart

from these *caveats*, any sort of subject will be fine, although—as with any new venture—it may be wise to avoid taking on an extremely complicated scene.

Sketch in your drawing in the normal fashion. Be a little wary of drawing too much: this can be a temptation, because the lovely slick surface invites pencil lines and detail. If you have been skipping the numbering of values and it has been working all right, fine—but this time, number them. There will be a need for special haste in the application of paint on this paper, and the numbered values may save you some crucial hesitation.

Start with your large, light washes. If you have a big sky area, wet the paper before attempting a graded wash. Be sure to run the clear water down well below your actual horizon, or sky edge. Paint below it, too, unless you have a white object adjacent to the sky. You will notice that the water, and the paint also, runs off smooth paper much faster than off rough. A bead of water will form quickly at the lowest part of your wetted area or wash. Watch this carefully, for it may gather and run in a streak down the dry part of your paper. Should this happen, quickly wash it out with a brushload of clean water.

Paint your wash as rapidly as you can, for the fast

76. Sonora Church, *1941 (detail).* *16½" x 22½", 3-ply smooth paper. Here you can see some of the qualities of paint on smooth paper. In the shadows on the towers a thin, wet wash has dried with textured edges. In the mountains O'Hara uses the evident brush strokes to aid in modeling. Rough brushing, with a very dry brush, appears in the window.*

147

77. Front Royal, *1945. 14" x 22½", 3-ply smooth paper. Pure, luminous washes are possible on this paper, but you must wet the paper first and work rapidly. Notice wet blending and "oozles" in the trees at left. The grasses in the foreground were wiped out of the wash when nearly dry. Rough brushing shows in the tree at right.*

78. Near Port Orford, Oregon, *1940 (Below). 16½" x 22½", 3-ply smooth paper. As with the mountains in Figure 76, O'Hara models the rocks here with brushstrokes. Waves are wiped out of an initial wash and some of the reflections set in later. A little rough brushing on the rock in the left foreground helps to indicate its wetness. Photo by Woltz.*

drying will almost immediately prevent your going back into the upper section, and the lower part will be impossible to rework shortly after.

As a general rule, it is best to paint single strokes and to leave them, when working with smooth paper. You can always go back and put new color over them when they are dry. But if you work over them when they are partly dry, you will produce ugly edges and scars within the area.

The darker tones and the smaller sections of the painting may be handled just as if they were on rough paper. Although they dry faster, this is not usually significant enough to require special thought.

One last thing: as smooth paper seems to welcome the pencil, so it also invites brushed detail. Think extra hard about what and how much you want to include by way of final touches. Resist any temptation to draw in "a few more" twigs, bricks, or leaves.

O'HARA'S SOLUTION

Sequoia Sempervirens (Color Plate 26) is a poignant and powerful affirmation of ongoing life. The statement is made with great simplicity and without sentimentality. The subject, the questing vitality in a deeply injured tree, is far from uncommon: on the contrary, it is an easily accepted symbol of man's own gallant efforts. O'Hara acknowledges all of this without question, merely reframing the old idea in his own unvarnished terms.

He makes no drawing for this picture, but begins by wetting the paper. After evening out the water, he picks up ultramarine blue, alizarin crimson, and burnt umber with a 2″ camel hair varnish brush, and paints the cloud pattern at the top of the sky. With a little less blue in the mixture, he places the sweeping strokes nearer the horizon. The lower section of the sky goes in with a very pale wash of orange fading into blue. He is careful to leave some white paper among the strokes above to insure a full value range and as much contrast in the picture as possible.

He waits for these first tones to dry. (Notice the tiny speckles from fine rain droplets.)

Since the entire remainder of the picture will consist of darker tones painted on lighter ones, O'Hara next puts in the distant hills. He uses the same ultramarine, alizarin, burnt umber mix as for the sky but with slightly less of the umber: the resultant purple tone is a little more intense than the sky but clearly related to it in tone. This color is painted on and bled out at the base of the area. Quickly, before the paint can dry, O'Hara indicates the silhouettes of distant burned trees with short, gentle whisking strokes. Using the trailing edge of the brush, he also draws in

a few nearer stumps and remnants.

The foreground is painted with ultramarine, umber, and burnt sienna. O'Hara paints on the wash first, and then goes back into it with whisking strokes that model the hummocks of sere grass.

The first bold strokes for the tree trunk are put in with a gray mixed from cobalt blue, raw umber, and Venetian red. The tip of the brush is dipped in sepia to give a double-loaded effect, the dark edge suggesting remnants of charred wood along the left-hand side of the fragmentary trunk. O'Hara quickly picks up ultramarine and alizarin, introducing it while the first strokes are still wet. Almost immediately, he adds the dark sepia tones, which also blend into the initial wash, modeling the tree's form. Some of this dark paint—applied quite heavily—is also applied to the right-hand section of the trunk, and the artist begins drawing in the characteristic convolutions of a trunk sculptured by fire. The complex contours of the base of the tree are modeled with the same tones, the dark sepia again being used very heavily. A daub of this color goes in at lower right to indicate another struggling stump.

Very heavy phalocyanine blue, with raw sienna in varying amounts, is painted with a dry brush in quick, flicking strokes about the top of the tree to show the living branches. The same paints, with some burnt umber, are drawn in with a small round brush to signal branches; some of these are lightened by knifing out. The same procedure is employed for the feather of green in the lower right.

O'Hara roots the tree into the earth by adding a bit of water to the foreground, coaxing the sepia into a blended edge, and pulling the brownish tone down into the grass.

To finish the painting, blue grays—mainly burnt umber and ultramarine blue—at various values, are drawn in for the more distant dead skeletons. The picture is completed in less than thirty minutes.

COMMENT

O'Hara's painting is remarkable for the subtlety of its grays. The number of pigments used is not great, but the paper allows the artist to exploit their range to the fullest. The picture is also interesting in the degree to which it illustrates smooth paper's hospitality to drawn form and edges. The brush slides along almost effortlessly, responding easily to every alteration of direction, speed, and angle of the artist's hand. This is a quality of the paper that you must be a little careful about, since it can lead to overabundant detail or excessively slick edges.

LESSON 27

SELECTIVE COLOR

In this lesson you will experiment with color control for the sake of design. (For O'Hara's solution, see Color Plate 27 on page 107.)

PROBLEM

The infinite diversity of nature's colors is impossible to use in any given picture, even were they all attainable from the pigments you have on your palette. But the limitations of your pigments are not so great that you cannot produce a painting that exhibits a veritable smorgasbord of hue, value, and intensity. Such a picture will often suggest to the viewer an overindulgence akin to the repulsion of watching a gourmand stack his plate with some of everything on the table.

As an artist, you will want to limit the tones you use in any particular picture. This need not be a simple decision, made in advance, to employ only cadmium red, raw sienna, and cobalt blue, for instance. Such a procedure, if adhered to, will yield a painting with fine coherence of color. But it is not necessary to submit yourself to the tyranny of the tubes in your box, for you command the multitude of mixtures they can make as well. Since, as always, your objective is to *control* your materials, you must familiarize yourself with your possible mixtures in order to select those most in accord with your intended design and meaning.

PROCEDURE

This is an experimental lesson, so you do not need to begin with fresh paper: some backs of old paintings will serve very well. It may be a good idea, though, to clean your palette and set out some new paint where required.

Start by mixing a color that you find inherently attractive, one that you enjoy for itself and by itself.

You may want to mix and try several on your paper before you find one that really satisfies you. When you do, paint a good-sized patch of it on a second paper, making the shape of the patch abstract, but pleasing to you.

Return to your sample sheet and mix another color that "goes with" the first, either by harmonizing with it or by enhancing it through contrast. Again, set a patch of this on your second piece of paper. You may place it adjacent to the first or leave a white area between the two. If your second tone is the same in value as the first, consider painting a lighter or darker version of it on the second sheet.

Now make a third color to join the others. It will probably be best not to introduce a fourth, but if your three colors are quite similar, you may want to add another to make for more variety.

Study the patches you have painted on the second sheet. Do they "feel" right together? Should you add further variations of them? Would they be more satisfactory if you tied them together with grays? If so, use some black paint to make grays at values that will set off the colors you have already painted on the paper.

When your color composition is finished set it up and analyze it. Recall the three dimensions of color, as well as your experience with color keying. What have you done? Ask yourself first whether there are likenesses among your colors, and—if there are—whether they are chiefly likenesses of hue, value, intensity, or of more than one of these. Is your design dependent to any degree upon keyed color? How is it working? Try to arrive at an analysis of your design that is clear enough so that you could repeat the *principles* you have employed using a different group of tones. For example, if your first color was a middle-value orange, could you make a new color design on the same principles but starting with a middle-

value green? When you think that you have seen clearly what you did, try it with another color.

Your purpose in these exercises is two-fold. You are, first, acquainting yourself with sets of color combinations that you find pleasing, regardless of subject, and that function together agreeably. Second, you are attempting to understand the significant organizing factors in a color arrangement that you like. You may find, for instance, that you are most happy with colors that are relatively low in intensity; or you may prefer colors that contrast in value; or it may be that you respond most comfortably to the warmer hues, regardless of their intensity and value.

Whatever discoveries you make, returning from time to time to this lesson will enlarge your capacity to *choose* the color you use, and to control color design in your pictures.

O'HARA'S SOLUTION

Capitol Cherries (Color Plate 27) demonstrates the way in which a rather arbitrary color scheme may be fittingly adapted to perfectly recognizable subject matter. Taking as his excuse the overcast day, O'Hara here emphatically alters the color of the cherry blos-

soms. He turns them from their characteristic pale pink to a darker violet that he especially enjoys. Yellows and oranges provide a complementary foil for the violet, and large areas of neutral tone soften the painting as a whole.

O'Hara starts by making a drawing that locates the general size and shape of the violet sections of the picture. He specifies carefully the shape and size of the Capitol dome and its architectural underpinning. He does not want to have to make more than minor adjustments in his design once he starts painting.

He begins with a clear water wash over the upper-left corner of the paper. When it is well evened out, he adds some orange to the lower part. This is followed by a brushload of black with a little ultramarine blue, which forms the heavy dark cloud at upper left. With a bit more of the blue he draws in the lower clouds, carrying them behind the building and central patch of cherry blossoms. The right edge of the initial wash and the color he adds to it are left rough brushed.

While the sky wash is still wet, O'Hara picks out the lights along the Capitol drum, dome, and cupola with a well-dried, clean brush. He continues model-

79. Georgetown Canal, *1934. 15" x 22", 200 lb. rough paper. This is a vivid painting, contrasting a range of blues with intense vermilion in the building. Shadows on the snow, pure cobalt, model its contours. The reflections on the canal suggest the direction of the current and lend interest to the lower-left corner of the picture, balancing the branches to the right above. Photo by Woltz.*

151

80. Nets Drying, *1965 (Above).*
*15½" x 22½", 140 lb. rough
paper. This picture is almost
entirely done in values of
blue-green. O'Hara renders
the semitransparency of the
nets with wet blending, while
rough brushing and knifework
reveal their texture. Light ef-
fect results not only from re-
flected illumination, but also
from translucence, an effect
convincingly handled at right
center.*

81. Bryce Canyon, *1949. 15¼"
x 22½", 140 lb. rough paper.
Here O'Hara selects his color
from nature, using variations
of orange and red in many
intensities. The semi-abstract
treatment is basically planar
(see Lesson 30), but the forms,
like the colors, are derived
from actuality.*

ing this dominant architectural feature with some pale raw umber, which you can see at the left of the dome. Ultramarine blue, slightly neutralized with raw umber, goes on the right side of the dome to suggest sky reflection. O'Hara applies this with a very dry brush, because the sky is still wet in spots. He produces a soft line for this right edge of the dome.

Moving down the paper, O'Hara paints the raw sienna and raw umber tone of the lower part of the building in light. Raw sienna and vermilion are set in at the bottom edge of the paper, grading from nearly pure raw sienna at right to quite orange at left. This will be the grass in light. He adds some abstract strokes of phthalocyanine green, yellow, and vermilion that will become cars and buses.

Returning now to the architecture, the artist paints further shadow tones, this time using varying proportions of accra violet, burnt sienna, raw umber, and sepia. These form the cornices and soft cast shadows. With a rigger brush, he draws in a little suggestive detail. Notice how very schematic this is.

The lower sections of the building are treated with similar simplicity. Burnt sienna, raw sienna, and a touch of violet serve to indicate the broad architraves. A bit more violet in the same mixture is quite arbitrarily set in at the corner below the dome to enliven that surface. Pale sepia and violet strokes reveal the spaces between the columns at left, and a touch of burnt sienna suggests the deeper shadows beyond them. With sepia and black he paints some very tiny darks to stand for windows. Observe how effectively they convey a sense of the huge scale of the building.

O'Hara is now ready to begin the blossom areas. The color is mixed from accra violet, accra red, and ultramarine blue. He begins by painting rapidly with a 1″ brush fully loaded, laying it flat occasionally to rough brush an edge or a section. He alters the proportions of the colors a little, and in both the large mass at right and the small area at left he introduces very dark brushstrokes of sepia. These spread in the wet wash and will later be reinforced and articulated with branches. For some darker touches of color, the artist shifts to a 1½″ stroke, which he employs chiefly for rough-brushed effects in the right-hand section. He shakes a few drops of clear water into the area that oozles out to suggest the texture of the flowers.

O'Hara combines distance and shadow under the trees, painting it with broad strokes of ultramarine blue mixed with a little violet. The violet, with accra red, is used below the buses, as a dark on the grass. The same mixture, laid over the ultramarine at right, indicates the deeply shaded trees of the middle ground. Ultramarine and vermilion strokes go in for nearer shadows on the grass, and some touches of vermilion enliven the figures at right, the truck at lower center, and indicate a few small people below the dome. With a round #6 brush, O'Hara picks up heavy sepia, which he uses to introduce a few more trunks, branches, and figural details; a hint of reflected light on some of the larger branches and the tree trunks is shown with almost pure accra red.

Surveying the picture, O'Hara feels the need for further darks and greater resolution in the architecture. A violet, ultramarine, and sepia mixture is used for two simple strokes on the dome, some indication of deeper shadow in the niches of the lower drum, and the angle of the two wings of the building. The same color, drawn in with a smaller brush, makes the figure atop the cupola.

COMMENT

O'Hara has used a rather restricted palette for this picture. You will certainly have noticed how he keeps returning to the same paints for the various tones he chose to emphasize. This is the most obvious way to produce an harmonious color composition.

You can, however, select colors that are limited not in hue, but in value or intensity. For example, you might decide to employ any or all of the hues you have on your palette, but only at certain values. Similarly, you could paint a picture in which the intensity range is limited. In most instances you will find that effective paintings done with selected colors depend upon some sort of planned restriction in *each* of the three dimensions of color.

LESSON 28

FOG

This lesson discusses some of the special issues connected with painting fog. (For O'Hara's solution, see Color Plate 28 on page 108.)

PROBLEM

Fog transforms nature, obliterating inessential detail and reducing solid forms to intangible silhouettes. It dissolves the normal framework of our world, making near seem far away and hiding the horizon in its mysterious depth. Few other familiar atmospheric effects are so capable of generating enchantment and fascination among artists.

A little thought will suggest that painting a fog picture should be relatively simple. Since the fog, in actuality, simply hangs veils of mist between observer and objects seen, you face only a greatly exaggerated distance phenomenon. As far as technique is concerned, you can paint from light to dark, farther to nearer, using, for the most part, one overlap after another.

There are a few things to look out for, however. One is scale. Since the most distant things you can *see* will be relatively close, it is important to think particularly of the size relationships among the objects you plan to paint. Another factor to consider is the local color of the fog. Fog blends into smog in many circumstances and often has a distinct color of its own. This may vary from blue gray through warm grays and browns to a distinctly yellow hue. Clearly, your picture will take on something of the tonality of the fog itself, in such cases, and noticeable local colors of objects will be pushed in the direction of the fog's own hue.

A third matter you should attend to is the generally hard edges of objects in fog. Whereas edges seen through sheets of falling rain are normally softened and fuzzy, fog usually renders even the most distant visible objects pale but still sharply defined.

PROCEDURE

This is a lesson that will be most useful if done on location and *in* fog, so that effects may be immediately checked against the subject. Where this is not possible, however, you can use a completed painting as a model and render it as if seen in fog.

Consider your technical problem first: you will be painting in very high humidity, and you will want to maintain sharp edges. Unless you have very great patience, the quick-drying properties of smooth or cold-pressed paper may be usefully exploited for this subject.

Whatever paper you employ, you will want to make a drawing somewhat lighter than usual. Keep in mind that many of the objects you include will be extremely pale and that pencil lines will show at their edges. In designing your picture, try to keep in mind the *value* of the various areas: many objects of great interest will tend to disappear into the fog (if you get their values right!) and the picture may be much blander than you expected in its final state. For this reason also, it is wise to plan several objects of interest in the foreground, so that your picture will have a firm anchor. Finally, virtually all modeling disappears in fog: you will be painting silhouettes, for the most part. Therefore, select things for your composition that explain themselves, express themselves, or add interest to the picture in terms of their *contours*.

If the fog you face seems to possess no distinctive local color, you are free to create a tonality of your own. Because so few local colors are apparent in the scene, and those you can see are so neutral, it is

important that you think ahead about selecting a gray that will help support your expressive intention. When you have decided what colors you want to use, stick to them. Although the fog tone affects everything in your subject, you will notice that there is still a faint warming of nearer things, as well as an increase in their darkness and degree of definition or detail. For this reason, it will be prudent to include a markedly warm pigment among those you plan to use for the gray fog mixtures.

Before you begin painting, study your subject. Notice that the sky seems lighter up high than it does below—just the reverse of the value transition on a clear day, and for the same reason. The particles of floating dust and moisture close to the earth's surface that make the blue appear paler at the horizon on a sunny day join with fog to make an even denser atmosphere close to the ground. Directly above your head the sunlight illuminates the fog layer, making it seem lighter.

Your first wash, therefore, should go on lighter at the top and gradually become darker toward ground level. You will have to wait for it to dry before you can paint in the objects just barely visible. Pull them into one plane, as far as possible. Usually four planes from distance to foreground will be enough

to produce a strong sense of fog.

Proceed—waiting for each earlier tone to dry—from the palest planes to the nearer and darker ones. Until you reach the nearest objects (and perhaps not even then), you will do best to omit any modeling or interior detail. Use your judgment, however, and rely on what your eyes perceive. Remember that you can increase the effect of contrast by making the nearest tones warmer than those farther away.

O'HARA'S SOLUTION

London Fog (Color Plate 28) is a superb example of the extraordinary combination of strength and delicacy possible in a painting of fog. It is extremely simple yet thoroughly evocative of a time and place. The soft nuances of color in the varied grays prevent any dullness of tonality, and the play of natural and manmade silhouettes encourage the observer's contemplation.

O'Hara begins with a lightly sketched plan of the composition. He then starts the sky wash, using burnt umber with a smidgeon of alizarin crimson. To this he adds ultramarine blue when about halfway down the paper. The bluer, darker tone helps to suggest the thicker fog nearer the earth. This wash is carried to within about four inches of the bottom

82. Trawler, Monhegan, *1939. 15" x 22½", 140 lb. rough paper. For this classic subject, O'Hara wet-blends the sky and sets in the tones for water and ripples. As soon as possible, he paints the two islands, reserving the bow of the trawler at left. The trawler, dock, rocks, and reflection go on in one drying time (note the "dam" between the boat's hull and its reflection). Details of mast and rigging and their reflections, as well as the distant boats, are painted later.*

155

83. Lincoln Cathedral, *1948. 22" x 16½", 140 lb. rough paper. O'Hara exploits the fog in this handsome picture. The cloud across the paper, into which the towers disappear, lets the viewer assume that they continue almost endlessly. Verticality is enhanced, though lightly stated. A variety of strong horizontals in the foreground affirm stability and provides a tense balance for the composition.*

margin of the paper. The lower strip is left white, dry paper.

The artist now sits patiently, waiting for this first wash to dry thoroughly. He mixes burnt umber, raw umber, ultramarine, and alizarin crimson—this time on the palette, because he will need to dip back into the paint in order to cover the rather large area of the church silhouette, and it is important that the tone be uniform. He lays in the shape with a clean, smooth wash, omitting the window. With the same color, a few dabs of the brush indicate automobile shapes, signs, and posts. Taking a #6 round brush and the same color again, he draws in the window tracery and the pole to the left of the church: seeing that this is a little too dark, he dries the brush and picks up some of the paint.

With the 1″ brush once more and a little water added to the mixed wash, O'Hara rough brushes in the tree at extreme right. He employs the split-hair stroke for twigs and with thicker lines indicates the branches. As soon as possible, he puts in the automobile in front of the church, using a darker value, and a mixture containing more burnt umber.

While this group of washes dries, O'Hara begins painting the foreground pavement. The colors are mixed as before, with varying proportions of one pigment to another. The glistening sidewalk at extreme right, for instance, is predominantly raw umber, while the darker reflection of the church is made mostly with alizarin crimson and ultramarine blue. He lays on the lightest of these areas with the brush held at a very oblique angle, and he draws it across the paper swiftly. This provides a pale, rough-brushed effect. Before these strokes dry, he sets in two strokes with the more-violet paint that will become the reflection of the church in the wet pavement. He draws two strokes across the area with a clean, dried brush, picking up some lighter tire marks. A few vertical whisking strokes pull these sections together a bit, but he is careful not to lose the glints of white that make sky reflection.

Again, he must wait for drying. As soon as possible, he starts painting the nearest plane, and here, for the first time, there is some real variation of hue. In the tree at left burnt umber and sepia dominate; in the woman's figure, raw umber; in the man's, alizarin and ultramarine. Sepia is strong in the lamp and posts at right. Note that he sets in the tree with the 1″ brush, moving to a rigger only for the smallest branches. (This also is used for the man's cane, and the details of the lamp.) A ¼″ brush with sepia and blue draws the shadowed curbs. Reflections of these last darks are set in where appropriate and wiped out again to clarify the tire marks and a lost light between the reflections of the tree and figures at left.

COMMENT

Painting pictures of fog, besides often producing lovely works, offers practice in two very important aspects of the painter's craft: subtle value relations and spotting. Painting fog will also familiarize you with the look of one of nature's common simplifications of appearances and will suggest means you can adapt to your need to reduce complexity in pictures of other conditions.

84. Fog, Goose Rocks, *1968. 22″ x 30″, 300 lb. rough paper. In this late treatment of one of his favorite subjects, O'Hara submits everything to severe scrutiny and confines himself to basics: sky, islands, sand, and shore. As a declaration of atmosphere and space, it approaches the Oriental landscape artists whom he so much admired. The water is pure white paper, giving him a subtlety of value relations that cannot be fully reproduced. The picture exemplifies distortion by understatement (see Lesson 30).*

LESSON 29

DARK PICTURE

This lesson suggests techniques for creating darker than normal paintings. (For O'Hara's solution, see Color Plate 29 on page 109.)

PROBLEM

There are times—frequent or occasional, depending upon your temperament—when the most expressive treatment of a subject demands that you exaggerate the darkness of its values overall. When, for example, you wish to present your subject in a sober, serious guise, or if you are facing a subject that is dark in itself, or if you wish to paint a picture that will stand out on a wall, you will need to know how to handle deep darks.

As you have discovered, darks in watercolor tend to dry a great deal lighter than they appear when wet. They also have a disconcerting habit of drying luster-less and dead. These problems must be overcome, especially when the bulk of the paper surface is to be dark.

Painting a picture deliberately darker than you see it has carryover value, for it is useful in handling all darks in watercolor.

PROCEDURE

This lesson will be easier if you pick a subject that is inherently dark—a shaded backyard, the interior of a shed or garage, a narrow alleyway, almost any landscape scene at dusk.

Your first consideration, as you begin sketching out the general distribution of shapes and relationships, should be the size and location of the few relatively light areas you mean to include. This is a spotting problem, but in reverse (see Lesson 9). Design the placing of the lights as you would the darks in most paintings. In addition, select the shapes of these light areas for the most telling contours: you will not have many other means of indicating the basic parts of your subject.

When your drawing is complete, number the values. You may do this just as you did in Lesson 2, that is, as you see their proper relationships.

Check your palette to make sure that you have ample supplies of fresh paint among the naturally darker pigments. This includes the earth colors, the dark reds, greens, blues and violets, and black.

To start, leave your value #1 areas white, or tone them with a light wash. Paint the value #2 areas at what would normally be about value #4, as you did in Lesson 22. Now proceed down the value scale through the middle values. Watch the way areas are drying to be sure that your proportional relationships are being maintained. By the time you reach your darkest areas that you had numbered #6 or #7, you may realize that you are going to run out of values before you reach your darkest darks. From #5 areas on down, therefore, try to make the intervals (the contrasts) between values closer than usual. You may still find that you are running out of value distinctions too soon, and you may worry that your #8, #9, and #10 values, for example, will all be the same.

You have another means of distinguishing areas at these low value levels, however, and now is the time to use it. Make necessary differentiations in these very dark sections of your picture by using your darkest tube colors. You will find that by exaggerating *hue* differences you can achieve the clarity you require. For the moment, try resolutely to keep out of the black: you may want it later for some final precision of edge or shape.

Instead, contrast ultramarine blue with burnt umber, phthalocyanine green with violet, and so

forth. If these colors go on with too much intensity, you are using too much water, thinning them too much. You will have to use a very dry brush and use the paint almost as though it were oil or acrylic, brushing it on patiently with a vertically held brush. Try to employ the more transparent paints for these darks as they are less liable to turn muddy. Should you require it, a moderate light may be set in by this same means, but by using relatively opaque pigments. Raw sienna, for instance, is a medium-light pigment that is fairly opaque: painted over a dry darker area, it may suggest slightly illuminated shapes. You will find that the cadmiums, cerulean, and cobalt blue may also be used this way. A word of warning, though: restrain your use of these light-over-dark possibilities. You already have an unusual amount of paint on your paper, and each addition increases the possibility of your achieving a literal mud that will dry to pictorial mud.

Wait for the last darks to dry completely before "finishing" your work. Check the picture carefully for design and for clarity of representation. If necessary, now is the time to put in any black touches or final opaque lights among the darks.

O'HARA'S SOLUTION

Well over half the surface of O'Hara's *Moraine of the Tasman Glacier* (Color Plate 29) is at value-level #7 and below. The effect of the picture is definitely darker than usual, but modeling and differentiation of color are not lost. The painting has tremendous dramatic impact, as the very darkness of the mountain masses gives them an overpowering presence and monumental dignity.

O'Hara begins this picture with a summary pencil sketch, locating the primary areas and masses. He brushes clean water on the sky, being careful not to overlap the bit of snow on the mountain. With ultramarine blue, alizarin crimson, and burnt umber, he paints in the warm-gray clouds. While the wash is still wet, he adds phthalocyanine blue at about value #4, leaving an edge of white along the gray clouds.

While the sky is drying, O'Hara starts painting some of the lighter values in the near ground. The moraine itself goes in first. Using an ultramarine, alizarin, burnt umber mixture, he sets his 1" brush at the left margin of the paper. Holding it vertically, he draws it rapidly across the paper, leaving a streaked rough-brushed stroke. About halfway along the

85. Andalusian Street, *1930. 20¼" x 14¼", 90 lb. rough paper. One obvious application of the dark-picture technique is a night scene. All the values have been deliberately lowered, although O'Hara treats moonlight as if it had the power of sunshine. You will recognize that the light in the window at lower right has been added with opaque white. Stars in the #9 blue sky were picked out with a knife tip.*

159

stroke, he goes back lightly once more, pulling the brush less rapidly to the right. This creates a somewhat more solid tone on the moraine at the right side.

With a clean brush, he now picks up phthalocyanine blue and green, with a little raw umber, and in a few quick strokes indicates the cracks in a patch of old, melting glacial ice along the bottom of the picture. The value is about #3–#4. Sepia and raw umber, with little water, are rough brushed along the lower edge of the paper, and a few lighter dabs of the same mixture suggest dirt and discoloration on the ice. The trailing corner of the brush makes some cracks. Then, starting at the right and using raw umber with a little cobalt, he sets in some gravel and bare earth under the moraine. About #6 in value, this dark provides an emphatic silhouette for the rotting ice in the immediate foreground.

O'Hara paints the mountain masses with a medium tone of neutral violet made from ultramarine, alizarin, and burnt umber. Traces of this initial tone may be seen at the extreme right and left margins of the painting. The nearer hill at left is painted with a mixture of alizarin crimson and raw umber at value #6. At the same time, O'Hara sets in the pale blue-greens that articulate the snow on the mountain at left.

The artist quickly decides that the first tones on the mountains are not dark enough. He paints over his initial wash with pure ultramarine blue, using a heavy concentration of pigment in very little water. To indicate exposed rocky pinnacles, he picks up alizarin crimson, applying it purely and heavily as he did the blue. Lower down, extra-dark tones are composed chiefly of phthalocyanine blue. He models the nearer hill with a mixture of raw umber and cad-

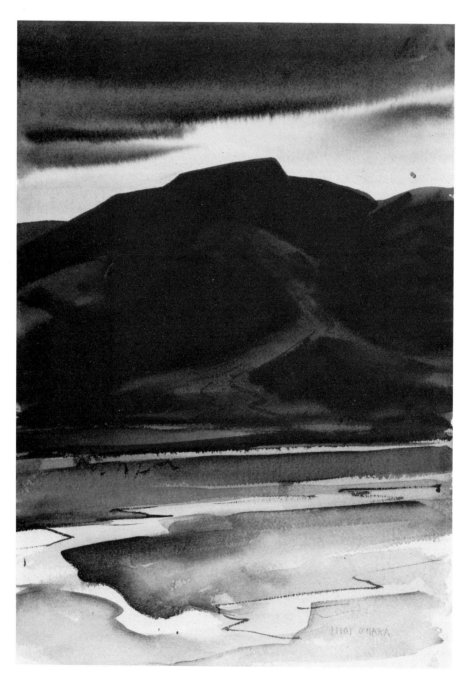

mium yellow medium, picking out the crest of this ridge with pure cadmium. All these values are very close, about #8 and #9. The elements are differentiated by hue.

O'Hara adds interest and form to these darkest areas by introducing lines of Venetian red among the upper peaks. In the same way, variation is achieved lower down with sepia and cadmium yellow medium. While the alizarin and phthalocyanine-blue strokes are mainly transparent, even though applied heavily, these articulating strokes are considerably more opaque. They function as lights over darks.

To complete the painting, O'Hara adds a further layer of sepia and cadmium yellow to the modeling on the nearer hill. A few darker strokes—ultramarine and sepia with a little alizarin—are set in along the bottom of the moraine.

The final picture is outstanding as an example of effective use of darks. Even though overpainted, it remains luminous and rich by judicious employment of dark transparent tube colors in combination with a few opaques. Notice that O'Hara does not actually omit a value level or two, as you have in your exercise. His result is similar, however, because he includes very little at values #4 and #5.

COMMENT

Learning how to handle deep darks successfully in watercolor will give your painting greater range and power. It will also help you with special representational problems, such as the double-value scale subject, and with techniques such as wet blending. Finally, it permits you much more flexibility of design. You may wish to return to this lesson from time to time.

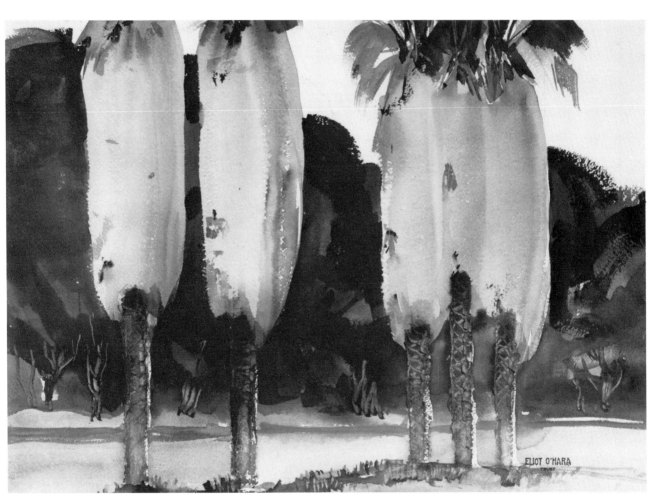

87. Five Palms, *1937. 15½" x 22½", 140 lb. rough paper. Although it is not, strictly speaking, a dark picture, O'Hara has treated this subject by similar means. The sky is white paper. This enables him to paint the reflected lights on the dead palm fronds at their full value and intensity. These values, moving down to #4 and #5 at their darkest, compel him, for contrast, to use values of #8 to #10 in the background foliage. This striking composition depends almost wholly upon spotting: no path of vision here!*

86. Bad Water, *1967 (Left). 22¼" x 15¾", 300 lb. rough paper. O'Hara has pulled all stops to provide an ominous ambiance for this Death Valley scene. The upper two-thirds of the paper is dark and heavy—deep, intense purples, and black. The nervousness of the qualifying calligraphy in the foreground contributes to the sense of useless water. No vegetation is included.*

LESSON 30

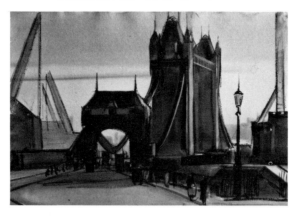

DISTORTION

This lesson suggests methods by which special selection and emphasis of pictorial means may be used to clarify your expressive intent. (For O'Hara's solution, see Color Plate 30 on page 110.)

PROBLEM

Even the most strictly representational painting involves some distortion. People are not unthinking, unfeeling recording devices: two artists, set before the same scene with the same tools and trying their hardest merely to reproduce what is before them, will turn out works that differ as their personalities differ. You cannot help imposing your own mind and hand upon your picture. As with all the projects in this book, this one seeks to provide you with understanding that will help you control some natural part of the painting process, so that it can serve your artistic ends. In this case, it is distortion.

Literally, to distort means to twist—that is, to alter with respect to some norm. Here, the norm is taken to be naturalistic representation. You may distort color, as suggested in Lesson 27, but generally the word *distortion* is used to signify modifications in drawing —alterations of shape, size, and proportion. It is on this narrower kind of distortion that the present lesson focuses.

The simplest and most common distortion is exaggeration—making a tall thing taller or an angular thing more angular, for example. More difficult and less frequent is understatement, wherein the tall thing is made less tall, the angular thing less angular, and so on. The effect of exaggeration is to increase excitement, to dramatize, while the effect of understatement is to render your composition more serene and stable.

The two principal forms of distortion, exaggeration and understatement, may be applied to any of your

representational or technical means. They may be used singly or in combination. For instance, you may choose to minimize depth, limit hue, but accent planarity and value contrast. Alternatively, you might wish to eliminate light effect while exaggerating textural differentiation. In whatever combination you select, however, try to maintain some balance: a picture in which everything is exaggerated will usually be strident, and one in which everything is understated may be simply boring. Remember that your aim is to control distortion for your own expressive purposes.

PROCEDURE

This is a good rainy day lesson because you can easily do it by working from previously painted pictures.

It might be a good idea to select from your flops a particularly bland picture, one that just doesn't seem to "do" anything. Look it over critically and consider first what you might do to give it more life. What aspects of the picture might you exaggerate to its benefit? Check the shapes: might their contours be accentuated or changed to more angular lines? Could the curves have more verve? What about their size, and the size of other areas? Perhaps you need greater contrast of sizes. If everything is in a "natural" proportional relationship, consider exaggerating the size of your more-important objects.

How have you presented space: would your picture acquire greater interest if depth were exaggerated? Often perspective lines, into space or on buildings, can be distorted to heighten dramatic recession. Aerial perspective, as you saw in Lesson 10, may be invoked to increase a contrast between near and far.

Could you enhance the modeling of three-dimensional form? Perhaps light effect might be increased by darkening darks and lightening lights. Check

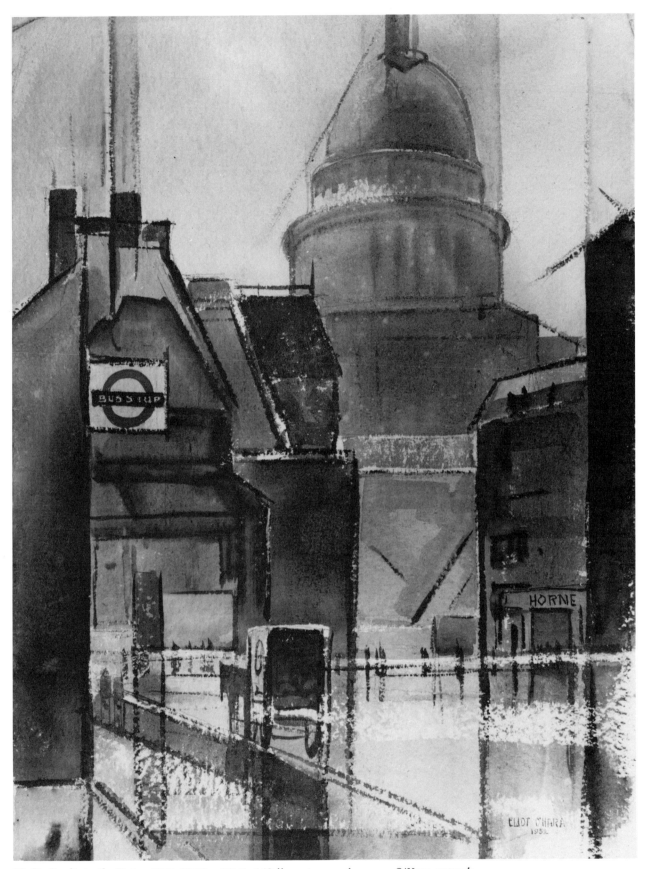

88. St. Paul's in the Rain, *1952. 22¼" x 16½", 140 lb. extra-rough paper. O'Hara extends and emphasizes the reflections in the pavement, creating abstract planes that are echoed in the sky. The tension between surface pattern and depth sets up a lively ambiguity that is the primary "subject" of the picture. Notice that there is a subordinate, but strong, path of vision as well.*

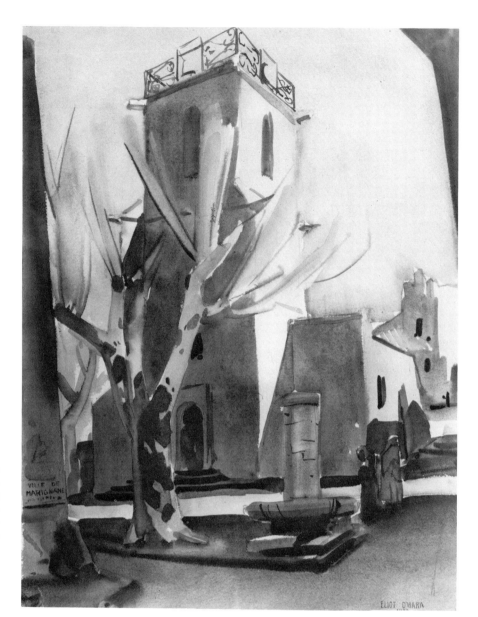

89. Plane Tree, Marignane, *1952.*
22" x 16½", 140 lb. rough paper.
Here O'Hara uses very little dis-
tortion, but it is ingeniously em-
ployed. The tree branches are
simplified by fading them out
into semitransparent planar
shapes. They are thus linked to
the plain, blocky church tower.
The actual intricacy of the
branches is pictorially trans-
ferred to the elaborate iron
grillwork atop the tower.

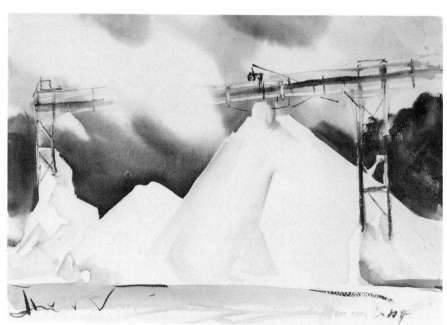

90. Dust and Limestone, *c. 1962.*
16" x 22¾", 140 lb. rough paper.
Understated modeling of the
crushed rock piles emphasizes
their whiteness; contours are
determined by the dark trees
behind. The blowing dust is wet
blended. O'Hara eliminates a
great deal from the scene in
order to play light against dark
and shape against line.

164

especially your reflected lights: often they can be treated with more intensity and higher values. Have you used textural contrasts to greatest advantage? Possibly you could employ the varied effects of wet blending and rough brushing to enhance your painting's interest.

Redraw and repaint your picture now, distorting it by selected exaggerations with the aim of clarifying and directing the image toward greater vigor and activity.

The more difficult exercise, which you should also do, is to improve your original painting by selective distortion of the understated type. Run through the questions above, but this time think about how you can change a merely dull picture into one that is *expressively* sober or serene. This may involve changing oblique edges to more horizontal or vertical ones. Could curved lines be regularized, made more suave? If you made more of the shapes similar in size, would that be only boring or could such a change help emphasize a positive feeling of tranquility?

Examine your treatment of space, modeling, light, and texture and plan such alterations as you feel may strengthen a feeling of calm and dignity. Then, once more repaint your original picture.

Survey your works critically, making note of distortions that have successfully crystallized the effects you sought.

O'HARA'S SOLUTION

As mentioned in the Introduction to this book, O'Hara's usual approach to a subject was through modified Impressionism—that is, a simplified realism with emphasis upon light effect. On the occasions of his departure from this style, his preferred treatment was either generally calligraphic (see Color Plate 20) or, more frequently, planar. It is this form of moderate distortion that distinguishes *Tower Bridge, London* (Color Plate 30).

Rather than summarizing the technical procedure employed by the artist in painting this picture, we will analyze the kind and degree of distortion used.

First, all objects in the painting are perfectly recognizable. O'Hara has not departed so far from appearances as to render the scene obscure. He has even included certain significant representational details, such as the particular appearance of the arched entrance to the bridge, the Gothic decoration of the towers, and the elegant cast-iron lamppost. He has restricted color severely, however, and translated all solid objects into simplified blocky masses with emphatic planar relations to each other and to the picture surface.

To begin, after having made the usual rough drawing, O'Hara paints a sky that is articulated by predominantly horizontal areas, creating the effect of a rather static, planar backdrop for the nearer objects. He wet-blends distant blue buildings into the lower section of the sky, using both tone and technique to exaggerate their remoteness and permitting them to form another approximately horizontal band that once again emphasizes the planarity of the entire background.

Having established this strong sense of a background plane parallel to the plane of the paper surface, O'Hara commences painting the nearby roadway. The angles of this plane thrust it, by mildly distorted perspective, from the picture plane into the entrance to the bridge. At the lower right both the road and the sidewalk are linked to the background by strong horizontals. Toward the center and the left, drawn angles shift the road plane to one clearly perpendicular to the paper surface and seen slightly from above. This road plane converges at the bridge entrance, where it is stopped by the rectangular and repeated planes of truck and auto forms that are also parallel to the picture plane.

Although the bridge-entrance structure is drawn to suggest a small perspective angle, it is painted as a massive element parallel to the picture surface. It thus links the background plane with the surface plane of the painting in an emphatic way. Behind it, the central directional axis of the bridge itself, and its cables, continues the angle of the roadway at left. This provides a powerful movement into the picture along the oblique vertical plane most evident in the towers and cables.

Subsidiary planar elements are arbitrarily created at the margin of the picture by developing the wharf cranes into triangular shapes at left and rectangular shapes at right. Here O'Hara is further developing planes parallel to the picture plane (as well as linking shapes on the picture surface in terms of flat design). The reason for such emphasis on these flanking parallel planes is that the angle of the roadway and bridge moves so strongly into the picture space that it requires powerful stabilization.

The result is a picture in which distortion of appearance creates a picture space full of counterbalanced tensions in dynamic equilibrium. In this picture O'Hara employs planar distortion to provide the viewer with a visual equivalent of the immense counterbalanced forces that animate the bridge itself.

COMMENT

It is imperative that you understand that distortion is, first of all, only a move away from representation, a move that you, as the artist, control in kind and degree. Second, distortion is effective only when it is deliberately employed for reasons of design or expressive intent, or both. Inadvertent distortion is read by the observer as simple inadequacy of drawing or painting. Understanding the uses of distortion, however will give you a greatly amplified range of means for developing a personal mode of painting.

LESSON 31

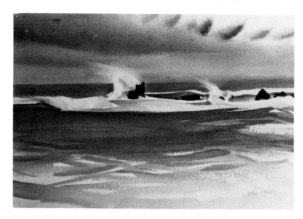

PAINTING FROM MEMORY

This lesson suggests some techniques for notetaking and for painting from notes. (For O'Hara's solution, see Color Plate 31 on page 111.)

PROBLEM

Despite the great convenience of watercolor for outdoor painting, there are always times when you see exciting subjects but do not have your equipment with you. The more often this happens, the more firm should be your resolve always to carry your painting gear! But that still doesn't answer every need: sometimes it is impractical or impossible to bring your full pack of materials, and in any case, accidents will happen in this imperfect world.

One way of reducing these misfortunes is to make a habit of *always* carrying a sketchbook and pencil. This is a basic minimum of equipment, and—as you perhaps already know—all you really need. Quite a small notebook is adequate, and it need not be composed of the highest-quality paper. Sizes 4″ x 6″ or 5″ x 7″ will fit easily into purse or pocket and provide a large-enough surface for a clear record of a composition, some details, and your written or shorthand notes.

If you wish to be a little more accurate, there are value-graded gray chalks available with which you can record a complete value range. For even more information, you may use a tiny watercolor sketchbox and water container. These again take up very little space and are easy to use. They permit rather full color notes—their primary advantage. Some artists find that they can successfully use an inexpensive camera, as well. With one or more of these tools, there is no reason why you should not be able to record and recover in the studio any attractive subject encountered at a time when to do a full-sized painting would be awkward.

PROCEDURE

For the first part of this exercise, you are going to work with no materials apart from your normal sketching and recording equipment. So sally forth, laden lightly, and find yourself a subject.

It may take some time for you to discover how much and what kind of information is most necessary for you as you face the blank paper in the studio and begin a painting from notes. For that reason, a number of suggestions will be included here: do not feel that you will finally need to employ all these possibilities.

Obviously, however, you will need a drawing. A soft to medium-soft pencil will give you dark enough lines to follow and will also erase fairly easily. Make a sketch of the sort you have been doing on your full-scale painting paper. Consider, now, that you will not be able to look up at your subject while you are actually painting, and add any further definition that seems to you significant. If there are details too complicated to render at the size you are working, turn the page and make sketches—as complete as you think you'll need—of those details.

You may find that you would like a further indication of the broad value pattern of the subject. If so, make one. You may also decide that a couple of compositional possibilities might profitably be worked out on the spot. These may all be of the thumbnail variety—that is, one or two inches on a side.

If you have value-graded chalks, you might now make a drawing using them. If you have a small watercolor box, make your color notes with it. And if you have a camera, take an overall shot and shots of any details you think will be valuable.

Whether or not you possess the ancillary equipment mentioned above and are using it, it would be wise for you to make notes *on your pencil sketch*

166

indicating the hue, value, and intensity of each important area. Numbering the values should by now be simple enough. You will require some method of hue and intensity notation, however. The best and easiest way to do this is to use the initials of the six spectrum colors: R, O, Y, G, B, and V. Similar abbreviations may be used for YG (yellow-green), BV (blue-violet), and others of the tertiary hues.

Because intensities are usually the most difficult variations of tone to *see*, they are also the trickiest to note. O'Hara sometimes wrote the hue initial lightly for a neutral and heavily for a fully intense hue. If you wish to be more precise, you might try using N for neutral, $\frac{1}{2}$N for a tone about halfway between full intensity and neutral, and $\frac{1}{4}$N and $\frac{3}{4}$N for the degrees of neutrality between. For example, your complete color notation for a spring field in sunlight might be YG-3-$\frac{1}{4}$N (hue, yellow-green; value, #3; intensity, $\frac{1}{4}$ neutralized). Blue sky might be B-4 (since the blue is as intense as it possibly can be, you need no indication of neutralization). A rusty barrel on an overcast day might be RO–6–$\frac{3}{4}$N. As you become accustomed to your own needs and to your notation system, you may find that you do not require

very much information about intensities. For the time being, however, it is best to note them as carefully as possible. This will train your visual judgment as well as provide you with helpful information.

For the second exercise in this lesson, go home and prepare to paint in the "studio." Your camera, however accurately it may record specific visual material, is not too useful until the film is developed and printed, unless you have one of the quick-developing variety.

Your notes should be assembled and placed within easy reference distance. Draw your picture from the sketch, incorporating any details you may have noted down in separate studies. Check your design and adjust the composition to suit you. Refer to your value sketch, if you have one. Now number your values, as usual.

Things generally go pretty well up to this point. It is when you actually begin painting that you are likely to miss the ready reference to your subject. As you proceed, make mental or written notes of the kind of information you sense yourself lacking: next time, you can get it. Even so, you will find that you have to depend to a very considerable degree on your

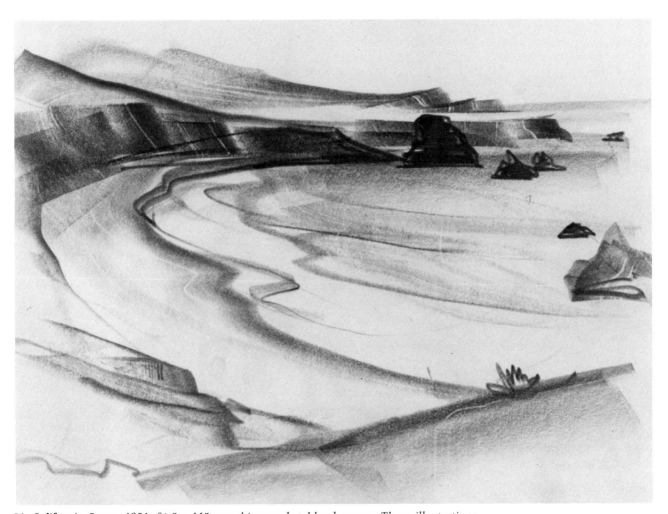

91. California Coast, *1951. 8½" x 11", graphite on sketchbook paper. These illustrations show three of O'Hara's typical techniques for notetaking. Here he uses a graphite stick to record shapes, value relationships, and movement. It was his habit to make as many as seven or eight quick versions of a subject he liked. This is one of three.*

personal "morgue," that file of visual images and relationships that all painters begin swiftly to build up. A sense of how a sky actually works, of where a transition *ought* to be, even though your notes don't include it, of the pattern of branches in a tree— these are the sorts of things that will force your memory to reach, providing you with invaluable exercise in recollection.

The chief failings of pictures painted from memory and notes are: *too little* and *too much.* When you have finished your painting, look at it to determine whether yours shares either of these problems. *Too little* generally results from insufficient information. One of the great values of memory painting is that a subject strained through the sieve of your mind presents itself only in terms of those factors that most impressed you. Emphasis, restraint, and a dominant focus are often more easily obtained by painting from notes than they are in on-the-spot painting. When you are starting out, though, you may have not

provided yourself with enough drawing and color information. Since your fund of remembered images and relationships has yet to grow to its full stature, you are forced to leave generalized areas. Too many of them may result in an empty picture.

Too much, on the other hand, can result either from inadequate information or from a plethora of notes. If you have neither sufficient notes nor a rich enough account in the memory bank, you are liable to try to make up for the blank areas you see developing by diddling, putting in all manner of stuff in the hope that it will "look right." Similarly, if you are scared from the start and arm yourself with color sketches, value sketches, and photos (especially photos), you may find the process of selection so difficult that overcrowdedness of another sort occurs.

The advantage of a kind of natural selection that painting from memory affords should be seen against the advantages of painting outdoors, where all of nature presents itself for your use and delectation.

92. Quebec Street, *c.1967. 11" x 8½", felt pen on sketchbook paper. Especially for texture, O'Hara liked wide-nibbed felt marking pens. Often he used four or five rather neutral colors —terre verte, sepia, raw sienna, gray, and maroon—to help him recall warm and cool tonal relationships.*

O'HARA'S SOLUTION

Seal Rocks (Color Plate 31) is a studio painting, done from memory and sketches such as Figure 91. It is painted very directly, very simply, in about twenty minutes.

After indicating briefly with pencil the location of the horizon, the main splash of surf, and the edge of the oncoming wave, O'Hara wets the sky with clean water. He is careful to reserve the white paper for the surf. In the upper right-hand corner, he sets in a little phthalocyanine green, using a fairly dry brush. The sky is painted with a mixture of black and alizarin at the left and along the horizon. A dryer brush, loaded almost wholly with black, makes the strokes of low-hanging clouds from left to center; and black again is used for the dabs at upper right that add interest to that corner of the painting. With a clean, dried brush he lifts out the blowing spray from the central breaking wave.

While the sky dries, O'Hara moves to the bottom of the paper. He uses alizarin and phthalocyanine green, very pale, to indicate in quick, rough strokes, the sloshing water of the foreground. The color is changed by adding ultramarine blue and is carried up the paper to the base of the breaking waves. More ultramarine, only slightly neutralized, is painted in above the wave crests, indicating the farther sea. A lesser spray of white is picked out with a dried brush toward the right.

While waiting for these areas to dry, O'Hara plays in the foreground water, adding six or seven single strokes of the 1″ brush with slightly darker green. He lets the swing of the strokes stand for the wave motion.

Returning now to the central focus of the picture, he picks up fairly pure phthalocyanine green, quite dark, and rough brushes the stroke in the middle that suggests a breaking wave. To the right and left he adds further single strokes of green, varying the value and carefully controlling the amount and shape of reserved white areas, most of which are left with a rough-brushed edge. Some short dabs of pale ultramarine blue model the forms of the surf.

Between the breaking waves and the foreground, O'Hara places another wash, primarily of ultramarine and alizarin. This darkens the water and gives him the opportunity to add some hard edges indicative of smaller wave movement in that area. He finishes the picture with a dark-sepia and black mixture, used for the tops of the rocks over which the breakers surge.

Although this is a simple painting, its convincing suggestion of the powerful movement of the water gives it authority and clarity of expression.

COMMENT

This is a good context in which to remind you that constant drawing is essential to good painting. Carry your notebook with you at all times, not just to record a striking subject or a detail for later incorporation into a picture, but to encourage perseverance in developing your ability to see and to render nature in its variety.

Remember also that among the best records to work from in the studio are quickies. Often a series of three or four five-minute quickies done on the spot will later provide ample information from which to select and compose the essentials of a fine picture.

93. Fjord, Norway, *1966. 8½″ x 11″, India ink and blue ballpoint on sketchbook paper. O'Hara draws contours with an India ink fountain pen, models with ballpoint shading, and notes value and hue with the described numbers and letters system. Terse descriptive words—"city," "vines"—will later jog his memory of specific areas.*

LESSON 32

STUDIO TECHNIQUES

This lesson presents some means of correcting pictures and discusses problems of repainting in the studio. (For O'Hara's solution, see Color Plate 32 on page 112.)

PROBLEM

Watercolor paintings are most pleasing, by and large, when they seem to have been freshly and immediately done. It is a good practice to paint as though no correction were possible, as though every stroke set down were irreversible. Pictures made this way, however, do not always turn out as planned. All too frequently a watercolor will disappoint you. O'Hara, in fact, alleged that he signed only one in thirty or forty.

However disappointing a painting may be, it is unwise to toss it out right away. For one thing, as you later look over a group of rejects, you may find that some are not as bad as you at first thought. Second, there do exist a number of ways in which watercolors may be repaired. Finally, a good subject can always be tried again in the studio, using the original as if it were a set of notes.

PROCEDURE

For this lesson you will need two abandoned paintings, the first a real flop and the second a picture with possibilities. Go through your stuff and find a couple of this sort.

With the flop in hand and your materials easily available, begin practicing repairs:

Adding Darks. This is the simplest kind of correction you can do. Fairly large washes can be painted over paint that is *well* dried. The trick is to do it quickly and lightly. You can blend in edges by wetting them with clear water, as was mentioned in the wet-blend-

ing lesson. You might remember, too, the admonition set forth in Lesson 29 regarding deep darks: overpaint wherever possible with transparent colors to minimize muddiness. Try adding darks to your flop.

Removing Darks (Adding Lights). This is trickier, but perfectly possible, especially in small areas. Generally speaking, the lighter the value of the paint from which you wish to remove a section, the more success you can expect. Depending on the nature of the problem, there are several procedures you may adopt.

Pencil lines remaining from your original drawing may be disconcerting in light areas. They can be removed with a soft gum eraser. If the area is painted with one of the more opaque pigments, however, proceed cautiously, for the grains of pigment tend to come off too. Estimate the risk before you begin erasing.

As you have just noted, opaque pigments can be removed with a gum eraser. Hence, if you have a cobalt blue sky that might be more interesting with some soft-cloud effects, you may be able to get what you want simply by erasing. The more transparent paints, which tend to stain the paper, are often difficult to remove, even when they are dilute and at a fairly high value. Still, you can try the gum eraser, and if it doesn't work, try harder rubber erasers, too. An ink eraser will take off small areas quite easily, but it does mutilate the paper surface a good deal and makes repainting the area a little harder.

An eraser may be used with a straightedge to produce shafts of sunlight in an uninteresting sky or through a window. You may also cut thin cardboard or acetate into shields of various shapes to permit your erasing freely around an area you wish to protect.

As was mentioned in Lesson 16, sandpaper will remove paint. On rough paper it leaves a stippled effect, however, which you may not want.

Water may also be used to take unwanted paint off a picture. For a relatively small section, wet the paper with clean water and let it sit, adding water as corners or narrow parts dry. After a minute or two, pick up the water with an absorbent towel, pat the area dry, and then rub with a gum eraser. You will get a clean white surface, though soft-edged and a little abraded. It is possible to paint on such an area, allowing for slightly softer edges that result from the roughing up of the paper fibers. A word of warning: test this procedure on a different sheet of the paper on which the painting to be corrected is done. Papers respond very differently to soaking and rubbing. Notice that you must be patient with this process or all will be lost.

Larger areas of paint—an entire sky, for instance—may sometimes be successfully removed by sponging. This works best on a tough-surfaced paper, either rough or smooth. Wet the area thoroughly, being careful to confine the water to the paint to be taken off. With a soft, wet sponge, rub the area gently, washing the paint off the edge of the painting. Ordinarily it is not possible to clean the paper to pure white, but you may get a fresh enough surface to try a new sky.

It is far easier to remove paint from smooth paper, simply by wetting and washing with the paintbrush. Smooth paper may also be sponged more successfully than rough, though staining paints are impossible to remove from it completely.

The most satisfactory means of removing small areas of paint from either rough or smooth paper is with knives. To take out an area for a flag or bird or small garment on a washline, for instance, you can use a frisket knife or other extremely sharp, pointed, and controllable instrument. Cut the contour of the area you wish to remove, bearing down enough to sever the paper fibers to a depth of no more than one sixty-fourth of an inch. Using the point of the knife, carefully lift the paper inside the area to be removed. A layer of paper, together with the paint covering it, can easily be taken up. If you wish to repaint it in any detail, you can burnish the ragged surface with any suitable tool, ranging from an etcher's burnisher to a ball bearing or teaspoon back.

The single most important drawback to the above procedure is that it may leave an excruciatingly clean edge. You can modify the edge either with paint or with an ink eraser.

Many watercolorists find single-edged razor blades helpful for corrections. They can be employed like frisket knives for small areas or like sandpaper on rough paper for a mottled area of lighter tone.

In general, it is wise to avoid too much tinkering with a watercolor. Make as few corrections as possible and integrate them as fully as you can with the handling of the rest of the picture. Realize that, at best, you may succeed in turning an unacceptable painting into a good one only about half the time.

The cures outlined above are, for the most part, drastic: they should be invoked only in terminal cases.

There remains, however, the possibility of repainting the picture entirely. If you have a good subject, one that continues to excite you but that is impractical for you to redo on the spot, this may be the answer.

The problems that beset the artist when repainting are similar to those that afflict the artist painting from notes and memory: too little information, and the temptation to put in too much. Before you do a practice repainting job, study your original, the one you selected earlier as having possibilities. Figure out what you want to do differently and where you may not have enough clarity to recreate a portion of the image with greater conviction. Consider composi-

94. Maple and Harbor, *1968. 14" x 22", 300 lb. rough paper. This picture, Figure 95, and Color Plate 32 document with unusual clarity the development of an idea. Here, on the spot, O'Hara's color, values, and scale approximate appearances. The picture is open and airy, and it focuses on the boathouse and dories.*

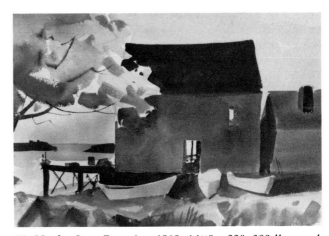

95. Maple, Cape Porpoise, *1968. 14¼" x 22", 300 lb. rough paper. Working from Figure 94, O'Hara here begins to shift his emphasis to the autumn reds against the boathouse. He makes the house much larger, and parallel to the picture plane. The foliage becomes a homogeneous mass. The sky is simpler and greener, the distance less complex. These decisions are developed in Color Plate 32.*

96. Gulls over the Pool, *1938. 15¼" x 22¼", 140 lb. rough paper. This picture, done on location, was taken to the studio for the gulls. O'Hara removed them by drawing them on the paper with a wet brush, allowing the water to sink through the paint layer, blotting any excess water, and carefully erasing the loosened paint and paper. He obtains a somewhat roughed-up pure white surface upon which he paints the modeling of the birds.*

tion, color, handling of the brush, textures, and so forth. Check the questions you asked yourself for Lesson 30. Make a small sketch to help you identify new solutions to your problems. If you discover that there are important gaps in your information (for example, how a set of gables relate to each other; or the structure of some foreground rocks), go back to the site or substitute something similar from another painting. Do *not*, in any event, begin painting until you are sure of what you are going to include, and how you are going to handle it.

With your original painting, your subsequent sketches, and any other material you feel you require, redo the picture. Be sure to note, as you work, any sort of forethought that would make the task easier were you to redo a painting another time. When you are through, you may have a greatly improved picture; you may have a worse one. If the latter, you have perhaps succumbed to pickiness or have failed to achieve the freshness of the original. Try to identify your problems and *write them down.* This will help you to remember them and will give you a list of suggestions to check another time.

O'HARA'S SOLUTION

Throughout his career O'Hara spent time in the studio—often as much as three months a year. He used this time to redo, enlarge, vary, or document his field paintings; and to mat, frame, pack, ship, and record his work. Although he was ruthless in throwing out failures, he kept any paper that seemed promising as the basis for a repainted picture. And for him, repainting was a serious method of working. It was a means of exploring variations of a subject and of eliciting new ideas from it.

Swamp Maples (Color Plate 32) is one of several versions of a Maine fall theme, of which the first on-the-spot picture is *Maple and Harbor* (Figure 94). *Maple, Cape Porpoise* (Figure 95) is yet another variation. Looking at the three pictures, it is evident that O'Hara was searching for an ever-bolder, simpler evocation of time and place. He leaves out more and more, relies increasingly on large masses of red foliage, and, though you cannot see the change, greater contrast of color. In Figure 94, for instance, the color is quite natural, with blues, violets, and variant grays included. *Swamp Maples*, on the other hand, is severely limited in color, the keyed reds and greens relieved only by a bit of blue to the left.

Though you must adapt studio repainting to the needs of your own style, it may be helpful to remember O'Hara's example: constant attention to clarification, simplification, and intensification of his intention.

COMMENT

As was noted in the Introduction, O'Hara mainly painted outdoors, directly from his subject. He constantly warned his students against the gradual loss of immediacy and enthusiasm that—for him—occurred with prolonged confinement to the studio. Nature, he felt, was the ever-reliable source of artistic regeneration. But he was too wise and insightful a man to insist that all artists work alike. As a teacher, O'Hara sought for his students—and as a man wished for them—that liberation which alone nurtures personal expression. He constantly encouraged the study of all styles, all techniques. And above all he insisted that painting should provide pleasure for the painter. To the satisfied and the discouraged alike he repeated the injunction: "Keep painting—until it stops being fun!"

BIBLIOGRAPHY

Albers, Joseph. *Interaction of Color.* New Haven, Conn., and London: Yale University Press, 1971. A book of exercises exploring the visual properties of pure color.

Evans, Ralph M. *An Introduction to Color.* New York: John Wiley and Sons, 1948. A thorough discussion of optics and the physical behavior of light, with good material on vision.

Gettens, Rutherford J., and Stout, George L. *Painting Materials.* New York: D. Van Nostrand Company, Inc., 1942. London: Dover, 1966. An especially thorough treatment of pigments and supports.

Grumbacher, M. *Color Compass.* New York: M. Grumbacher, Inc., 1972. A clear, concise summary of color as it affects the artist.

Kautzky, Ted (N.A.). *Painting Trees and Landscapes in Watercolor.* New York and London: Reinhold Publishing Corp., 1952. A very good discussion of the drawing and painting of trees. You may find that any good field manual identifying trees will also be helpful.

Mayer, Ralph. *The Artist's Handbook of Materials and Techniques,* 3rd ed. New York: The Viking Press, 1970. London: Faber and Faber, 1964. A complete compendium of materials and their uses.

Pope, Arthur. *The Language of Drawing and Painting.* New York: Russell and Russell, 1968. An excellent and complete introduction to drawing and color.

Whitney, Edgar A. *Complete Guide to Watercolor Painting,* rev. ed. New York: Watson-Guptill Publications, 1965. An especially helpful discussion of design in painting.

The following books by O'Hara are out of print, but you can find them at libraries and they are all valuable:

O'Hara, Eliot. *Making the Brush Behave.* New York: Minton, Balch and Company, 1935.

———. *Making Watercolor Behave.* New York: Minton, Balch and Company, 1932.

———. *Watercolor at Large.* New York: Minton, Balch and Company, 1946.

———. *Watercolor Fares Forth.* New York: Minton, Balch and Company, 1938.

———. *Watercolor with O'Hara.* New York: G.P. Putnam's Sons, 1966.

You may also want to look up:

O'Hara, Eliot. *Art Teacher's Primer.* New York: Minton, Balch and Company, 1939.

———, and Short, Walker. *Watercolor Portraiture.* New York: G.P. Putnam's Sons, 1949.

INDEX

Entries in italics refer to reproductions of paintings by Eliot O'Hara.

Designed by Bob Fillie
Set in 10 point Astro by University Graphics, Inc.
Printed and bound in the U.S.A. by Halliday Lithograph Corp.
Color printed by Sterling Lithograph